touch

touch

Sensuous
Theory
and
Multisensory
Media

Laura U. Marks

 University of Minnesota Press Minneapolis / London

Copyright 2002 by the Regents of the University of Minnesota

Published by the University of Minnesota Press
111 Third Avenue South, Suite 290
Minneapolis, MN 55401-2520
http://www.upress.umn.edu

Library of Congress Cataloging-in-Publication Data

Marks, Laura U., 1963-
 Touch : sensuous theory and multisensory media / Laura U. Marks.
 p. cm.
 Includes bibliographical references and index.
 ISBN 0-8166-3888-8 (alk. paper) — ISBN 0-8166-3889-6 (pbk. : alk. paper)
 1. Experimental films—History and criticism. 2. Experimental videos—
 History and criticism. 3. Video art. I. Title.
 PN1995.9.E96 M37 2002
 791.43'3—dc21

 2002005682

Printed in the United States of America on acid-free paper

The University of Minnesota is an equal-opportunity educator and employer.

12 11 10 09 08 07 06 05 04 03 02 10 9 8 7 6 5 4 3 2 1

Contents

III. Olfactory Haptics

IV. Haptics and Electronics

Acknowledgments

The companions on whom I relied over the years of this writing provided me with a working atmosphere that united intellectual curiosity, creative passion, and physical serenity. First among my intellectual companions I thank Patty Zimmermann, for her sisterly model of scholarly and political action; Grahame Weinbren, who has always goaded me to think more complexly; and Vivian Sobchack for her constant inspiration and encouragement. I thank Janet Wolff and Janet Walker for their untiring support. Cathy Busby taught me ways to keep mind, body, and spirit together. I thank Pat Goodspeed, my model of grace and ferocity, and the constantly stimulating Mike Hoolboom. Scott MacDonald tried to teach me to move from the films to the ideas, not vice versa. Without Baldvin Vidarsson I could not write at all. I am also grateful to my scholarly friends Robin Curtis, Phil Gentile, Peter Harcourt, Jan-Christopher Horak, Akira Mizuta Lippit (who understood when my dream crashed his computer), Janine Marchessault, James Missen, Tollof Nelson, Charles O'Brien, Ian Rashid, Mady Schutzman, and my Peircean pals William Echard and Marc Fursteneau.

The scholars and writers I thank are creative people, and the artists I thank are intellectuals. Still, the guidance of my artist friends has always had extra weight because their ideas come from a rich engagement with the world and its poetic and political possibilities. Among these precious friends I thank especially Samirah Alkassim, the Available Light Collective,

Shauna Beharry, Gary Kibbins, Willy Le Maitre, Ardele Lister, Ming-Yuen S. Ma, Walid Ra'ad, Eric Rosenzweig, Jayce Salloum, Lisa Steele, and Kim Tomczak.

This manuscript was shaped into a book thanks to the intellectual generosity of several people. I thank Chris Straayer a dozen times for her engaged and challenging reading of an early version of the manuscript. Lee Carruthers's infinitely perceptive editorial suggestions wove the manuscript together. At the University of Minnesota Press, Jennifer Moore shepherded *Touch* through the editorial process with keen intelligence and enthusiasm. After her departure, Anna Pakarinen, Douglas Armato, Mike Stoffel, and Carrie Mullen maintained the Press's tradition of lively engagement with books as intellectual and aesthetic, as well as commercial, objects, and the excellent Lynn Walterick was a bang-up copy editor. The Social Sciences and Humanities Research Council of Canada generously supported the completion of the research and writing of this project.

As always, for information, inspiration, love, and surprise, I thank my parents, Anne Foerster, Bill Marks, and Jack Diamond. It fills me with joy that our relationships continue to expand from the filial to the intellectual and spiritual.

Introduction

How can the experience of a sound, a color, a gesture, of the feelings of arousal, anxiety, nausea, or bereavement that they provoke, be communicated in words? They have to be translated. Like synesthesia, the translation of qualities from one sense modality to another, writing translates particular, embodied experiences into words.[1] Writing about artists' media, I must translate something about their audiovisual, sensuous materiality into words. My writing will be successful if you, the reader, can reconstitute in your own body the experience I had. It will succeed in a different way if my translation connects with other things that are virtual for you—not to confirm what you already knew, but to actualize a common event that lay dormant, immanent, somewhere between us. Sometimes it is the *inability* of writing to capture experience that is the most evocative. Over some years of attempting to achieve these translations, the best moments have been when my writing did not master the object but brushed it, *almost* touched it. For love of this sense of touch—the haptic sense—the essays in this book mark the beginnings of a haptic criticism.

Translation and Connectivity

When Walter Benjamin was working on a translation of Baudelaire's *Tableaux parisiens,* he was troubled with the question of just *what* he was translating. It was not the literal meaning of the words, nor the information the words conveyed. Information is the least of poetry. The task of

the translator, Benjamin concluded, was to render the relationship between the words of the original and a third thing that it indexes, which he called pure language, and even God.[2] I too would say that the expression of a film and my words that "translate" it are referring to some common third thing. I wouldn't call it God, or even seek out its identity, because what the work of art, the writing, and the world in which they exist have in common is not as valuable as the *differences* among them are. The world would cease to exist if this common language were found. Benjamin quotes from Mallarmé to emphasize the preciousness of difference: "the diversity of idioms on earth prevents everybody from uttering the words which otherwise, at one single stroke, would materialize as truth." Difference is life; unison collapses life into death. The uniqueness, or *haecceity*, of each manifestation is the stuff of life.[3] If I had to name the third thing these specific events refer to, I would call it the "plane of immanence," following Deleuze and Guattari.[4]

When translating from one medium to another, specifically from the relatively more sensuous audiovisual media to the relatively more symbolic medium of words, the task is to make the dry words retain a trace of the wetness of the encounter. I am confident in the ability of language to condense experience and re-explode it in another form. Symbolization, which includes language, is not a rupture with sensuous perception but exists on a continuum with it.[5] The richest words do not convey information, which remains stuck in the symbolic, but are "the most valuable witness to Being."[6]

The artworks I write about seize on particular events—a movie of a long-ago biplane crash, the cooking of a dog in a Myanmar village, a programming quirk in Macromedia Dreamweaver™—and bring them into the present. They remember; they make manifest, they actualize something virtual. In turn, my writing about them actualizes the virtual states in which these works exist, waiting to be seen and appreciated. Art and writing constitute a sort of connective tissue among material entities separate in place and time. To use Maurice Merleau-Ponty's beautiful phrase, perception is a fold in the flesh of the world. Each time we express something we have perceived of the world, we make a fold in its thickness, the way folds in the brain permit chemical communication among its surfaces. One of my favorite metaphors from quantum physics is that the universe is like a great surface that has been infinitely folded together, until points that were unfathomably distant in space-time come to touch each other. I once watched someone make a strudel, beginning with a pliant sheet of dough, so thin it was translucent, that covered the top of a

large table, and then folding and folding it until those thin layers pressed close together in a dense roll (with apples and raisins). The universe is like a strudel. Each time we perceive something, we acknowledge the continuity between its many layers. Expressing these perceptions, we actualize the virtual events enfolded in those layers.

Connective Materialism

"This material is very good to hold. It's more substantial than ordinary film. It's still pliable and limber, but in a different way."[7] As Morgan Fisher speaks lovingly of his collection of film fragments as though each were a dear old relative or a tender lover (here describing IB or imbibition film stock in his film *Standard Gauge* [1986]), so I approach these objects as tangible and beloved bodies. Like André Bazin, that tireless seeker of the immanent in cinema, I search the image for a trace of the originary, physical event. The image is connective tissue; it's that fold in the universal strudel. I want it to reveal to me a continuity I had not foreseen, and in turn reveal that to you. No need to interpret, only to unfold, to increase the surface area of experience.[8] By staying close to the surface of an event, I hope to trace a connection between the event's material history, the event itself, me, and you. I try to make my body and my history as integral as possible to this connective tissue. This is why, along with descriptions of art and ideas, you will read findings from science and from my own dreams in these essays. They're all real, and all intertwined.

Materiality is mortality. Symbolization, or the abstraction of communication into information, is an attempt to hold mortality at bay. When I insist on the materiality of an image, I draw attention to its aspects that escape our symbolic recognition. Watching a commercial movie on a big screen, we may become entranced by a gesture, a lock of hair falling across an actor's face, the palpability of sunlight spilling through a break in the wall. Watching Peggy Ahwesh's film *The Color of Love,* we might miss the pulsing pink and green of the color-treated, decayed emulsion that we do not cognize because we are busy trying to figure out whether the man on the bed in the homemade porno film is really dead—or we may miss the man in favor of the emulsion. Visiting Antoni Abad's Web site "1.000.000," we might miss the particular plummy shape of the mouth that blows kisses in windows opening all over our screen, because we are busy trying to click the damn things closed—or the other way around. I worry that the information age is making us very good at symbolization, at the expense of bringing us into contact with that which we do not know and for which we have no categories. Surfing most Web sites

or playing most video games confirms our ability to execute certain tasks, but I am not sure how it opens us to the unknown—except perhaps for those moments when, waiting for a download, we notice the shape of our fingernails for the first time. To appreciate the materiality of our media pulls us away from a symbolic understanding and toward a shared physical existence. What I want to share with you is *this* particular film with its scratches and splices, *this* video whose demagnetization speaks of memory loss, *this* Web site that makes my computer crash.

If every object and event is irreducible in its materiality, then part of learning to touch it is to come to love its particularity, its strangeness, its precious and inimitable place in the world. I don't believe in the alterity or ultimate unknowability of other things, people, and times. We all live on the same surface, the same skin. If others are unfathomable, it is because it takes an infinite number of folds to really reach them. Part of materialism, then, is celebrating the uniqueness of the other. Things, people, and moments pass, they age and die and can never be duplicated; so materialism's close corollary is cherishing.

The Haptic

Touching, not mastering. The term *haptic* emerges in Deleuze and Guattari's description of "smooth space," a space that must be moved through by constant reference to the immediate environment, as when navigating an expanse of snow or sand.[9] Close-range spaces are navigated not through reference to the abstractions of maps or compasses, but by haptic perception, which attends to their particularity. Inuit and other nomadic people are Deleuze and Guattari's privileged agents of haptic perception. "It seems to us that the Smooth is both the object of a close vision par excellence and the element of a haptic space (which may be as much visual or auditory as tactile). The Striated, on the contrary, relates to a more distant vision, and a more optical space—although the eye in turn is not the only organ to have this capacity."[10] The philosophers trace the term *haptic* to the art historians Aloïs Riegl and Wilhelm Wörringer, an etymology I follow in "Video Haptics and Erotics" to describe how haptic visuality works in the cinema. Here I wish to emphasize that Deleuze and Guattari do not understand haptic and optical to be a dichotomy, but insist that they slide into one another, just as property laws striate land once traversed by nomads, but then homeless people, urban nomads, smooth the striated space of the city. Similarly, Manuel de Landa, in his distinction between the two social structures of hierarchy (comparable to striated space) and meshwork (comparable to smooth space), insists that the

point of social change should not be to replace the former by the latter, but to encourage a more lively flow between the two. He spends time valorizing meshworks, as Deleuze and Guattari spend time describing smooth space, because postindustrial capitalism has privileged the hierarchical structure.

In my emphasis on haptic visuality and haptic criticism, I intend to restore a flow between the haptic and the optical that our culture is currently lacking. That vision should have ceased to be understood as a form of contact and instead become disembodied and adequated with knowledge itself is a function of European post-Enlightenment rationality. But an ancient and intercultural undercurrent of haptic visuality continues to inform an understanding of vision as embodied and material. It is timely to explore how a haptic approach might rematerialize our objects of perception, especially now that optical visuality is being refitted as a virtual epistemology for the digital age.

The haptic critic, rather than place herself within the "striated space" of predetermined critical frameworks, navigates a smooth space by engaging immediately with objects and ideas and teasing out the connections immanent to them. Some critics have called what I do "impressionist criticism." I dislike this term, because it implies that impressions will eventually give way to a coherent and removed critical structure. Impressionism may, however, be valued as a way of moving through smooth space by relying on one's sensory impressions. As Dudley Andrew once noted, phenomenological criticism is often deemed impressionistic, because it does not seek to impose a philosophical view on the object.[11] I try to move along the surface of the object, rather than attempting to penetrate or "interpret" it, as criticism is usually supposed to do.

Haptic criticism is mimetic: it presses up to the object and takes its shape. Mimesis is a form of representation based on getting close enough to the other thing to become it. Again, the point is not to utterly replace symbolization, a form of representation that requires distance, with mimesis. Rather it is to maintain a robust flow between sensuous closeness and symbolic distance, which we may also, following Peirce, call Firstness and Thirdness. In the spirit of Marshall McLuhan's thermostatic understanding of cultural distance, I offer haptic criticism as a way to "warm up" our cultural tendency to take a distance.[12]

The Critic

Classical film theory emerged from an intimate relation with filmmaking practice and film criticism, as in the writings of Eisenstein, Vertov, and

later Bazin. Film criticism is proliferating again, along with historiography, as people are interested to derive theory from the objects themselves rather than impose theory on objects. This is the endeavor of critics such as B. Ruby Rich, Scott MacDonald, Coco Fusco, and Bruce Jenkins—all of whom are also film programmers—who have come close to their objects and generated theory from the encounter. Meanwhile, "new" media are still new enough that theory emerges from specific encounters with the work, in the way early film criticism generated theory.

This writing is deeply theoretical, but it is theory taken personally, tasted, embodied in my own encounters with artists' media. It comes out of years of engaging with communities of experimental media makers: film, video, digital media, and independent television, as well as performance and visual art. I love these communities and treasure the work that people within them produce. Some of these essays draw from particular events based in these communities: conversations, interviews, screenings, festivals, even funding juries. Several were developed from programs I organized for collectives, galleries, and festivals. Being a critic of contemporary media almost necessitates being a programmer, too, for we see so many exciting works that we simply must share with others. Such events, like the works themselves, are ephemeral.

Experimental media are a fertile ground of new ideas. Their findings are usually taken up only much later by the larger culture. As such they constitute a "minor science" that the "imperial sciences" of commercial media may eventually incorporate.[13] I do not consider experimental media to be elite art forms, because elitism implies a bifurcated class structure that does not obtain in the current "specialized" market for culture. Also, the relative poverty of almost all the producers and venues for these works makes the idea that they are elitist a bad joke. Although they are intelligent, critical works, my goal is not mainly to celebrate cultural objects that "resist" dominant powers. They may come out fighting, but they stay to play. Resistance, as Sean Cubitt points out, is not a practicable political strategy in the age of infinitely flexible corporate control.[14] It is more productive to look for the "appropriate" uses of media, in the sense that appropriate technologies are put to specific uses and "appropriated" from the general purposes they were designed for. It is most productive to look for objects made for the particular pleasure of making and interacting with them. The artist's love is embodied in the object and translated to the audience or recipient, if not as love then at least as intensity.

Love builds, and these works produced out of love do not simply "resist" but actually build new ideas and affects. In *The Logic of Sense,*

Deleuze seeks objects of experience whose particularity exceeds their de-
notation, so that they lead us in a series of investigations that replaces the
ideal with the singular.[15] We may feel this sense of excess in conversation
when we become aware that what we are saying has a sense that exceeds it
(as in, the sense of "Will you pass the salt?" is "I'm leaving you"). Similar-
ly, a work of art is rich in sense if it cannot be contained in a description.
This flowering of reality that is potential in an object does truly resist the
idealization that serves to instrumentalize an object, whether to make it
compliant to the flow of capital or to the marketplace of ideas. The criti-
cism most appropriate to such objects is one that does not bring them in
line with ready-made principles but forms multiple points of contact
with them.

The events that critics want to approach are endlessly complex and
nuanced; their surfaces are textured and porous. The best criticism keeps
its surface rich and textured, so it can interact with things in unexpected
ways. It has to give up ideas when they stop touching the other's surface.
"The basic error of the translator," Benjamin writes, "is that he preserves
the state in which his own language happens to be instead of allowing his
language to be powerfully affected by the foreign tongue."[16] Contact with
another language should deepen one's own. We critics cherish our ideas
and forget that they become hard tools that chip at, or merely glance off
without ever touching, the surface of the other. But if we measure with
more delicate tools, fashioned for the occasion, our critical activity be-
comes less a hacking away and more a sort of precision massage. Fractal
algorithms supply a very good model for the act of haptic criticism, be-
cause rather than staying on a flat plane (dimensions 2) they become so
complex that they build into depth, attaining spongelike dimensions of
2.1 or 2.2 or so. Fractals fill up the space between two hierarchically relat-
ed elements. Haptic criticism similarly is so sensitive to its object that it
takes on a form of subtle complexity, building toward its object, brushing
into its pores and touching its varied textures.

Haptic criticism cannot achieve the distance from its object required
for disinterested, cool-headed assessment, nor does it want to. These es-
says are about works that engage my uncool, nose-against-the-glass en-
thusiasm. Aesthetics, as the interface between the ideal and the sensible,
has been relegated in dualist philosophy to an account of sensuous expe-
rience that must struggle to integrate that experience into some over-
arching idea. "Aesthetics suffers from a wrenching duality. On one hand,
it designates the theory of sensibility as the form of possible experience;
on the other hand, it designates the theory of art as the reflection of real

experience."[17] But it is only in an idealist world that aesthetics need be torn between material and ideal. Haptic criticism is an aesthetics in the sense that it finds reason to hope for the future in, and not despite, the material and sensuous world.[18]

Haptics and Erotics

What is erotic? The ability to oscillate between near and far is erotic. In sex, what is erotic is the ability to move between control and relinquishing, between being giver and receiver. It's the ability to have your sense of self, your self-control, taken away and restored—and to do the same for another person. Elaine Scarry writes that torture deprives a person of language and reduces him or her to nothing but a body.[19] Language, she argues, is what makes us subjects; it allows us to take a distance from our bodies. A lover's promise is to take the beloved to that point where he or she has no distance from the body—and then to let the beloved come back, into possession of language and personhood.

In the sliding relationship between haptic and optical, distant vision gives way to touch, and touch reconceives the object to be seen from a distance. Optical visuality requires distance and a center, the viewer acting like a pinhole camera. In a haptic relationship our self rushes up to the surface to interact with another surface. When this happens there is a concomitant loss of depth—we become amoebalike, lacking a center, changing as the surface to which we cling changes. We cannot help but be changed in the process of interacting.

But just as the optical needs the haptic, the haptic must return to the optical. To maintain optical distance is to die the death of abstraction. But to lose all distance from the world is to die a material death, to become indistinguishable from the rest of the world. Life is served by the ability to come close, pull away, come close again. What is erotic is being able to become an object with and for the world, and to return to being a subject in the world; to be able to trust someone or something to take you through this process; and to be trusted to do the same for others. Thus you will see that many of the works I write about are erotic even though they have nothing to do with sex.

A sexual encounter invites a relationship of trust that the other will not break you but, gently or "cruelly," open you to new experience. Haptic criticism, similarly, invites the critic to have faith that these encounters may be transformative but need not be shattering: as Leo Bersani suggests, a sexual act that breaks the boundaries of the body (like anal sex for men) need not destroy the self, unless your idea of selfhood is equivalent to self-

sufficiency.[20] Haptic criticism aims to reembody criticism and willingly accepts the resulting lack of ideality. Far from the rigor of sound scholarship, haptic criticism calls for well-developed "erotic faculties." Joanna Frueh writes, "The erotic thinker and practitioner may focus on sex, but erotic faculties affect all connections that human beings make with other species and with all things invisible and visible."[21] Theory modeled on eroticism cannot be self-sufficient. It does not incorporate its observations into judgments conjugated with "is," but tries to be always open to the "and" of a new idea, as Deleuze observed of Godard. "Godard's not a dialectician. What counts with him isn't two or three or however many, it's AND, the conjunction AND. . . . AND isn't even a specific conjunction or relation, it brings in all relations, there are as many relations as ANDs."[22] Rather than incorporate the new idea into a totality, erotic criticism opens knowledge to the outside, the unthought, and the new.

I hope these essays, each with its enthusiasm and outspilling of ideas, invite the reader to follow their ANDs. The arguments in these essays develop from each other, but readers may want to depart from the book when they've come across an idea they like, be it the polymorphousness of gay porn or the molecular world of the Brothers Quay or the embodied nature of digital media, and not ride on to share, for example, my synechistic love of subatomic particles. That's okay, because all these ideas continue to be useful; stop when you've found something you want to play with.

Organization of the Book

The sections of *Touch: Sensuous Theory and Multisensory Media* trace an intellectual, erotic, and spiritual journey over the course of about ten years. These essays, some published before, some not, were written before, after, and on the underside of the doctoral dissertation that became my first book, *The Skin of the Film: Intercultural Cinema, Embodiment, and the Senses.* While I was a student, I cranked out reviews and essays, including a couple of these, for journals that paid instead of scholarly journals. The writing benefited as a result, being more warm and reader-friendly and a bit less serious.

The collection begins with "Video Haptics and Erotics," a sustained inquiry into the nature of haptic spectatorship. I expand on the above proposition that haptic visuality is an alternative model to the mastering, optical visuality that vision is more commonly understood to be. A history of optical visuality shows that its dominance parallels the dominance of idealism in Western cultures. When the incorporeal world of idealism begins to lose its gleam (partly due to the acceleration of intercultural

encounters through colonialism, and the emergence of the modernist emphasis on the materiality of the medium), haptic visuality returns to acknowledge the material presence of the other. Yet haptic visuality is not the same as actually touching, and the essay concludes by suggesting that a look that acknowledges both the physicality and the unknowability of the other is an ethical look.

The first section, "The Haptic Subject," begins the rather aggressive work of breaking down a certain ideal of unified subjectivity, because of the violence and isolation that the demarcation of such a subject engenders. "Animal Appetites, Animal Identifications" criticizes the liberal tendency to identify with animals and against the humans who make use of them. I suggest that the best way for Euro-Americans to deal with "cruelty to animals" in the documents of seal hunts and other aboriginal traditions is to respect the thickness of untranslatability between these cultures and our own. A romantic notion of subjectivity is broken down, but in order to build unidealizing connections with other people, and incidentally with animals. The next essay, "I Am Very Frightened by the Things I Film," examines radical self-abnegation in the work of Japanese filmmaker Hara Kazuo. Hara's remarkable documentaries show how in struggling with his interlocutors, to the point of masochism, he is able ultimately to gain strength and grow. In Hara's films, this essay suggests, yielding and being touched are the route not to shattering but to transformation.

My early concern to break down intersubjective boundaries developed into a particular notion of erotic spectatorship, which itself broke down into a generalized eroticism, a series of shifts charted in the next section, "Haptics and Erotics." "Here's Gazing at You" describes filmmaker Ken Jacobs's performative screening of an antique porn film at the Robert Flaherty Seminar, and the generational conflict that ensued between the experimental filmmaker, his peers, and the feminists and theory-heads in the audience. In the essay I argue that Jacobs's *XCXHXEXRXRXIXEXSX* does not "transcend" the porn on which it is based, in the modernist style that the artist intended, but that the sexual arousal of the original is part of the disturbing strength of Jacobs's Nervous System performance. At the time, I managed Jacobs's arousing and annoying performance through an act of intellectual one-upmanship that strikes me, in retrospect, as a rather phallic performance on my part. Yet I realized later that this encounter was one of the first to stir my awareness of the erotic potential of a haptic image. "Love the One You're With: Straight Women, Gay Porn, and the Scene of Erotic Looking" again implicates my own libidinal position, as I describe the pleasure a hetero woman (me) gets from looking at gay men's

erotic imagery. The emergent theory suggests that spectatorship may be modeled on a particular kind of sexuality. I suggest that spectatorship is a "scene" in which pleasure, responsibility, and trust are negotiated between viewer and film. It avows the pleasure of being the "bottom" in a sexual encounter, or the recipient of a film's tenderly timed assaults. The pleasure of yielding may be that the self is broken down only to be rebuilt again, larger and more porous.

The next essay, "Loving a Disappearing Image," is the center of the book, its broken spine. It asks what are the consequences for spectatorship when the film or video we watch is dying before our eyes. To acknowledge the materiality of a medium means we must suffer its passing as we suffer the death of someone close to us; and given the openness of our engagement with it, we suffer a death within ourselves as well. Looking at Freud's understanding of melancholy as a model for this suffering, I reject it as too dependent on a model of the ego that defends itself at all costs. Instead I model loss on the melancholy of mysticism, where the subject does not defend herself from loss but accepts loss as part of her permeable constitution. Though it may not look like one, this was a very personal essay. I wrote it to mark the finish of a love affair, wanting to acknowledge the end without denying the reality of the love; hence my attempt to recuperate melancholia as a viable subject position. At this point I stopped aggressing the subject and willing it to become permeable, and moved to find another reason to love, a microlevel reason. A new kind of subjectivity, a real haptic subjectivity, emerged, which could find connection among all things and for this reason not need to shelter itself from the threats to the large-scale human subject.

Readers may notice that the first few essays struggle with theories of subjectivity from the Lacanian psychoanalysis that still dominated film theory in the early '90s. I fought against this theory, which is ever anxious about a subject that it assumes to be a void, ever trying to break through its thin shell, but could not extricate myself from it. I vividly remember the thrill of recognition I had, sitting under a tree in Rochester's beautiful Mount Hope Cemetery in summer 1994, reading Vivian Sobchack's *The Address of the Eye*.[23] Sobchack made the ethical implications of these two different kinds of subject so clear to me, and I began to believe in a subject that *does* have a center, even one that is constantly being transformed by its encounters with the world: the embodied, embracing, and unfearful subject of phenomenological psychoanalysis.

This shift freed me to think of the relation between viewer and image not as antagonistic (this never made sense anyway, when speaking of

experimental media) but as a mutual embodiment. No longer needing to dog the human subject with reminders of our frailty and permeability, I moved my exploration to other bodies. Expanding the ideas of "Loving a Disappearing Image," I continued to think of the bodies of media works as mortal and fragile, like our own. How audiovisual media can invite responses in the other senses was an important aspect of understanding the relationship between "viewer" and film (or video, or digital work) as an intercorporeal relationship.

I have always liked tiny things. While other critics forcefully demonstrate the existence of macromaterialisms, for example, in analyses that ground the flow of capital in the shifting of labor markets, I am drawn to micromaterialisms, arguing, as though I were a Pasteur of the digital age, that just because things are invisible doesn't mean they're virtual. In particular, I explore the physicality of molecular communication through smell. The section "Olfactory Haptics" explores the particular knowledges afforded by smell, attempting to glean for us humans some of the nuances of plant communication. The unique relationship between odors and individual memory would seem to guarantee that smell is one perceptual space that cannot be colonized by corporate media, as practically all our other senses have been. Yet smell too is vulnerable to instrumentalization, and the essay "The Logic of Smell" is a challenge to corporate applications of smell as a control medium, focusing on the bizarre but serious efforts of Digiscents.com. The essay has an olfactory-interactive component, which is expanded in the only short story in the book, "J's Smell Movie: A Shot List." This story offers an experiment in translating smell memories into audiovisual analogues, based on my own formative smell memories. Such an experiment is practically doomed to fail, but I believe that in the distance between smells, words, and images the reader can discover the different ways of knowing entailed by these three modes. If the purpose of a film is to communicate, to appeal to shared experience, then it's better to evoke smells audiovisually than to spray them through a movie theater (or from a computer accessory). I have performed versions of this story a few times, supplying audience members with scents to inhale at appropriate points. As I hoped, the smells conflicted, even violently, with the story I was telling, as listeners were pulled back into their own olfactory memory circuits.

Olfactory awareness, and a concomitant fascination for extrahuman knowledges, are embodied in films by the Quay Brothers. The Quays' films, especially their feature-length *Institute Benjamenta,* decidedly debase human life in favor of a microscopic, nonorganic life. The haptic

image in their films opens onto the sense of smell, and the nonhuman life embodied in the traffic of molecules.

Impassioned to understand how images provide a material connection between the viewer (hearer, toucher) and others distant in time and space, I become enraptured with Peircean semiotics, especially the indexical sign. What is an index if not an emissary from others that, even if they no longer exist, speaks to us in the present? This question drew me to science discourse, especially physics and chemistry, in order to better understand the rich entanglement of matter. Smell is a microindex, a molecular emissary linking our brains with distant material causes.

Microindexicality means that not only smells but all sorts of processes that can't be deemed conscious are still forms of communication. *Synechism* is Peirce's term for the deep connectivity produced by constant communication. I find it thrilling that communication is happening in and around us all the time at invisible, microscopic, and subatomic levels, and that those exchanges of which we are aware are the grossest manifestations of a billion delicate transactions.

Like smells, electronic images are bodied forth in very small but nonetheless material entities. It's fascinating that the word for the heady food of the gods, *ambrosia,* derives from the word *amber,* the Greek for which is *elektron.* When rubbed, amber releases charged particles, "which became regarded both as the elixir of life and as nourishment for the gods."[24] Amber, fossilized resin, the photographic mineral, is volatile both fragrantly and electrically. I find it beautiful that the same word begets both fragrance and electrons, two kinds of traveling and communicating particles. The essays in "Haptics and Electronics" take the indexical passion to digital media, whose apparent immateriality many critics have bemoaned, or celebrated. Digital electronic media, though they seem to subsist entirely in a symbolic and immaterial realm, can remind us powerfully that they and we are mutually enfolded in material processes. It is the shift from analog to digital and, more importantly, the instrumental uses made of digital symbolizations, that create the appearance of a virtual world. The Cartesian spaces of interactive media are the products of specific practices, not of the media themselves: centrally the military, medical, and other instrumental practices that construct the user of interactive tools and games as a disembodied and sovereign subject. Artists' works in electronic media are implicated and embodied. They are as tactile as they can be in these highly optical media. The essay "Video's Body, Analog and Digital" explores the specific embodiment of digital media, again taking up a phenomenological view. If the ontology of digital

media is founded in the database, what is the database's bodily nature? I look for ways that digital video, while mourning the loss of its analog body, still indexes the physicality and mortality of its medium. But I go on to suggest that the fundamental stuff of the database, arrays of quiescent or excited subatomic particles, has a life of its own.

The essay "How Electrons Remember" addresses the question of what becomes of materiality in the translation from analog to digital. Digitization would seem to entail the reduction of the multivalent stuff of the world to symbolic information. I resort to radical formalism to argue that the irreducible materiality of electronic media is that mutable particle, the electron. Currently the electron is the rank-and-file worker of the sophisticated communications systems of digital computers. These ranks may soon be swelled with other tiny laborers, such as the photon, the quantum particle, and, on a grosser scale, DNA, as computing technologies develop. In *Touch*'s deepest plunge into science discourse, I tangle with quantum physics, solid-state engineering, and quantum computing to point out that the electron, as physical entity, thickens and interconnects the physical world. It is far from an agent of dematerialization. This argument may frustrate readers, as it seems to move far from the social world to trace the materiality of digital media. The next essay, "Immanence Online," brings the materialist analysis to a more macro scale. Moving from the quantum to the machine, software, and ultimately social levels, I argue that work on the Web, far from being virtual, indexes several levels of material, interconnected life.

Touch concludes with an experiment in synechism. From the deep communicativity that Peirce posits, it should be an easy step to believe that my own dreams are not just a communication from my unconscious to my conscious self but, insofar as I can make them meaningful to you, yet another ligament in the world's connective tissue. The unconscious is a rough, corrugated surface that offers more points of potential contact than does a preconceived and avowedly rational argument. "Ten Years of Dreams About Art" offers my psyche as a surface to touch the world. Written to celebrate the tenth anniversary of the Toronto screening venue Pleasure Dome, it uses my own dreams during the decade 1990–2000 to generate thesis statements about the changing landscape of experimental media over the same period. The essay refuses to "analyze" the dreams, instead assuming that they have predictive capacity—and indeed they prove surprisingly apt. By concluding with this essay, so deeply committed to the world of experimental media, I bring this book's experiments in interconnectivity back to the community in which it took root.

1. Video Haptics and Erotics

I am watching *It Wasn't Love,* Sadie Benning's Pixelvision videotape from 1992. In it Benning tells the story of a short-lived love affair that began as a road trip to Hollywood but never got much further than the parking lot. Not much happens in this story. Its most arresting moment is when Benning slowly sucks her thumb, inches away from the unfocusable, low-resolution camera. Yet watching the tape feels like going on a journey into states of erotic being: the longing for intimacy with another; the painful and arousing awareness that she is so close to me yet distinct; being drawn into a rapport with the other where I lose the sense of my own boundaries; and the uncanny loss of proportion where big things slip beyond the horizon of my awareness while small events are arenas for a universe of feeling.

Seoungho Cho uses more expensive equipment than Benning does, but in his works as well the image gives up its optical clarity to engulf the viewer in a flow of tactile impressions. In works such as *Robinson and Me* (1996), *Identical Time* (1997), and *Cold Pieces* (2000), Cho has developed sophisticated ways to make the video image dissolve and resolve into layers whose relations to the foreground of the image and the position of the camera lens are uncertain. In his *Forward, Back, Side, Forward Again* (1994) people moving quickly past on a New York street at dusk are transformed, through long-exposure and slow motion, into ghostly paths of light that ripple through the space of vision. The luminous images evoke

Still from *If Every Girl Had a Diary* (1993), by Sadie Benning. Courtesy of Video Data Bank.

the loneliness of a person in a crowd, the thousands of missed encounters leaving their traces on consciousness. An embodied view is encouraged, strangely perhaps, by these disembodied and floating images, for they approach the viewer not through the eyes alone but along the skin. A few times the image cuts in of a silhouetted hand holding a slide, or the glowing coils of a clear lightbulb, as though these are the only certain objects in a world of swirling mystery.

What is it about works like *It Wasn't Love* and *Forward, Back, Side, Forward Again* that excite this array of responses? I believe that it is the visual character of the medium, as Benning and Cho use it, which appeals to a tactile, or haptic, visuality. In this essay I will examine how video can be haptic, and explore the eroticism to which the haptic image appeals. Although many visual media are capable of these qualities, it is particularly interesting to see how the electronic medium of video can have this tactile closeness, given that it is generally considered a "cool" medium.

Haptic *perception* is usually defined as the combination of tactile, kinesthetic, and proprioceptive functions, the way we experience touch both on the surface of and inside our bodies. In haptic *visuality,* the eyes themselves function like organs of touch. Haptic visuality, a term contrasted to optical visuality, draws from other forms of sense experience, primarily touch and kinesthetics. Because haptic visuality draws on other senses,

the viewer's body is more obviously involved in the process of seeing than is the case with optical visuality. The difference between haptic and optical visuality is a matter of degree, however. In most processes of seeing both are involved, in a dialectical movement from far to near, from solely optical to multisensory. And obviously we need both kinds of visuality: it is hard to look closely at a lover's skin with optical vision; it is hard to drive a car with haptic vision.

The term haptic *visuality* emphasizes the viewer's inclination to perceive haptically, but a work itself may offer haptic *images*. Haptic images do not invite identification with a figure so much as they encourage a bodily relationship between the viewer and the image. Thus it is less appropriate to speak of the object of a haptic look than to speak of a dynamic subjectivity between looker and image.

In recent years many artists have been concertedly exploring the tactile qualities of video. Many of these works seem to express a longing for a multisensory experience that pushes beyond the audiovisual properties of the medium. Perhaps this longing is especially pronounced in video because its images tend not to have the depth and detail of film. Video art is also defined in part by artists' resistance to the limits put on the medium by television, with its narrative- and content-driven requirements of

Still from *Forward, Back, Side, Forward Again,* by Seoungho Cho. Courtesy of the artist.

legibility. But the desire to squeeze the sense of touch out of an audio-visual medium, and the more general desire to make images that appeal explicitly to the viewer's body as a whole, seem to express a cultural dissatisfaction with the limits of visuality. This dissatisfaction might be phrased by saying, The more our world is rendered forth in visual images, the more things are left unexpressed. Many video artists have used the medium to critique vision, to show the limits of vision. And many of the haptic works I discuss here spring from this suspicion of vision. An example is the "Blindness Series" by Tran T. Kim-Trang, *Aletheia* (1992), *Operculum* (1993), *Kore* (1994), *Ocularis: Eye Surrogates* (1997), *Ekleipsis* (1999), and *Alexia* (2000). These works carry out a critique of instrumental vision, while also suggesting reasons people might not *want* to see. In doing so, they begin to present to the viewer a different kind of visuality.

As I will discuss, this denial of depth vision and multiplication of surface, in the electronic texture of video, has a quality of visual eroticism that is different from the mastery associated with optical visuality. Ultimately, the erotic capacities of haptic visuality are twofold. It puts into question cinema's illusion of representing reality, by pushing the viewer's look back to the surface of the image. And it enables an embodied perception, the viewer responding to the video as to another body and to the screen as another skin.

Origin of Haptics: Riegl

The term *haptic* as I use it here originates at the turn of the twentieth century, with the art historian Aloïs Riegl. Riegl's history of art turned on the gradual demise of a physical tactility in art and the rise of figurative space. He observed this development from the haptic style of ancient Egyptian art, which "maintain[ed] as far as possible the appearance of a unified, isolated object adhering to a plane" to the optical style of Roman art, in which objects relinquished a tactile connection to the plane.[1] His narration dwelt on the moment in late Roman art when figure and ground became thoroughly imbricated.[2]

Interestingly, Riegl was initially a curator of textiles. One can imagine how the hours spent inches away from the weave of a carpet might have stimulated the art historian's ideas about a close-up and tactile way of looking. His descriptions evoke the play of the eyes among non- or barely figurative textures. In the late-Roman works of art Riegl describes, sculpture, painting, and especially metal works, optical images arose with the distinction of figure from ground, and the abstraction of the ground that made possible illusionistic figuration.

Listen, for example, to this description of the difference between Byzantine and late Roman mosaics. The aerial rear plane of Roman mosaics

remained always a plane, from which individual objects were distinguished by coloring and [relief]. . . . However, the gold ground of the Byzantine mosaic, which generally excludes the background and is a seeming regression [in the progress toward depiction of illusionistic space], is no longer a ground plane but an ideal spatial ground which the people of the west were able subsequently to populate with real objects and to expand toward infinite depth.[3]

Riegl is pointing out that the ascendancy of optical representation in Western art represents a general shift toward an ideal of abstraction. The long-term consequences of this shift include Renaissance perspective, which reinforced the visual mastery of an individual viewer. Haptic space, while it may be considered abstract in that the line and form of the image do not set out to depict as much as to decorate, is concrete in that it creates a unified visual field only on a surface. The rise of abstract space in late Roman works of art made it possible for a beholder to identify figures not as concrete elements on a surface but as figures in space. Abstraction thus facilitated the creation of an illusionistic picture plane that would be necessary for the identification of, and identification *with,* figures in the sense that we use "identification" now. In other words, optical representation makes possible a greater distance between beholder and object that allows the beholder to imaginatively project him/herself into or onto the object. Antonia Lant notes this implication when she writes, "Riegl's understanding of the relation of viewer to art work is not derived from his or her identification with a represented human figure, but rather operates at the level of design, suggesting an additional avenue for discussing film figuration besides narrative and plot."[4]

The revolution in visual styles Riegl observed coincided with a revolution in religious thought. The barbarian invasion of the Roman Empire precipitated a clash between the southern belief that the body could be the vehicle for grace and the northern belief that spirituality required transcending the physical body.[5] Barbarian notions that the spirit transcends the body seem to be reflected in the development of a figurative picture plane that transcends the materiality of the support. Hence the origin of modern illusionistic representation can be traced to the cultural clash between beliefs in transcendent and immanent spirituality, represented by the late Roman battle of the optical and the haptic.

Gilles Deleuze and Félix Guattari appropriate Riegl's findings to describe

a "nomad art" (appropriate to the idea of the small, portable metalworks of the late Romans and their barbarian conquerors) in which the sense of space is contingent, close-up, and short-term, lacking an immobile outside point of reference.[6] Riegl described the effects of figure-ground inversion in hallucinatory detail in *Late Roman Art Industry*. But where he saw this viral self-replication of the abstract line as the final gasp of a surface-oriented representational system before the rise of illusionistic space, Deleuze and Guattari take the power of the abstract line as a sign of the creative power of nonfigurative representation. Haptic representation does not reinforce the position of the individual, human viewer as figuration does: "The abstract line is the affect of smooth spaces, not a feeling of anxiety that calls forth striation. The organism is a *diversion* of life," they write, whereas abstract line is life itself.[7] They argue that the "smooth space" of late Roman and Gothic art is a space of freedom before the hegemony of Cartesian space. Haptic representation has continued to be a viable strategy in Western art, though until recently it has been relegated to minor traditions.

Riegl observed tactile modes of representation in traditions generally deemed subordinate to the procession of Western art history: Egyptian and Islamic painting, late Roman metalwork, textile art, and ornament. One can add high-art traditions such as medieval illuminated manuscripts, Flemish oil painting from the fifteenth to the seventeenth centuries, and the surface-oriented, decorative rococo arts of eighteenth-century France. I would also include the "low" traditions of weaving, embroidery, decoration, and other domestic and women's arts as a presence of tactile imagery that has long existed at the underside of the great works.

All these traditions involve intimate, detailed images that invite a small, caressing gaze. Usually art history has deemed them secondary to grand compositions, important subjects, and an exalted position of the viewer. However, a number of art historians suggest alternative economies of embodied looking that have coexisted with the well-theorized Gaze. Svetlana Alpers describes a way of seeing in which the eye lingers over innumerable surface effects, in seventeenth-century Dutch still life, for example, instead of being pulled into the grand centralized structure of contemporaneous southern European painting.[8] Norman Bryson argues that the notion of the *glance* suggests a way of inhabiting the image without identifying with a position of mastery.[9] Naomi Schor argues that the detail has been coded as feminine, as negativity, and as the repressed in Western tradition, and constructs a complex aesthetics of the detail.[10]

Mieke Bal constructs readings of paintings around the navel, rather than the punctum: the viewer's look is organized around an inward-directed point (which people of all sexes possess) rather than a phallic point of penetration.[11] Jennifer Fisher proposes a haptic aesthetics that involves not tactile visuality so much as a tactile, kinesthetic, and proprioceptive awareness of the physicality of the art object.[12]

There is a temptation to see the haptic as a feminine form of viewing; to follow the lines, for example, of Luce Irigaray that "woman takes pleasure more from touching than from looking" and that female genitalia are more tactile than visual.[13] While many have embraced the notion of tactility as a feminine form of perception, I prefer to see the haptic as a feminist visual *strategy,* an underground visual tradition in general rather than a feminine quality in particular. The arguments of historians such as those I mentioned above supplant phallocentric models of vision with those that seem to be more comfortable in a female body. Yet their arguments seem not to call up a radically feminine mode of viewing so much as to suggest that these ways of viewing are available and used differently in different periods. The tracing of a history of ways of tactile looking offers these ways as a strategy that can be called on when our optical resources fail to see.

Haptic Cinema

In its early years cinema appealed to the emerging fascination with the instability of vision, to embodied vision and the viewer's physiological responses.[14] Like the Roman battle of the haptic and the optical, a battle between the material significance of the object and the representational power of the image was waged in the early days of cinema (at least in the retrospection of historians). The early-cinema phenomenon of a "cinema of attractions"[15] describes an embodied response, in which the illusion that permits distanced identification with the action onscreen gives way to an immediate bodily response to the screen. As the language of cinema became standardized, cinema appealed more to narrative identification than to body identification. In recent theories of embodied spectatorship, we are returning to the interest of modern cinema theorists such as Benjamin, Béla Balász, and Dziga Vertov in the sympathetic relationship between the viewer's body and cinematic image, bridging the decades in which cinema theory was dominated by theories of linguistic signification.

The term *haptic cinema* itself has a brief history. The first attribution of a haptic quality to cinema appears to be by Noël Burch, who uses it to

describe the "stylized, flat rendition of deep space" in early and experimental cinema.[16] Deleuze uses the term to describe the use of the sense of touch, isolated from its narrative functions, to create a cinematic space in Robert Bresson's *Pickpocket* (1959). He writes, "The hand doubles its prehensile function (as object) by a connective function (of space): but, from that moment, it is the whole eye which doubles its optical function by a specifically 'grabbing' *[haptique]* one, if we follow Riegl's formula for a touching which is specific to the gaze."[17] To me, Deleuze's focus on filmic images of hands seems a bit unnecessary in terms of evoking a sense of the haptic. Looking at hands would seem to evoke the sense of touch through identification, either with the person whose hands they are or with the hands themselves. The haptic bypasses such identification and the distance from the image it requires. Antonia Lant has used the term *haptical cinema* to describe early films that exploit the contrast between visual flatness (created by the use of screens and scrims parallel to the plane of the lens) and depth.[18] Noting the preponderance of Egyptian motifs in such films, she posits that they are explicitly indebted to Riegl. This tendency occurred at an interesting juncture in early cinema, before classical narrative conventions had entirely prevailed. Bill Nichols and Jane Gaines discuss documentaries whose haptic, visceral intimacy engenders an ethical relationship between viewer and viewed, by inviting the viewer to mimetically embody the experience of the people viewed.[19] I will return to this question of the ethics of shared embodiment. Writing of video in particular, Jacinto Lejeira notes that Atom Egoyan uses different processes, such as speeding up video footage in the film, enlarging the grain, and creating *mises-en-abîme* of video within film, to create a more or less optical or haptic sensation. "These techniques function in such a way that the overall image . . . seems to obey an instrument capable of bringing the spectator's opticality or tactility to a vibratory pitch of greater or lesser intensity."[20] These visual variations are not formal matters alone but have implications for how the viewer relates bodily to the image.

Haptic looking tends to rest on the surface of its object rather than to plunge into depth, not to distinguish form so much as to discern texture. It is a labile, plastic sort of look, more inclined to move than to focus. The video works I propose to call haptic invite a look that moves on the surface plane of the screen for some time before the viewer realizes what it is she is beholding. Haptic video resolves into figuration only gradually if at all, instead inviting the caressing look I have described.

Of course, there are more and less successful examples of videos that use these strategies. Any out-of-focus or low-resolution image is not nec-

Video within film: frame enlargement from *Felicia's Journey* (1999), by Atom Egoyan.

essarily haptic. The digitized blobs that replace the faces of crime suspects on reality TV do imbue them with a certain mystery. Generally they do not invite a lingering, caressing gaze, nor do they test the viewer's own sense of separation between self and image.[21]

Video as Haptic Medium

How does video achieve a haptic character? It is commonly argued that film is a tactile medium and video an optical one, since film can be actually worked with the hands. Now that more films are edited and postproduced with video or computer technologies, this distinction is losing its significance.[22] (An exception is experimental filmmaking techniques such as optical printing and scratching the emulsion.) Many prohaptic properties are common to video and film, such as changes in focal length, graininess (produced differently in each medium), and effects of under- and overexposure.

The main sources of haptic visuality in video include the constitution of the image from a signal, video's low contrast ratio, the possibilities of electronic and digital manipulation, and video decay. Because the video image occurs in a relay between source and screen, variations in image quality, color, tonal variation, and so on, occur in the permeable space

between source and viewer, affected by conditions of broadcast or exhibition as well as reception.[23] Other sources of video's tactile, or at least insufficiently visual, qualities are its pixel density and contrast ratio. VHS has about 350,000 pixels per frame, while 35mm film has twenty times that.[24] The contrast ratio of video is 30:1, or approximately one-tenth of that of 16mm or 35mm film.[25] While film approximates the degree of detail of human vision, video provides much less detail. How much these differences have abated with the introduction of digital video is hotly debated, currently with no "resolution," on the Frameworks listserv. The listserv is frequented by experimental film (and video) makers, the people who best comprehend the variety of perceptual experiences available with each medium.[26]

When vision yields to the diminished capacity of video, it gives up some degree of mastery; our vision dissolves in the unfulfilling or unsatisfactory space of video. Leslie Peters exploits the haptic potential of the traveling shot in her *400 Series* (1997–2000), brief single-shot videos from the window of a car traveling along the monotonous Trans-Canada Highway. Slight shifts of focus tease with the promise of optical resolution, but usually the image is more satisfying when it is slightly unfocused, the speed of travel turning the yellow median strip into a Rothkoesque abstraction. Phyllis Baldino similarly takes advantage of variable focus to render banal objects wondrous and strange, in her *In the Present* (1997) and *Nano-Cadabra* (1998). Both these works involve close-up shots of what, if we could get a good look at them, would probably turn out to be plastic toys and kitchen accessories. But the speed with which the images fade in and out and the brevity with which each shot remains in focus frustrate optical knowledge and, instead, invite haptic speculation.

A third intrinsic quality of the video medium, and an important source of video tactility, is its electronic manipulability. The tactile quality of the video image is most apparent in the work of videomakers who experiment with the disappearance and transformation of the image due to analog synthesis and digital effects.[27] Electronic effects such as pixellation can render the object indistinct while drawing attention to the act of perception of textures. Interestingly, Pixelvision, the format of the discontinued Fisher-Price toy camera that used audiocassette tapes, is an ideal haptic medium.[28] Pixelvision, which cannot focus on objects in depth, gives a curious attention to objects and surfaces in extreme close-up. Thus some of the best Pixelvision works focus on scenes of detail. Sadie Benning tells her rueful love stories with props like tiny cars, Hershey's Kisses, and birthday-cake candles. Azian Nurudin's lesbian S/M scenes in *Sinar Durjana (Wicked Resonance)* (1992) and *Bitter Strength: Sadistic*

Response Version (1992) become elegantly stylized in Pixelvision; she uses the high contrast of the medium to echo the effects of Malaysian shadow plays. Part of the eroticism of this medium is its incompleteness, the inability ever to see all, because it's so grainy, its chiaroscuro so harsh, its figures mere suggestions. And Michael O'Reilley's *Glass Jaw* (1993) powerfully demonstrates the embodied relationship between viewer and moving image. This tape, about the artist's experience of having his jaw broken and wired shut, sympathizes with O'Reilley's incapacity and asks our bodies to respond as well. Small objects become tactile universes that have a visceral pull. A shot of the vortex in a blender where O'Reilly concocts his liquid meal takes on engulfing proportions. Over a shot of hands using an awl to punch holes in a belt, the artist speaks in voiceover about losing weight, about Louis Braille having been blinded with an awl, and about feeling that his slurred words "are like Braille in butter": the close-up, minimal image creates a visceral relay with the viewer's own body. As in Tran's "Blindness Series," the image of blinding overdetermines the suggestion of a different kind of visuality.

A work that exploits many of video's haptic potentials, while reflecting explicitly on the relative kinds of knowledge offered by haptic and optical visuality, is Dave Ryan's *Haptic Nerve* (2000). Ryan draws on experiments done in 1944 on army veterans who, following brain surgery, lost the ability to distinguish objects by touch. In effect, their hands became blind. Haptic perception is evoked by a quick montage of indistinguishable shapes and textures, while a whispered voice, its tone distinct but its words unintelligible, provides an aural counterpart to the haptic image. *Haptic Nerve* contrasts haptic and optical images in a single shot, by closing down the iris and closely panning objects so that a very narrow plane is in focus, as when red and black blobs resolve briefly into hands typing at a manual typewriter. Many of the images on the video are of hands: veined hands brushing a Braille text, an old person's hand clothed in soft folds of wrinkles, an infant's hand reaching toward a mobile. Infants can feel but they cannot identify what they feel, because the ability to symbolize must be acquired. The 1944 patients have returned to a similar state. Over a blurry shot that evokes stumbling in the woods, the transcribed text of a patient's interview reads:

PATIENT: This is something I don't know at all. It has angles. Does it have a name?
DOCTOR: Every object has a name.
PATIENT: I don't think this has a name.

Haptic Nerve reminds us of the high stakes of both kinds of perception. Optical perception allows us to symbolize, to give every object a name, and for the same reason it blinds us to the richness of sensory experience. Haptic perception allows us to experience in detail, but not to take a distance from experience in order to define it. Ryan's video insists on the necessity of both.

As these descriptions suggest, few videos or films are entirely haptic. The haptic image usually occurs in a dialectical relationship with the optical: as well as Ryan's thoughtful dialectic, Cho's swirling lights resolve briefly into figures of people walking on the sidewalk, Benning's face (and her cat's) dissolves into grain but her tiny props show up distinctly. Distinct sound can provide clarity to an optical image: O'Reilley's voice-over in *Glass Jaw*, though it too is manipulated to be less discernible, off-sets the indistinction of his images, as does the almost painful clarity of piano notes in *Haptic Nerve*. These works stress the relationship between optical and haptic, their ability to dissolve and resolve one onto the other.

Haptics and Erotics

A visual medium that appeals to the sense of touch must be beheld by a whole body. I am not subjected to the presence of an other (such as a film image/film screen); rather, the body of the other confers being on me. This is Vivian Sobchack's argument in *The Address of the Eye*. Sobchack's

Still from *Haptic Nerve* (2000), by Dave Ryan. Courtesy of the artist.

phenomenology of cinematic experience stresses the interactive character of cinema viewing. If one understands cinema viewing as an exchange between two bodies—that of the viewer and that of the film—then the characterization of the film viewer as passive, vicarious, or projective must be replaced with a model of a viewer who participates in the production of the cinematic experience. Rather than witnessing cinema as through a frame, window, or mirror, Sobchack argues, the viewer shares and performs cinematic space dialogically.[29] Cinematic perception is not merely (audio)visual but synesthetic, an act in which the senses and the intellect are not conceived of as separate. Thus it makes sense to talk of touch participating in what we think of as primarily a visual experience, if we understand this experience to be one of the lived body.

Haptic visuality is an aspect of what Sobchack calls *volitional, deliberate vision*. It is distinguished from passive, apparently pre-given vision in that the viewer has to work to constitute the image, to bring it forth from latency. Thus the act of viewing, seen in the terms of existential phenomenology, is one in which both I and the object of my vision constitute each other. In this mutually constitutive exchange I find the germ of an intersubjective eroticism. By intersubjective I mean capable of a mutual relation of recognition, in Jessica Benjamin's term:[30] though here the intersubjective relation is between a beholder and a work of cinema.

Like the Renaissance perspective that is their progenitor, cinema's optical images address a viewer who is distant, distinct, and disembodied. Haptic images invite the viewer to dissolve his or her subjectivity in the close and bodily contact with the image. The oscillation between the two creates an erotic relationship, a shifting between distance and closeness. But haptic images have a particular erotic quality, one involving giving up visual control. The viewer is called on to fill in the gaps in the image, engage with the traces the image leaves. By interacting up close with an image, close enough that figure and ground commingle, the viewer gives up her own sense of separateness from the image.

These qualities may begin to suggest the particular erotic quality of haptic video. As the metalworks and carpets of which Riegl wrote engage with vision on their surface rather than drawing it into an illusionary depth, so haptics move eroticism from the site of what is represented to the surface of the image. Haptic images are erotic regardless of their content, because they construct a particular kind of intersubjective relationship between beholder and image. Eroticism arrives in the way a viewer engages with this surface and in a dialectical movement between the surface and the depth of the image. In short, haptic visuality is itself

erotic; the fact that some of these are sexual images is, in effect, icing on the cake.

Not all art videos that deal with sex and sexuality make use of the medium's haptic propensities; those that do, use the tactile quality of the electronic image to a number of different ends. Some are devoted openly to the question of how to represent desire, given the well-theorized thorniness of pornographic representation, and they bring in video effects for this reason: examples are Meena Nanji's *Note to a Stranger* (1992) and Ming-Yuen S. Ma's *Toc Storee* (1993) and *Sniff* (1997). Others, such as Sadie Benning's *Jollies* (1991) and *It Wasn't Love* (1992) and Azian Nurudin's *Sinar Durjana* (1992) are less overt. The electronic texture of video may seduce by refusing to satisfy the viewer's curiosity, cajole the cautious viewer to watch a violent or sadomasochistic scene, or invite a more multisensory engagement with the visual image. Appealing to the sense of touch provides another level of delight at the same time that it de-privileges the optical, as in Shani Mootoo's *Her Sweetness Lingers* (1994). Mootoo is a poet, and the love poem she reads on the sound track is responsible for much of the sensual quality of the tape: not only its evocative words, but the rich voice that carries each phrase on a current of breath. "I'm afraid," are her first, whispered words; "I'm afraid of dying. . . . Why else would I be afraid to touch you, when I have not allowed my mind to lie fallow beneath this fear?" As she speaks, we see a group of women in a beautiful garden. One is captured in slow motion jumping on a trampoline, the impact echoing in a deep boom that emphasizes her phallic intentness; another laughs and turns her lovely face as though unaware of the camera's gaze. Like Mootoo's words, the camera tentatively circles around this woman, and then it drifts away across the grass; then the tape cuts to a circling close-up of a half-open magnolia blossom. On one hand, this and similar cuts, to images of flowers and a gushing waterfall, evoke the lover's averting her eyes from the beloved; on the other, given the sexual symbolism of the images, they are outrageously explicit, a kind of poet's Production Code for erotic contact. Keyed-in, colorized shots of scarlet quince blossoms, grape hyacinths with a wandering bee, and yellow forsythia against the bright blue sky recall the dense textures and vivid colors of Indian miniatures. The intimacy of these shots, suffused with the buzzing sounds of insects in the garden, overwhelms the viewer with their immediacy, with even a sense of humidity on the skin.

At one point the camera slowly pans the beloved woman's body as she reclines naked in a dim room, digital effects denaturalizing her brown skin to a luminous pale green, a sort of video veil over the body of the

Still from *Her Sweetness Lingers* (1994), by Shani Mootoo.

beloved. Then finally, after the poet's reasoning has come full circle, the two women in the garden ever so slowly approach each other, brief shots from different angles capturing the long-anticipated meeting; and just as they bring their lips together, the tape ends. But another consummation has already been achieved, in the video's tactile, sensuously saturated caresses. *Her Sweetness Lingers* embroiders its colorful and sumptuous optical images with the intimacy of tactile images: it expresses the greedy desire of a lover to know the beloved through every sense all at once, to admire the beloved from a distance and at the same time bring her or him close. Mootoo's words—the passion to be united with the beloved in "momentary splendor," even if this should herald the love's demise—describe the self-eclipsing desire that propels haptic visuality.

The reader may be asking, Can pornography be haptic? Pornography is usually defined in terms of visibility—the inscription or confession of the orgasmic body—and an implied will to mastery by the viewer.[31] The erotic relationship I am identifying in haptic cinema depends on limited visibility and the viewer's lack of mastery over the image. Haptic visuality suggests ways that pornography might move through the impasse of hypervisuality that by this point seems to hinder rather than support erotic representation. This description of haptic visuality might suggest

ways porn can be haptic, even if this is not usually the case. A haptic pornography would invite a very different way of engaging with the image. The haptic image indicates figures and then backs away from representing them fully—or, often, moves so close to them that for that reason they are no longer visible. Rather than making the object fully available to view, haptic cinema puts the object into question, calling on the viewer to engage in its imaginative construction. Haptic images pull the viewer close, too close to see properly, and this itself is erotic.

As I've noted, most cinema, pornography included, entails some sort of combination of these modes of seeing. I do not at all wish to subscribe to a distinction between pornography and erotica—that is, between optical, commercial porn and haptic, art erotica. Nevertheless, it is significant that much of the video work that first experimented with haptic qualities was made by women, often by feminist or lesbian makers interested in exploring a different way to represent desire.

Mona Hatoum's *Measures of Distance* (1988) begins with still images so close as to be unrecognizable, overlaid with a tracery of Arabic handwriting. As the tape moves the images are shown from a greater distance and revealed to be a naked woman with a luxurious body, still veiled in the image's graininess and the layer of text. Meanwhile, Hatoum's mother's letters, read in voice-over, make us realize that these are images of her that her daughter took; further, they tell that Hatoum's father was very jealous of his wife's body and the idea of another, even/especially his daughter, being in intimate proximity to it. The pulling-back movement powerfully evokes a child's gradual realization of separateness from its mother, and the ability to recognize objects: to recognize the mother's body as a separate body that is also desired by someone else. It also describes a movement from a haptic way of seeing to a more optical way of seeing: the figure is separate, complete, objectifiable, and indeed already claimed. At the point where the image of the mother becomes recognizable, narrative rushes in.

Interestingly, a number of haptic images are made by daughters of their mothers: another example is Shauna Beharry's *Seeing Is Believing* (1991), in which the artist's camera searches a photograph of her mother, following the folds of the silk sari in the photograph as they too dissolve into grain and resolve again. Such images evoke a tactile mirror stage in which the infant's awareness of belovedness and of separation are learned in terms of touch. Changes of focus and distance, switches between more haptic and more optical visual styles, describe the movement between a relationship of touch and a visual one.

Still from *Seeing Is Believing* (1991), by Shauna Beharry.

These observations about infant's-eye vision lead to some suggestions about identification and the haptic. As I have argued, haptic images encourage a bodily relation to the screen itself before the point at which the viewer is pulled into the figures of the image and the exhortation of the narrative. Desire in such a space operates differently than in optical visuality, since it is not limited to the operations of identification.

The haptic is a form of visuality that muddies intersubjective boundaries, as I have been arguing in phenomenological terms. If we were to describe it in psychoanalytic terms, we might argue that haptics draw on an erotic relation that is organized less by sexual difference than by the relationship between mother and infant. In this relationship, the subject (the infant) comes into being through the dynamic play between the appearance of wholeness with the other (the mother) and the awareness of being distinct. As Parveen Adams suggests, to define sexuality in terms of the relation to the mother is also to understand it as organized around a basic bisexuality.[32] This seems to corroborate a kind of visuality that is not organized around identification, at least identification with a single figure, but that is labile, able to move between identification and immersion. In a sexual positioning that oscillates between mother- and father-identification, it seems that haptic visuality is on the side of the mother.

Haptic visuality might seem to represent the "over-closeness to the image" that Mary Ann Doane and others have attributed to female spectatorship,[33] while optical visuality implies the ability to stand coolly back that characterizes "regular" spectatorship. Haptic visuality also has some of the qualities of Gaylyn Studlar's theory of masochistic identification, in which the film viewer gives him/herself over to an entire scene, sometimes literally a shimmering surface (as in the Marlene Dietrich–Josef von Sternberg spectacles), rather than identifying with characters.[34]

The difference is that I base haptic visuality on a phenomenological understanding of embodied spectatorship, which is fundamentally distinct from the Lacanian psychoanalytic model that castigates the "over-close" viewer for being stuck in an illusion. I find it more compelling to suggest how haptics work at the level of the subject as entire body. The engagement of the haptic viewer occurs not simply in psychic registers but in the sensorium. The longing communicated by *Measures of Distance* and *Seeing Is Believing* cannot be explained by an analysis of the cultural dynamics they exploit or the psychic states they bring into play. Nor can the eroticism of *Her Sweetness Lingers*, the experience of the placeless traveler in Cho's videos, or the acute sense of touch in *Haptic Nerve*. To describe the effect of such video works requires paying attention to the body of the viewer, specifically what happens when the video image dissolves out toward the viewer.

Haptic cinema appeals to a viewer who perceives with all the senses. It involves thinking with your skin, or giving as much significance to the physical presence of an other as to the mental operations of symbolization. This is not a call to willful regression but to recognizing the intelligence of the perceiving body. Haptic cinema, by appearing to us as an object with which we interact rather than an illusion into which we enter, calls on this sort of embodied intelligence. In the dynamic movement between optical and haptic ways of seeing, it is possible to compare different ways of knowing and interacting with an other.

Let me return to the word *caress* that I use to describe haptic visuality. You may hear a resonance with Emmanuel Levinas's statement that sight, in contrast to cognition, has a quality of proximity to its object: "The visible caresses the eye."[35] Levinas finds such a caress possible much in the manner of visual eroticism as I define it. Eroticism is an encounter with an other that delights in the fact of its alterity, rather than attempt to know it. Visual erotics allows the thing seen to maintain its unknowability, delighting in playing at the boundary of that knowability. Visual erotics allows the object of vision to remain inscrutable. But it is not voyeurism,

for in visual erotics the looker is also implicated. By engaging with an object in a haptic way, I come to the surface of my self (like Riegl hunched over his Persian carpets), losing myself in the intensified relation with an other that cannot be known. Levinas calls the relationship of consciousness to sensibility "obsession": I lose myself as a subject (of consciousness) to the degree that I allow myself to be susceptible to contact with the other. This being-for-the-other is the basis of the ethical relation for Levinas, but as Paul Davies points out, it blurs with the erotic relation as well.[36]

"'Sensibility' thus names not only a relation subservient to cognition but also a 'proximity,' a 'contact' with *this* singular passing of what has always already made of the life of consciousness something more than a matter of knowledge. Something more which can perhaps only register as something less, as absence,"[37] Levinas writes. Haptic visuality activates this awareness of absence, in a look that is so intensely involved with the presence of the other that it cannot take the step back to discern difference, say, to distinguish figure and ground. A visuality that is so engaged with the present that it cannot recede into cognition would seem to inform the kind of "yielding-knowing" of which Michael Taussig, following Horkheimer and Adorno's plea for a form of knowledge that did not bend its object to its will, writes.[38]

A video by Brazilian artist Ines Cardoso, *Diastole* (1994), uses haptic visuality to poetically approach an ineffable object. Dedicated to a loved one who died, *Diastole* is a brief and moving meditation on death, occupied with only a few images. It makes use of the wide range of resolution possible in video, and manipulates color with extreme subtlety, from naturalistic to digitally altered (in the age of digital media, this is of course a stylistic choice). The image of the moving hands of an old-fashioned clock appears in clear focus, with the subtle tones of a daylit interior. An image of two children laughing and rolling on a bed is slightly pixillated, giving a pointillist effect to the dark expanse of their hair and the glowing edges of the tumbled sheets. Other images, shot through different sorts of screens, play overtly with the inability to see what you are looking at: a barely recognizable, sunlit outdoor scene turns out to be shot through a sheet of plastic bubble wrap; a hand is shot through a fine screen.

What captures me most is this last image. The hand gently presses against the screen, and as it does its boundaries blur and merge with the even mesh of the screen, which in turn merges with the digital texture of the video image. Colors shimmer around it in the camera's reaction to overexposure: pastel, barely there colors, blue-green, a pinkish flesh tone,

edged with darkness but dissolving into light. As the image of the hand dissolves into the double grain of the screen and the video image, the sound track carries the voice of a child reading a poem about death (translated from Portuguese into English subtitles). The tape ends with the words "How can we ever understand death?" Perhaps this seems an overly diagrammatic illustration of a haptic medium: a verbal text about the limits of knowability reinforcing a visual play with the limits of visibility. Nevertheless, the effect is a powerful expression of respect and relinquishment at the border of the unknowable experience of death. The "something more which can only register as something less" is doubly figured as the dissolution of the optical image into the intimacy of the haptic, and a reverent nonunderstanding in the face of death.

The point of tactile visuality is not to supply a plenitude of tactile sensation to make up for a lack of image. Similarly, when elsewhere I discuss images that evoke senses such as smell and taste,[39] it is not to call for a "sensurround" fullness of experience, a total sensory environment, to mitigate the thinness of the image. Rather it is to point to the limits of sensory knowledge. By dancing from one form of sense-perception to another, the image points to its own caressing relation to the real and to the same relation between perception and the image.

What is erotic about haptic visuality, then, may be described as respect for otherness, and concomitant loss of self in the presence of the other. The giving-over to the other that characterizes haptic visuality is an elastic, dynamic movement, not the rigid all-or-nothing switch between an illusion of self-sufficiency and a realization of absolute lack. It is with the same recognition that Vivian Sobchack describes the relation between perceiver and perceived as one of mutual embodiment, dynamic rather than destructive. A visual erotics that offers its object to the viewer but only on the condition that its unknowability remain intact, and that the viewer, in coming closer, give up his or her own mastery.

I. The Haptic Subject

2. Animal Appetites, Animal Identifications

In a series of short, thrilling clips on the late-night TV ad for *Trials of Life*, the BBC, Turner Broadcasting, and Time-Life wildlife video series, a lion mauls a gazelle and tears its guts out. Wolves fight each other for the first chance to sink their teeth into a still-struggling deer. "Uncensored, shocking photography," promises the histrionic male announcer, concluding salaciously, "Order now, and find out why we call them animals!"

This tautological howler is, on second thought, profoundly puzzling. The documentary series clearly styles itself as pornography. The lascivious voice-over that accompanies these creatures doing what they do naturally acts as rhetorical black bars over their eyes. But why would footage of anything animals do be censored, assuming there are only animals involved? Animals aren't capable of obscenity, are they?

Animal documentaries used to be the staid fare of Disney and the Discovery Channel, but in recent years BBC et al. have hit upon a great way to sell them. The ads for this series exploit a particular form of human identification with animals. Projecting him/herself into the action onscreen, the home video viewer experiences the ordinary struggles of the wild kingdom as cruel, wanton, depraved, like the lowest of humans—indeed, *like animals.* (Clearly, the ad's rhetoric, including its use of "exotic" settings such as the Serengeti Plain, appeals as well to a racialized hierarchy that considers certain humans closer to, more like, animals.) If you think of the lineage of popular movies that feature animals as protagonists,

Frame enlargement from *Season of the Cheetah* (1989), by National Geographic Films.

movies like *Born Free, Flipper, Day of the Dolphin,* and, in the enduring dog-as-star genre, *Rin Tin Tin, Lassie, Benji, Beethoven,* and *My Dog Skip,* with few exceptions, feature animals as wise, selfless, and noble creatures, often to the disadvantage of merely human characters. Even though films in the tradition of *Jurassic Park* and *Jaws* show animals as the representative of a nature that is seen as cruel and wanton, generally it is good human qualities such as innocence, dignity, and industry that Western viewers like to attribute to creatures. Projected, these qualities reflect back on us. My point in the following is not to figure out how these cinematic animals are actually feeling but to stress that, whether noble or depraved, animals only have these qualities insofar as humans are invested in identifying with them. Anne Friedberg has termed this form of identification "petishism": a movement that allows us both to perceive good qualities in animals as reflections of our ideal selves, and to project the best human attributes onto animals. Or, in Donna Haraway's words, we "polish an animal mirror to look for ourselves."[1] The belief in radical alterity, that it is absolutely impossible to share the experience of an Other, be it a cultural or species Other, ironically leads to collapsing the difference between Us and Them. In disavowing any commonality between self and other, one renders the other a screen for

projection, whether it is to project noble-savage fantasies on other humans or bestial-animal fantasies on beasts. This essay will build an argument in favor of accepting commonality with other creatures that includes our common, little-O otherness. Such a view requires us to take into account the human populations that are pushed offscreen in the act of animal identification.

Mainstream nature documentaries like *Trials of Life* draw their authority and seeming objectivity from the natural sciences. However, as theorists such as Haraway have pointed out, most scientific research on animal societies is from its inception modeled on assumptions about human nature. The resulting "knowledge"—for example, the belief that species survival is dependent on domination and competition—is projected back on human societies. The human sciences of anthropology and sociology marshal animal societies "in the rationalization and naturalization of the oppressive orders of domination in the human body politic."[2]

Cinematic conventions have a lot to do with our powers of putting ourselves in the other's paws. In nature documentaries, shot–reverse shot structure creates a sense of narrative; quick editing makes for excitement; cutting gives a sense of simultaneous action; eyeline matches between animals and their prey establishes intentionality; and when the creatures gaze into the camera, their eyes seem to communicate with the depths of our souls. The overall effect is to allow the human viewer an identification with the nonhuman subjects, a way to get into their furry or feathered heads. A cheap way, to be sure. Movies that rely on reaction shots from dogs for their effect, such as the inane *As Good As It Gets* (1997), fall into a special circle of hell for their lethal combination of imbuing animals with human subjectivity and being unable to convince audiences of a scene's import without this last resort.

Part of our desire to protect animals can be traced to that centripetal identification that sees animals as "better," the other that affirms our own (lost) beauty and innocence. Friedberg offers a tongue-in-cheek analysis of human identification with dogs in film in her essay "The Four-Legged Other and Cinematic Projection."[3] Friedberg draws from Christian Metz's psychoanalytic account of filmic identification to argue that dogs are open to projection and fetishization in a way similar to the cinema screen. The screen is a space in which viewers can identify with an image that is *not* of them—the screen is not a mirror—but confirms their existence and reflects back on them.

Friedberg defines petishism as "a fetishism in which one overidentifies

The canine reaction shot: frame enlargement from *Lassie* (1994), by Daniel Petrie.

with animal Others and allows oneself to be fascinated by non-human Others." Petishism is built on a mechanism of disavowal similar to fetishism. A fetish is useful for its ability to distract from the anxiety-inducing scene at the origin of difference, in order simultaneously to affirm and to disavow it. Usually the scene in question provokes sexual difference and the fear of castration. In the present case the difference in question is species difference and the fear of animality. I would argue that the primal scene of petishism is the terror of finding that we are not, after all, so different from animals. Like sexual fetishism, petishism takes an ideologically troubling difference and represents it in terms of individuals.

Between Western, urban humans and the exotic animals of Africa, the Amazon, the Arctic, and elsewhere, there happen to live other humans who coexist with these animals. They do not have the luxury of distance that permits idealizing identification; rather they see humans as existing on a continuum with other species. Petishism works to disavow this continuum. Petishists believe that animals are both just like us and fundamentally other.

Our ability, as Western or urban viewers, to identify so unproblematically with the animals safely confined in the zoo or on *Wild Kingdom* rests in part on the colonial legacy of human hierarchies. Like the tourist

Joy Adamson opening her heart to Elsa the lion cub in *Born Free,* conservation groups appeal to a Western fantasy that our innate goodness will be confirmed through communication with the wild beast.[4] Many pro-animal movements participate in a global politics that valorizes the innocents of forest and plain over the much less photogenic human creatures who must fight them for survival. In the decades of their founding, the 1950s and 1960s, conservation organizations overtly championed threatened animals over the threatened human groups that lived among them. In a 1960 report, UNESCO recommended that Masai people be expelled from their traditional lands, where the grazing of their livestock infringed on wildlife reserves.[5] East and Central African organizers are still protesting the World Wildlife Federation's protection of jumbos and lions because the elephants destroy village crops, the lions attack their children.[6] Western environmental activists would prefer to protect the creatures of an Africa that is patently an illusion, the wild territory of the nineteenth-century explorers rather than a continent irrevocably scarred by colonization. They do not want to acknowledge that the global movements of capital and empire have swallowed the vestiges of "natural" life. There are some environmentalist groups, such as Cultural Survival, that hold a more holistic view that takes into account both the preservation of animal and plant life and the maintenance of traditional cultures. But the astonishing Western ability to value animals over the third-world humans who share resources with them reared its head after the U.S. war on Afghanistan, when hundreds of thousands of private American dollars were lavished on the forty surviving animals in the Kabul zoo—while many suffering Afghan humans starved.

To my amusement and dismay in writing this essay, I find that I am criticizing both environmentalism and vegetarianism, movements I sympathize with. But we need to be aware when these issues function as decoys from colonial human relations. As Paolo Fabbri writes, "la pitié est la distance la plus totale de toutes": pity is the ultimate form of othering.[7] To have selfless and altruistic attitudes toward others is to *affirm* their utter distance.

A small subgenre of recent independent video radically undercuts some of our most cherished projections onto animals, by documenting the literal destruction of the screen. I think of them as the dog-eating tapes. Three that I will discuss here critique the European/North American obsession with the humanity of dogs, suggesting in quite different ways that this passion veils a problematic ethnocentrism. This is not to say that they set up dog eating as an exemplary activity. Ken Feingold's

"Pets or meat": frame enlargement from *Roger and Me* (1989), by Michael Moore.

Un Chien Délicieux (1991), as the title's play on Dalí and Buñuel's *Un Chien Andalou* suggests, pushes the iconoclastic premises of Surrealism. This tape purports to record the first-person story of Burmese peasant Lo Me Akha, who was brought to Paris in the '40s by anthropologists and spent a year hanging out at cafés with André Breton and his crew. He was then sent back to Burma, where he apparently stayed in his village until the videomaker came along and recorded his story. The engaging, wizened man holds a stick, up and down which two cockatoos march for the duration of the interview, which is translated in voice-over. His story, a sort of reverse ethnography of Westerners by their purported object of study, undermines any vestigial Western illusion of the separateness of the East. He tells how the anthropologists came scrambling through the jungle, adding offhandedly, "I guess nobody told them about the road." He notes the strange habits of the Surrealists, such as their fascination with his dreams and how Breton was always writing them down. He is amused at the Europeans' dependence on money. In particular, he finds it bizarre how much the Parisians dote on their dogs. He tells what an effort it was for him to find a dog to cook as a festive meal for his friends on the eve of his departure, and then to convince them to take part. The Surrealists, who prided themselves on their ability to explore that which is taboo,

could not stomach this dinner. The tape cuts to a black-and-white snapshot of a group of people sitting around a dinner table. Lo Me Akha says that these are Breton and his friends, who have just eaten the meal of dog he has prepared. He concludes his story by saying to the camera, "And now, since you are an honored guest in our village, we will cook a dog for you." In the second half of the tape, some of the villagers kill and cook a dog. The video camera watches the process obediently, from clubbing to skinning and evisceration to slow roasting on a rotating spit.

The viewer may or may not realize that the first part of the tape, the delightful story about the anthropologists and Breton, is all made up. The second part, though, definitely happened. Audiences tend to be outraged when they find the artist has deceived them in this way.[8] The tape's superior, *épater le bourgeois* attitude makes Feingold's critique hard to countenance. Nevertheless, it deftly questions the Western hierarchy that thinks nothing of uprooting a person from his home and bringing him across the world to study, but reacts with horror to the notion that man's best friend also makes a good main course.

Another dog-as-dinner tape takes on these issues from a quite different perspective. Michael Cho's *Animal Appetites* (1991) documents the

Still from *Un Chien Délicieux* (1991), by Ken Feingold. Courtesy of Electronic Arts Intermix.

legal persecution of Southeast Asian immigrants living in Los Angeles whose diets include dog meat, focusing on the trial of two Cambodian men. Cho reaps a wealth of ironies from simple juxtapositions. The trial's allegations that the dog had been killed in a "cruel and inhumane" manner are read over gory shots of acceptable meat-animals being slaughtered. Statistics about the population of dogs and cats in shelters that end up being destroyed and the use of dogs in scientific experiments are followed by shots of pet cemeteries, with headstones memorializing "Our dear Fluffie," and so on. Quoting public responses to the trial, Cho shows that assimilationism blurs quickly into racism: "Americans don't eat dogs"; "The more we accept of their barbaric ways, the more ground they gain."

In a third tape in this quirky subgenre, *The Search for Peking Dog* (John Choi, 1995), a German American housewife attempts to prepare the delicacy of the title for her Chinese American husband. At the pet store, she is turned away after she reveals that the cute puppy is intended not for lifelong companionship but for dinner. Finally she convinces a homeless man to sell her his dog. Her husband arrives home to find her chasing the mutt around the house with a meat cleaver. Light is shed when he pronounces the dish of his dreams more carefully, Peking *Duck*. The eager-to-please wife's misunderstanding is merely a function of

Still from *Animal Appetites* (1991), by Michael Cho.

Western attitudes toward Chinese "omnivorousness." They eat dogs, don't they?

All these works suggest that the status Westerners ascribe to dogs is far higher than that they apply to certain third-world people. The reason, I argue, is that dogs—so understanding, and so conveniently mute!—are much more conducive to projected fellow-feeling than are humans who speak an alien language, practice strange customs, and, well, eat dogs.

Projection transacts differently on domesticated animals and so-called wild animals. What sort of identification is at work in a hybrid of these relationships, the experience of visiting a zoo? Zoos are in some ways already constituted in terms of how they invite viewer identification. The textual aids to zoo visitors that encourage certain readings of the zoo experience, the orchestration of the zoo-going event as an entertainment complete with popcorn and soft drinks, all encourage a movie-like experience. But more significantly, the proscenium space in which the captive animals exist encourages a sort of one-way viewing relationship in which the animal, rendered a visual spectacle by the cues the zoo provides, is available for identification. Also, zoos are maps of postcolonial relations, in that they depend on the intercontinental traffic in animals, as well as fantasy reenactments of colonial relations.

Frederick Wiseman's documentary film *Zoo* (1993) is interesting to look at in light of the issue of human identification with animals, as it both highlights the process of identification and disrupts it. *Zoo* documents a few days in the life of the Miami Zoo, in its public spaces and behind the scenes. It has the seemingly dispassionate style, observing events without verbal comment, that is Wiseman's trademark.

Zoo prompts at least three ways to identify with animals. First is a seemingly "unmediated" look at animals in the zoo. This look puts us in position of zoo visitor, by showing animals alone, without human intercessors. So as well as making us observe the behavior of human visitors to zoos, Wiseman pushes us to have that same identification ourselves. Typical camera activity in these scenes is a long shot that brackets out fences and other signs of captivity. The zoo animals seem to be living in the wild, and this encourages the viewer to imagine these animals as completely separate from human existence. Oddly, the creatures that are most often observed in this way are birds. Birds are relatively unsympathetic creatures, difficult to hang an identification on. Wiseman seems to have found them mysterious for that reason, and thus to have filmed them in a way that stresses their alterity.

Second, in many scenes the camera pulls back to look over the shoulders

Frame enlargement from *Zoo* (1993), by Fred Wiseman. Courtesy of Zipporah Films. Photograph by Miami Metrozoo. Copyright 1993 Zoo Films.

of zoo visitors and share their interactions with the animals. Many of these scenes are predicated on complete identification. People laugh at the monkeys; children corner deer in the petting zoo; a burly man beats his chest as though to communicate with gorillas. Wiseman allows us to watch these visitors identifying, in a way that makes us reflect on our own ways of looking at animals. As most of us tend to do at zoos, people in the film take the opportunity to marvel at the strangeness, indeed uncanniness, of animals. They comfort themselves from the fact of this strangeness by concentrating on the animals' seeming similarity to humans.

Uncanniness, of course, is what fetishism seeks to keep at bay. The uncanny is when the other, the absolutely alter, erupts into your space. An uncanny moment in *Zoo* begins with a scene in which the person in charge of the animals' meals is preparing a vat of food: canned fruit salad, raw ground meat, crumbled boiled eggs, which he mixes with his hands. I saw this film at the Margaret Mead Film Festival, whose audiences typically subscribe to documentary film's discourse of sobriety. The audience I was in withheld our reactions during this scene, in proper documentary-viewing fashion. Our reaction did not come until a later scene: an outdoor evening banquet, with lots of people in fancy dress. When the camera focused on a big bowl of Caesar salad that a server is mixing up, the audience broke into moans of disgust. I think what was

happening in that reaction was the uncanny eruption of the other, represented by unappetizing animal food, into the places we keep cordoned off for ourselves. Suddenly our eating habits were like those of animals, and all the distinctions that had been carefully built up between us and them became involuted.

Zoo contrasts the adoring attitude of zoo visitors with the instrumental attitude of zoo workers. Here the third sort of identification comes into play. The zoo workers get to know animals intimately, and they use human expressions with them. But their jobs require that they not simply see themselves reflected in the animals. They have to feed fresh-killed ducklings to the iguanas, castrate wolves, and do other things behind the scenes of this live museum. Zoo workers have to make the transition from seeing the animals as pets to seeing them as meat (compare the jarring contrast of the two suggested uses of rabbits for sale at a roadside stand in Michael Moore's *Roger and Me*).

One of the most striking sequences in *Zoo*, which spans all these identifications, concerns the birth of a hippopotamus. We learn that the female hippo had been shipped to Philadelphia to get inseminated by a bull hippo. The whole process of negotiation had taken two and a half years, so this kid was eagerly awaited. Wiseman films the last minutes of the female's labor, a scene that is only tense because of the urgent whispered

Frame enlargement from *Zoo* (1993), by Fred Wiseman. Courtesy of Zipporah Films. Photograph by Evan Eames. Copyright 1993 Zoo Films.

comments of the zoo staff. The baby is stillborn, and the heroic efforts of the zoo veterinarian cannot resuscitate it. Quite a while later in the film we witness the necropsy on the dead baby hippo. What would have been extremely cute and endearing, a real crowd-pleaser, in live form is now a carcass being taken from cold storage and dumped on the pavement that serves as dissection table. The same veterinarian who tried to revive the kid cuts it open to take tissue samples for various labs. She cuts off its head and sets it up like a strange trophy for the photographer to record, who also records its splayed, bloody carcass from several angles. Finally the vet and her assistant sling the remains into an outdoor furnace to be cremated. This is decidedly not a scene of mourning. The contrast between this bundle of meat and the hopes for a hippo family could not be greater, as the animal has been torn from its relation of identification to a relation of indifference.

This scene makes clear the utter instrumentality of the relation between humans and animals in this environment. The death of the hippo kid is sad because it is a failed investment, as is made clear by the distress at a board meeting later. The animals are useful only as spectacle, and the zoo pays dearly to keep them in shape for that reason. So even the empathic relation between the zoo workers and the animals is not enough to qualify the animals' existence as commodities. A film cannot set up a different kind of relation between humans and animals unless the local ecosystem encourages it in some way. In *Zoo* it is an all-or-nothing relation: animals are mirrors, or they are meat.

There exist counterexamples of identification that might yield a less all-or-nothing relationship between human and animals. For example, many works by First Nations film- and videomakers suggest a relation to animals that asserts their *difference* from human beings. This may sound contradictory, since it's a common cliché that aboriginal peoples respect animals, communicate with animals, exist on a continuum with animals. But it is a different kind of respect to attempt to communicate with animals across a distance, instead of to assume one already knows what they're thinking!

Video artist Mike MacDonald takes an urgent yet sardonic tone toward the conservation of animal life. MacDonald, having been raised/assimilated in Nova Scotia and only later identifying with his heritage as Micmac and Beothuk, worked to educate himself about First Nations issues. He now lives in British Columbia, where he has made works dealing with the land claims of the Gitksan Wet'suwet'en nation. MacDonald's video installation *Seven Sisters* (1989) documents the beauty and majesty

of the eponymous B.C. mountain range, using video monitors to create a portrait of each peak. Long shots of mountain tops wreathed in cloud, taken from a helicopter, suggest a timeless grandeur. However, each of the seven meditations concludes with shots of clear-cut forests and macabre dioramas of indigenous wildlife from a natural history museum.

MacDonald sets up a melancholy contrast between two sorts of stationary-camera shots: those of living mountains, where the movements of cloud and shadow gradually alter the face of the slope, and those of the dead, stuffed creatures gradually gathering dust in the museum. Perversely, the dioramas are as chock-full of "human" qualities as stills from a 1950s TV sitcom. Family groups of deer or of foxes pose in perpetuity, with dad at the head of the patriarchal pyramid; a single tableau captures bears, geese, and mountain goats in mid-activity like so many Saturday-morning shoppers; the dead animals' glass eyes gleam with intelligence.

Some wildlife, however, is alive and kicking in MacDonald's work. *Rat Art* (1990) focuses on one of the creatures with which we feel least compelled to identify, because our interactions with it show humans in an unflattering light. Like *Seven Sisters, Rat Art* exploits the meditative quality of the stationary camera, this time to engage a rat in a work of performance art. For ten all too real-time minutes we stare at a mousetrap in a trash-strewn corner, which a rat tentatively approaches again and again. An odd sort of sympathy begins to flow as the rat gets bolder and begins to take food from the spring-loaded mechanism. You cheer the rat on, believing that it may outsmart the trap, only to have your hopes dashed as abruptly as the rodent is dashed against the wall and the piece ends. In combination with *Seven Sisters,* this tape offers a cynical take on environmental awareness and the human role in destroying and creating the conditions for animal life. MacDonald's work is directly involved in the conservationist movement, but he identifies as a conservationist only as part of the movement for First Nations land claims. "If we're going to have forests and wildlife and fish in the future, then the people who live with these resources are going to have to have more of the control of harvesting and conservation than is now the case. This is what land claims are all about—regional resource control. If we win land claims for native people, everybody wins."[9]

MacDonald pointedly critiques the adoring attitude toward nature evinced by some environmentalist movements: "I have a lot of problems with what I call sob-sister ecology. If my ancestors hadn't eaten seals I wouldn't be here."[10] Some of the shows produced by Inuit independent

producers and by the Inuit Broadcasting Corporation (IBC) take a similarly nonhumanist attitude toward animals, one that argues for negotiated coexistence. The children's program *Takuginai,* produced by Leetia Ineak for IBC and broadcast on the Aboriginal People's Television Network, borrows *Sesame Street*'s combination of skits, lessons, and conversations between human and puppet hosts. However, in designing the wonderfully appealing puppets, *Takuginai*'s producers make a point of not endowing certain animals with human-friendly qualities. "We don't want to depict animals as cute and cuddly," early producer Blandina Makkik explains, because Inuit people are dependent on seals for food, and polar bears pose a real danger.[11] For Inuit children to learn that the animals that form the subsistence base of Inuit society are humanlike would be to alienate them from their own culture. Therefore the show's producers chose animals whose meanings are fairly neutral in Inuit tradition, such as Tulu the Raven and Johnny the Lemming. Now broadcast on the Aboriginal People's Television Network, the show has been on the air since 1987.

The IBC's hunting show, *Igliniit,* is illuminating to look at for the difference between its attitude toward animal representation and mainstream animal documentaries. Produced by Philip Joamie and now discontinued, the show followed hunters of seal, bear, narwhale, and other useful animals. While this Inuit program shares some of the look of a nature documentary, it is actually a how-to show. Its format is a dialogue between a woman in the television studio and a man, presumably speaking over short-wave radio, narrating the progress of the hunt. Like *Takuginai,* it borrows some of the forms of conventional North American broadcasting, but its purpose is quite different. *Igliniit*'s slow pans of the landscape are not the caressing gaze of Discovery Channel documentaries. These long, attentive pans mimic the hunter scanning for prey. When the camera is still, focusing on a school of narwhale close to the edge of an ice floe, the camera operator's motionless shadow tips us off that this is not the reverential stillness in the face of the wonders of nature but the quiet hunter's caution. Unlike conventional animal documentaries, the action is quite slow, and there is little use made of cross-cutting or close-ups on the animals. *Igliniit* is not concerned with creating any identification with the animals as subjects; quite the opposite.

Among the thirteen episodes of the television series *Nunavut* (Our Land) (1995) by Zacharias Kunuk and Igloolik Isuma Productions, nine are devoted to the hunt of animals in season: caribou, seal, fish, walrus. Each episode of this costume drama set in 1946 emphasizes that hunting

is necessary for survival, and that when the hunters return empty-handed, people go hungry. Cinematographer Norman Cohn apprenticed himself to Kunuk in order to learn the cinematographic style appropriate to documenting the hunt: as in *Igliniit,* it is a slow, attentive pan of the landscape, not admiring it for its beauty but searching it for signs of edible life. Victor Masayesva includes this kind of long take in his survey of indigenous aesthetics: "this skill of patient observation is essential to the success of any hunter."[12] In episode nine, *Aiviaq* (Walrus), the hunters are jubilant when they manage to harpoon one of the heavy but alert animals and pull it in. After clubbing it they immediately fall to, carefully incising the skin and peeling it back to reveal the freshly bleeding flesh. *Martha Stewart Living* this is not, but the shots of hunters enjoying the fresh morsels of walrus flesh and still-warm liver and licking their knives definitely have a gourmet-show character. Darrell Varga points out that in Inuit hunting shows, "the animal is not constructed as an absent referent, it is named and its death is directly connected with consumption. There is no mediation of the commodity-fetish."[13] That is, unlike the standard Western practice of representing food as utterly distinct from the mass-processed animals it came from, to the point that smiling chickens can advertise the Quebec chain St. Hubert's Barbecue, Inuit video connects food with the animals whose lives were taken to feed the people.

Instead of assimilating animals to human likenesses, the Inuit works encourage a sort of creative coexistence. Inserted in the narwhale-hunting episode of *Igliniit* is an animated hunting tale that stresses the intermingling of Inuit human and animal life. As the graphic style indicates— smooth forms in black and white with incised details that evoke Inuit lithography—the story is drawn from traditional Inuit tales.

In the tale bears, seals, and giant geese by turns menace, are menaced by, and converse with an Inuit family, composed of a woman, a man, a child, and a dog. I am not in a position to explain this story. But to give you an idea, picture two human-sized geese appearing to the man as he sleeps in his igloo. In gestures ambivalently threatening or protective, the birds dress him and, one on either side of him like cops, walk him to the water's edge. Then, with their great wings, they knock him into the black water—not once, but twice. Yet despite this cavalier treatment, there seems to be no animosity among the three of them when he finally struggles back onto the land. When he returns home, in another event similarly opaque to a southern viewer like me, the woman refuses to feed him. So he prepares to go hunting, fashioning a spear (which the animators render in diagramlike detail), which he ties to the woman's waist. So when

Still from *Aiviaq (Walrus)* (1995), from *Nunavut* by Zacharias Kunuk. Courtesy of V Tape.

he spears a seal, it swims off with her! It is not clear whether the woman was meant to provide ballast for the spear, or the man is acting in revenge, or he has been somehow enchanted by his encounter with the geese. From this impasse (or resolution), the show cuts to a scene of actual humans spearfishing.

One thing is clear from this story (besides that there seem to be a number of trickster figures around): it is not a humanist tale. Animals in these aboriginal works are protectors and predators, mischief makers and dinner. They are capable of exchange with humans, but on their own terms. Even when they have supernatural powers, they are not inherently noble, innocent, or wise. While these animals have a lot a humanlike qualities, they are not necessarily the set of qualities that Western humans like to project onto animals.

Identification with animals, at least of the sort that nature documentaries encourage, is predicated on an exploitative relation of Western postindustrial nations with "developing" nations. In this relation's implicit hierarchy, the sympathetic beasts of the wild and the hearth come below the Western viewers but above many other people. Ecological and cultural survival demands that we reconsider the order of this chain, indeed its very necessity.

In conclusion, let me raise the possibility not of identifying across a chasm but establishing communication along a continuum. We must dispense with some of the cherished myths we hold about animals in order to preserve human ways of life. In the process we may learn to respect animals in their *difference,* as well as their commonality with humans. I suggest that we call this relationship *empathic nonunderstanding.* This is a relationship that gives up the self's need for constant affirmation. If the primal scene of petishism is the fear of finding that we are not so different from animals, then to overcome this perversion would entail respecting the opacity of other creatures. Unable to make assumptions about these furry and feathery others, we may be pulled into a more material understanding of our connection with them. We would do well to extend this relationship to other human beings as well.[14]

3. "I Am Very Frightened by the Things I Film"

Many recent documentary films respond to the question of the filmmaker's power over his or her subject by engaging in a partisan filmmaking practice that speaks alongside, rather than about, the film's subject, to paraphrase Trinh T. Minh-ha. Yet often the rhetoric of responsibility still disguises an unequal power relation that remains between the people on each side of the camera. As Paul Arthur points out, the self-reflexive admission that one's filmmaking effort is doomed to fail can be a way of seeming to relinquish power without ever having put it on the line. Similarly, Bill Nichols notes that the reflexive mode of documentary filmmaking, in drawing attention to its own act of representation, emphasizes the relationship between filmmaker and viewer rather than filmmaker and subject; it can preempt the ethical problems of the encounter by avoiding them altogether.[1] In this essay I would like to explore another approach to the problem posed by this power relation. This approach is to exploit the adversarial relation between filmmaker and subject: rather than disavow power, to produce a film out of the very process of struggle. Such a practice disputes both the truth claims of documentary and the centrality of the filmmaker's subjectivity.

The work of Japanese documentarist Hara Kazuo reveals his relationship to his subject as a need to be completed by the other person, a need to grow through the process of mutual struggle. The North American reception of Hara's films has been both enthusiastic and marked by

controversy. When Scott MacDonald and I interviewed Hara in summer 1992, some striking issues came up: the relation of the documentary film-maker to the subject of the film as one of collaboration and mutual in-fringement; how it is possible for the filmmaker to relinquish agency and mastery; and how Hara's relationship with his interlocutors undermines his masculine privilege.

There is a vigorous mutual deterritorialization at work in Hara's films. It responds to Trinh's call for radical reflexivity in the power relationship around representation, "undoing the I while asking 'what do I want wanting to *know* you or me?'"[2] In Hara's relation with his subjects there is an explicit wanting that is almost a metaphor for the relation of desire that, Trinh suggests, structures the documentary encounter in general. Hara describes his process as reversing the relation of power between filmmaker and subject, and filming the process of that reversal. "When you confront a strong character and work face-to-face with this person on a film, you become confused within yourself. In that state of confu-sion the world starts to look different—and you have the opportunity to show your audience something special."[3]

One of the most compelling ways the adversarial relationship is played out is through the construction of the filmmaker's own masculini-ty, as well as the gender relations implicit in filmmaking itself. Hara is re-markably willing to reveal his woundedness and lack of self-sufficiency on film, and these qualities work as structuring principles of his films. Conversely, his films' abnegation of the documentary filmmaker's con-trol implicate the films' construction of masculine power. (Although a gendered structure persists in the filmmaker-subject relationship, Western gender and power relations can't be mapped completely onto Japan. Later in this essay I will suggest some differences in how the relation of power across the lens is considered in Japan and in the West.) The image of filmmaking as a struggle between two or more subjects, each of whom becomes transformed in the process, describes some of the more power-ful documentary works that have been produced in recent years and of-fers a practice for dealing with—not disavowing, but engaging—the power relations inherent in filmmaking. The following analysis of two of Hara's films is a contribution to such a reworking of the notion of an "alongside" documentary filmmaking.

The adversarial relation between filmmaker and subject is particularly pointed in Hara's *Extreme Private Eros: Love Song 1974*, because of the sexual history between Hara and his subject, Miyuki Takeda. Once lovers, they are now bound by the one-way love of Hara for Takeda that moves

him to film her in order to remain in her life, and the less clear motivations of her acceptance. Hara's insertion of himself into Takeda's sexual exploits could easily be understood as an exercise in male voyeurism and control. However, by throwing himself into an adversarial relation with Takeda, Hara opens his own position to criticism. His dilemma is similar to that in which Dennis O'Rourke finds himself in his documentary *The Good Woman of Bangkok* (1991), in which the filmmaker attempts to "rescue" Aoi, a Thai prostitute who ambivalently becomes his lover, only to find his charity rejected.[4] Both Hara and O'Rourke attempt to intervene in the life of their subject, in the process opening themselves to criticism as voyeurs and parasites of female sexual life. The filmmakers open their actions not to a reflexive and self-contained criticism but to an actual failure, which turns the relations between maker and subject on their heads.

Hara's practice of long-term, partisan collaboration with his subjects has precedents in other Japanese documentary filmmaking. In its relatively short history, beginning mainly with filmmakers who explicitly allied themselves with the activist movements of the '60s, documentary in Japan has not been built around the notion of critical distance that characterizes conventional Western documentary practice. For example, the making of Ogawa Shinsuke's *Nippon-Koku: Furuyashiki-mura* (A Japanese Village: Furuyashiki-mura, 1982) began when a group of farmers criticized the superficiality of a film of Ogawa's about rural life. In response, the filmmaker and his production company settled in the community and devoted themselves to rice farming for six years, only producing *Nippon-Koku* after they felt they understood farming life.[5] This sort of commitment also animates the films of Hara, who at one point considered joining Ogawa's production company.

Like Imamura Shohei, for whom he was assistant director for several years, Hara finds his subjects among people beyond the pale of conventional Japanese society; he uses their experience as a filter through which to view official history. It was through Imamura that the initial contact leading to Hara's best-known film, *The Emperor's Naked Army Marches On* (1986), was made.[6] Hara says of his meeting with the inflammatory political activist Okuzaki Kenzo, "It was 'love at first sight.'"[7] The film follows Okuzaki's mission single-handedly to excavate the terrible history of his World War II regiment in New Guinea, only about thirty of whom survived out of more than a thousand. Okuzaki searches out and confronts his former commanders, forcing them to confess to their roles in the executions of prisoners and the decision, when the men were starving,

to resort to cannibalism. Okuzaki's sheer determination seems to power the film. Hara tells horrific tales of 6 A.M. wake-up calls from Okuzaki, his subject's propensity to bribe police officers with Hara's money, and how fifty rolls of film shot in New Guinea were confiscated thanks to Okuzaki's histrionics. Such transgressions of the respectful distance between filmmaker and subject suggest that Hara was utterly in thrall to his subject—who did not like the finished version of the film, according to a review he wrote from jail.[8]

At first Hara's camera appears to be no more than a passive witness, a recording prosthesis, as Okuzaki choreographs his confrontations. Yet as the repressed wartime stories emerge with increasing clarity, one gets an inkling of an increasingly fraught relationship between filmmaker and subject (perhaps more clinically described as passive-aggressive), in the sorts of violence that Hara appears to let pass without intervening. When he continues to film while Okuzaki assaults his weak and ailing former commander, Sergeant Yamada, then patiently waits for the police to arrive, it is as though Hara is daring Okuzaki to go further. In fact, Hara incited Okuzaki a great deal more than it appears in the film; it was he, for example, who raised the issue of cannibalism as a subject for the film.[9] Hara speaks of his subject as his *aite,* which translates as both partner and opponent. When his subjects get depressed, he says, he will attack in order to provoke them; if they come at him, he will defend himself. With Okuzaki, he says, he could not fight back directly because he would lose. Instead, he uses a Japanese phrase, "Losing is winning," to describe how being pliable to the demands of his subject allows him to capture the experience he wants.

To see *Extreme Private Eros: Love Song 1974* is truly to comprehend the radicalism of Hara's adversarial approach. In this film the struggle between Hara and his subject is more apparent than in *Emperor,* partly because he includes a voice-over commentary on his emotional reactions. Here the strong character is Takeda Miyuki, a young woman who had been Hara's lover, and whom the filmmaker clearly still loves. Hara follows Takeda's odyssey in the tough red-light districts of Okinawa as she throws herself into the sexual, racial, and national politics that color life in the early '70s, on these islands that are already marginal relative to the rest of Japan. She asks him to film her while she pursues her goal to become pregnant and deliver the child on her own, to "express that she is alive": thus the series of events to which *Extreme Private Eros* bears witness is orchestrated by Takeda herself. As Jeffrey K. Ruoff summarizes, Takeda "has an affair with a woman, conceives a child with an African-

Okuzaki attacks his former sergeant: frame enlargement from *The Emperor's Naked Army Marches On* (1986), by Kazuo Hara.

American soldier stationed in Okinawa, gives birth on-camera . . . , starts a day-care center for prostitutes, joins a feminist commune, and works as a stripper in a GI bar, all the while arguing with Hara and his new lover, Kobayashi [Sachiko], the sound recordist and producer of the film."[10]

Much as the usual structure of control becomes a struggle between Hara and Okuzaki in *Emperor's Naked Army,* so the conventional structure of voyeurism is complicated in *Extreme Private Eros.* Since his motivation to make the film was ostensibly that it was the only way he could continue to be close to the woman who had left him, the points that revolve around Takeda Miyuki's love relationships with others are crises of a different sort for the filmmaker. Takeda's odyssey is motivated by a rejection of everything about Hara. The many scenes in which Takeda is subject to the camera's insistent gaze—most notably when she gives birth and when she is making love with the American soldier, but also when she pleads tearfully with the woman she loves or fights with Kobayashi— are also the moments when Hara is most vulnerable and his jealousy, fear, and hurt are most apparent. For example, several times Takeda criticizes Rei, her son by Hara, saying, "He's so like you . . . his cowardliness. The way he becomes hysterical with me. The uncertainty in his heart. . . .

I'm greater than you

Frame enlargement from *The Emperor's Naked Army Marches On*.

I hate people who don't know what's important." At the same time she determines to have "an aggressive child of my own." Hara follows one of these scenes with a shot of Takeda and Rei in the bath: the child playing with his mother's breasts while Takeda absently pats him looks so much like Hara that a comparison to Hara and Takeda's relationship is invited. And when Hara learns that Takeda is pregnant, his anger that the father is black pushes him to break down and cry on camera. For once he is not operating the camera, because he cannot keep steady. Eighteen years later, when we interviewed him, Hara was still extremely embarrassed by this scene.

The film's climax, as she planned, is when Takeda gives birth to her child without any assistance. The birth takes place in Hara's apartment, with Hara filming, Kobayashi doing sound, and Takeda's first child watching and wailing. Takeda narrates her own delivery, almost matter-of-factly, acknowledging the pain, calling out to the newborn baby, explaining to Hara and Kobayashi about the placenta, making sure the infant is not choking. Her deep pride is evident as soon as the baby is fully out. "Yatta, yatta," she says—"I did it, I did it." Afterward she telephones her mother: "I did it all by myself. . . . Yes, it's mixed-race. . . . No, I can't kill it now." The contrast is remarkable between the assured Takeda and

Frame enlargement from *Extreme Private Eros: Love Song 1974*, by Kazuo Hara.

Frame enlargement from *Extreme Private Eros: Love Song 1974*.

the filmmaker, who, though he never appears on camera, structures the image with his own anxiety. "*I* [*boku no ho,* my side] was the one upset," he explains in a voice-over: he is panicking, his sweat fogs up his glasses, and he gets the focus wrong. So the high-tension birth scene is rendered in romantic soft focus. Though Hara is controlling the camera, he visibly betrays his lack of control. When it is all done, Takeda says, "I didn't need your help, Hara"—but then she pulls him the other way: "I should be more helpless—then you'd be all over me." In short, even this scene is structured by the tension between Hara and Takeda.

A savvy heroine, Takeda is aware of the stakes of Hara's parasitical desire to base a film on her life. Near the beginning of the film, shortly after Hara has moved into the tiny apartment Takeda shares with her female lover and her children, she warns him, "You can't make a film out of this squalor." Similarly, Aoi, the prostitute in O'Rourke's *The Good Woman of Bangkok,* tells her interlocutor: "You pulled me out of the rubbish heap only because you wanted to make this film. I think everything you do and say to me is to manipulate me for your film." In persisting to intervene ineffectually in the "rubbish heaps" of their subjects' lives, both Hara and O'Rourke ultimately produce works that allow their subjects to gain dignity at the filmmakers' expense. Linda Williams writes,

Frame enlargement from *Extreme Private Eros: Love Song 1974.*

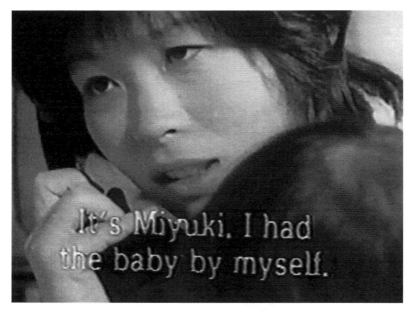

It's Miyuki. I had the baby by myself.

Frame enlargement from *Extreme Private Eros: Love Song 1974.*

The real interest of his film [is] not that O'Rourke "saves" Aoi and shows himself a good, ethical documentarian, but perhaps that he doesn't, and can't, "save" her and yet in the process of trying he generates resistance by Aoi, both to his prurience and his rescue, that grants her more integrity and autonomy as a man-hating, self-supporting whore than she would have had as a "saved" good woman.[11]

Like O'Rourke, Hara makes a "good" film out of his failure to to successfully assert the masculine role of savior.

Freud's observation that the "true" masochist "always turns his cheek whenever he has a chance of receiving a blow"[12] seems to describe the peculiar incendiary passivity at work in Hara's films. Though Hara is the one on the structuring side of the image, his interlocutors, his intercessors, repeatedly challenge his power. Takeda says cuttingly, "I hate people who don't know what's important. The difference between knowing what must be done and when and having no clue." Yet her words ring true to Hara's mission in his filmmaking practice. Avowedly *not* knowing what's important, he chooses to attach himself to people who have no doubt about it, and to let their determination flow through him. Rather than confront his subject, Hara has said, he tries "to become empty inside myself and [let] my subject enter me." Hara's feminine metaphor (or more

precisely the image of being the "bottom" in a sexual encounter) aptly describes his collaborative process. "I like to be the one who receives—for the duration of making a film, say one or two years."[13]

Hara allows himself to be opened up and made vulnerable by the force of his partner/opponent's subjectivity. His receptivity, his desire to surrender or to become feminized, drives his films. *The Emperor's Naked Army* and *Extreme Private Eros* seem to enact the "phallic divestiture" that Kaja Silverman describes, because they are structured by a masculine abnegation of power, indeed masochism.[14] Silverman argues that male "feminine" masochism, because it puts into question the male identification with masculinity, is one way of revealing masculinity as a sham. Thus it would seem that Hara's practice is exemplary of a critical male masochism that destroys the myths on which male subjectivity is founded. The filmmaker's professed vessel-like quality recalls Leo Bersani's argument that for a man to become receptive is a "self-shattering" experience. Specifically, for a man to be penetrated sexually destroys his illusion of self-completeness: "The rectum is the grave in which the masculine ideal . . . of proud subjectivity is buried."[15] Hara's films, especially *Extreme Private Eros* but also *The Emperor's Naked Army,* for the way in which he relinquishes power and will to Okuzaki, are built on and record the process of his shattering. This process of destruction, Silverman and Bersani argue in slightly different ways, is crucial to reveal the illusory nature of the male subject in its privileged relation to patriarchy. Yet Hara is not simply masochistic in these films. Surrendering to his subjects allows him to be transformed along with them, to become confabulator in their stories.

The adversarial process of pique, surrender, and fabulation at work in Hara's films recalls Jean Rouch's desire to involve his documentary subjects as critical narrators. In making films such as *Jaguar* (1954/67), *Moi, un noir* (1960), and *La pyramide humaine* (1959), Rouch worked with the notion that ethnographic film is a collaborative fiction. As David MacDougall points out, the subjects who are most willing to collaborate will likely be those who have agendas of their own that are pressing enough to involve an outside agent. They may be unusually "enquiring of mind," marginal to the community, or already in an intermediary position between community and explorers from outside. In any case, their expressive urgency may surpass that of the filmmaker. MacDougall describes the resulting phenomenon, familiar to anthropological fieldworkers, of "feeling one's work disintegrating and being pulled back and reclaimed by the lives which generated it." Some of the most arresting

documentary films carry a seeming excess of meaning, the result of the subjects' hijacking the film vehicle for their own concerns. "There are many instances in documentary," MacDougall writes, "of the physical and spiritual being of a person seeming to overflow the film that sets out to contain it. The film 'transmits' the presence, but it is as though the film is then consumed by it."[16]

MacDougall's arguments describe the phenomenon at work in Hara's films, as well as the motivation Hara himself avows in his practice. Okuzaki Kenzo and Takeda Miyuki do spill out of the frame. And this is not simply by virtue of the fact that these are collaborations, but because of the particular energy devoted to these collaborations. It is certain that Hara's presence, even his goading, precipitates the events of the film; and this too is comparable to Rouch's practice "not to film life as it is, but life as it is provoked."[17] Hara, like Rouch, is willing to be "used" by his subjects. As in *Jaguar*, where some of the characters take advantage of the French anthropologist's presence to get past customs on the border between Niger and the Gold Coast, so in *The Emperor's Naked Army* does Okuzaki use the camera's presence to threaten his interviewees, and in *Extreme Private Eros* Takeda uses it to record her process of self-actualization. In each case the film is the product and document of a tough negotiation, a struggle. There is a world of difference between the collaborative films that result when the filmmaker is so assured of the superiority of her power over the subject that she bends over backward *not* to allow power imbalances to come into play, and when the filmmaker trusts that the subject is truly a worthy opponent. Despite the magnetism of these characters, Hara does not let them walk all over him; he respects their strength more than that.

An important difference remains between Hara's practice and that of Rouch in his West African films. The colonial relations across which Rouch filmed guarantee that the power to define did ultimately rest with the filmmaker to a large extent. The structure of distribution and audience for films like *Moi, un noir* meant that the characters did not move in the same society that their stories did.[18] In Hara's films differential social relations are minimized: Okuzaki and Takeda are of the same nationality and similar class as the filmmaker, and particularly in Okuzaki's case, the subject was involved in financial arrangements for the film. These films are less open to the criticism, leveled at Rouch, that a story produced from mutual struggle does nevertheless hinge on colonial power relations. Thus Hara's films' topic is more purely the struggle involved in their own mythmaking or fabulation.

The fabulous quality of Hara's documentaries, the larger-than-life

stature of his characters and the journeys they take against all odds, re-
flects the filmmaker's frequently asserted affinity for action films like
Superman and *Batman*.[19] The films lack all but the most minimal signi-
fiers of documentary authority, emphasizing instead their quality of will-
ful construction. As Ruoff points out, even the historical subject of *The
Emperor's Naked Army* is not backed up with archival footage, authorita-
tive voice-overs, or other didactic means. Hara's subjects contribute to
the fabulous quality of their filmic odysseys. "Whereas Okuzaki seems al-
most religiously attached to literal facts in his investigation of the mur-
ders," Ruoff writes, "he reveals himself as an opportunist in his search,
willing to stage certain actions in his pursuit of the truth."[20] Similarly,
though she occasionally disavows the ability of film to glorify her life
("You can't make a good film from this squalor"), Takeda structures
"her" film in terms of a heroic journey.

The element of fabulation in these films makes them the sort of docu-
mentary Gilles Deleuze celebrates, in which the characters "make up leg-
ends."[21] What Deleuze finds striking about Rouch's films is the ability of
the characters, and indeed the filmmaker as well, to be transformed, to
become another, during the course of the film.[22] Deleuze refers to the
characters who enable this transformative encounter as *intercessors* who,
rather than being the film's obedient subjects, multiply its points of view,
taking part in the construction of documentary as fiction. In the process
of working together, filmmaker and intercessor dispute each other's
memories and viewpoints. Each subject infringes on the subjectivity of
the other, in a process that produces the other anew.[23]

In the adversarial relation between filmmaker and subject and the
filmmaker's productive masochism, Hara's films bear a strong resem-
blance to both Canadian, American, and European direct cinema of the
'60s and early '70s and the more recent Euro-American trend of self-
reflexive documentaries. However, it is important to consider ways in
which the Japanese cultural context might shed light on Hara's strategies,
before we appropriate them wholesale to describe other documentary
practices. Hara himself, dismissing some of the parallels mentioned ear-
lier,[24] distinguishes Japanese documentary practice from North Ameri-
can work in terms of a different relationship between filmmaker and
subject. "In Japanese there's a phrase, 'eating rice from the same bowl.'
There's a sense of community that is born from a close relationship, and
conflicts develop from that closeness as well. . . . Of course, American
filmmakers become very closely involved with their subjects, but I feel
they tend to leave space between themselves and the subjects."[25]

At the same time, Hara criticizes what he sees as North American documentaries' willingness to take things at face value. A particular fault is the tendency to rely on interviews, patching them together with other bits of information to make a film. A documentary, he argues, is like a pickled garlic:[26] you keep peeling layers from it, each of which represents a different level of reality. "What is interesting about making documentary films is peeling those layers, and it is difficult to do that simply by relying on the words you record, on the interviewing process, where you only face the first layer of reality.... There is a difference between what a person is saying and what a person is feeling. So I try to peel the expression on a person's face, and go to other levels of truth."[27]

Hara's own acknowledgment of the difference between Western and Japanese documentary practice serves as entry to a final elaboration I would like to make about the notion of productive masochism. It may not be possible blithely to adapt strategies from Hara's practice for Western consumption and concoct a psychic model to go with it. Clearly, in borrowing Freudian and Lacanian models of subjectivity, particularly masochism, to discuss the mechanisms at work in Hara's filmmaking, I have been accepting that psychoanalysis has some cross-cultural applicability. However, we must at the very least acknowledge that even if certain psychoanalytic mechanisms obtain across cultures, the cultural psychic field, or cultural Imaginary, will be different. Hence there is some friction between Hara's filmmaking practice and the model of male masochism into which I have been trying to wedge it.

Norman Bryson has used this difference between cultural Imaginaries productively to critique the way objects appear "menacing" in Lacanian psychoanalysis.[28] Bryson, while accepting the Lacanian argument that the subject is ultimately illusory (if not "shattered"), has suggested that this realization need not be the dark experience that other scholars argue it is. Interestingly, Bryson's argument in "The Gaze in the Expanded Field" draws on Western-Japanese intellectual commerce to make his point that it's not so bad to be decentered. Bryson notes that both Jacques Lacan and Japanese philosopher Nishitani Keiji expand on Sartre's idea that individual vision is negated by the preexistence and omnipresence of the gaze. In the Western tradition of Sartre and Lacan, however, this negation is greeted with a dread at the annihilation of the subject. In Nishitani's argument, the self, rather than resist the field of nihility that surrounds it, cannot be separated from the continuum of time and space. "Its being is interpenetrated by what it is not: which is to say that things exist in the ways they do exist, under a mode of constitutive negativity or

emptiness."[29] For Nishitani, as for many Taoist and Ch'an and Zen Buddhist philosophers, the surrender to emptiness is not a state to be dreaded but a more simple acknowledgment of an ontological state. This view may be compared to Bersani's argument that the "shattering" of the male subject entailed by sexual penetration also need not be so devastating.

Bryson undertakes this daring hybrid of Western psychoanalysis and Eastern intellectual traditions polemically. His purpose in questioning the Western assumption that the gaze menaces is to make specific the ways in which *particular* gazes are menacing.

> It is a bit easier, since Lacan, to think of visuality as something built cooperatively, over time; that we are therefore responsible for it, ethically accountable. Yet Lacan seems to me, at least, to view the subject's entry into the social arena of visuality as intrinsically disastrous: the vocabulary is one of capture, annexation, death. Against this someone else might say: the degree of terror depends on how power is distributed within that construct once it is built, and on where one is made to stand within it. . . . Terror comes from the way that sight is constructed in relation to power, and powerlessness. To think of a terror intrinsic to sight makes it harder to think what *makes* sight terroristic, or otherwise. It naturalizes terror, and that is, of course, what is terrifying.[30]

We might move even further from the view that terror is intrinsic to the social field by looking to another philosopher who borrowed from Sartre, Maurice Merleau-Ponty. The subject of Merleau-Ponty's existential phenomenology is constituted in mutual acts of perception, such that the world's look upon me, while it challenges any notion that I might exist separately from it, is not out to annihilate me. This in turn allows us to identify and negotiate with particular opportunities not for shattering, but for becoming. Hara's films offer a cultural perspective in which masochism need not be shattering. The approach that the subject is not so much destroyed as transformed in struggle informs a filmmaking practice that is not afraid of energetic exchanges between the power-wielding and the power-hungry, maker and subject, intercessor and intercessor. This sort of exchange characterizes some of the most productive, deepest-reaching documentary films, films that go beyond the ruse of collaboration. "What I want to do is not to intrude on *other* people's privacy, but to reveal my own, and to see how far I can go in the revelation. I want to drag my audience into my life, aggressively, and I want to create a mood of confusion. I am very frightened by this, and by the things I film, but it's because I am frightened that I feel I must do these films."[31]

II. Haptics and Erotics

4. Here's Gazing at You

November 30, 1992

Dear Ken Jacobs:

You might remember me from the Flaherty seminar this summer. Our conversation about the *XCXHXEXRXRXIXEXSX* experience was unfortunately cut short, and I guess neither of us felt up to trying to continue it later. I was the one who sort of pushed you over the edge by talking about whether one could jerk off while watching the film. But I did not mean that as a criticism of the film, or rather your Nervous System performance of the film, which I found fascinating and enjoyed very much.

The reason I am writing to you now is that I am working on an article for the *Independent* on the issue of generational differences in watching experimental film, which will focus on the experience we had at your screening at the Flaherty. I want to explore why people responded so divergently to the film, took pleasure in it or took offense to it, for such a variety of reasons. I want to argue that people educated with my generation have learned certain attitudes toward popular culture, critical theory, feminism, etc. that allow us to look at experimental film differently. I will argue that this sort of background affords us an experience of films such as yours that is very rich, if different from the experience that the filmmakers may have anticipated. I'll be talking about my own experience of your film as an example.

I would like to ask you some questions about the film, how it relates to your other work, your own view of pornography, how you relate to other work that plays with the film apparatus, and things like that. We could also talk about issues that you think are important to raise about the film, and about the Nervous System. If you'd be willing to do this, let me know whether you'd like to talk on the phone or respond to some questions by letter. I do hope you will work on this with me.

My deadline is the end of December, so if you could get back to me in the next week or so, just letting me know whether and how you'd like to do a little interview, I'd be very appreciative. I know this is a difficult time of the year to be doing extra projects, but I'd like to make it easy for you. If I don't hear from you in the next week or ten days, I will give you a call.

Many thanks,

Laura U. Marks

About ten days after I mailed this letter I received a brief reply from Ken Jacobs. He wrote that, after consultation with friends who work in film theory and feminist theory, "We do not believe your invitation to dialogue to be in good faith." He felt he had been set up when he presented the film in question, *XCXHXEXRXRXIXEXSX* (1980), as part of a program organized by Scott MacDonald at the thirty-eighth Robert Flaherty Seminar in summer 1992. He didn't want to participate in such a setup again. He asked me not to call him.

In the following I want to draw a picture of the way several generations of film folks interact with experimental cinema. I'll suggest that a view is emerging that allows us to enjoy a "difficult," experimental work simultaneously for its formal and durational qualities, through the complicating lens of critical theory, and ultimately with a pleasure that does not separate aesthetics, politics, and eroticism.

What happened that day to make Jacobs so suspicious? The screening took place on the second night of the six-day seminar. The audience was already a bit restless and irritable, as often happens at the midpoint of the Flaherty seminar.[1] As Jacobs described in a handout available at the seminar, *XCXHXEXRXRXIXEXSX* is "an intensive examination and bringing to life of a very small amount of film material originally photographed circa 1920; selections from a French pornographic short." The title with all the Xs visually mimics the effect of projecting the original film, *Cherries*, through an apparatus of Jacobs's invention called the Nervous System. Two analytic 16 mm projectors advance identical copies

of a film frame by frame, while the blades of a propeller alternately block them. One projector is stationary, and the filmmaker manipulates the other one so that the two images differentially overlap, producing flicker and a three-dimensional effect. The result is that the 1.5-minute film fragment is elongated into a two-hour film performance, each frame becoming its own animated experience. Jacobs accompanied the performance with a variety of recorded music.

In other words, we viewed a vintage porn film, which was both charming and explicit, for two hours, in a sort of cross between extreme slow motion and an intense flicker film. For the duration Jacobs engaged his apparatus, in what must have been an exhausting performance. At least a third of the audience walked out of the auditorium at various points during the screening. When the rest of us emerged, we found the

Ken Jacobs with the Nervous System. Courtesy of Flo Jacobs.

Frame enlargement from *XCXHXEXRXRXIXEXSX* (1980).

walkouts divided roughly into those who objected to the film because it was (based on) pornography and those who were annoyed by what they felt was an extreme example of the avant-garde viewing experience.

Thus, as the discussion that follows all Flaherty screenings began, there was a lot of tension in the room, and Jacobs was already on the defensive.[2] With moderator Richard Herskowitz, the filmmaker began by discussing how the Nervous System worked with the formal qualities of the film. Audience members became restless, as it seemed Jacobs was being intentionally obfuscatory. Obviously many participants wanted to discuss the content of the work he chose: the first question was from programmer John Columbus, who asked about the choice of pornography as source material. But Jacobs and Herskowitz managed to keep the discussion to aesthetic and technical matters for the first fifteen or twenty minutes.

Finally one participant, one of the younger women in the audience, told Jacobs that she felt violated by the film because its pornographic object was created by and for a male gaze. "I left because I found the experience offensive and disturbing, and very violent. . . . For me to watch this is like watching a rape. Pornographic imagery is about women and power. I don't know if you're interested in that, but for me it was just this male

gaze thing for two hours." Jacobs countered, "Well, it disturbs me that you don't want to talk about *art*," and pointed out that nobody gets hurt in the film. Clearly Jacobs had heard this sort of critique many times before, but rather than address it he seemed to freeze with anger. The next woman to speak was me. Then a graduate student, I had recently been steeped in Linda Williams's book *Hard Core*. I was uppity, as graduate students are. I suggested that pornography was not incidental but in fact the ideal object for his apparatus, and asked in an over-clever way how the function of pornography, namely to aid "jacking off," changed when its duration increased so drastically. The rest of the discussion went like this:

> JACOBS: I don't understand what you're saying. If you're hopped up on the male gaze, and pornography, and power, I guess that's the way you'll see my film. But *[XCXHXEXRXRXIXEXSX]* and my other work is also about becoming conscious of what exists on the screen, of *seeing* what exists.
>
> I *don't* think I stretched a minute and a half into a two-hour masturbation festival . . .
>
> MARKS: That was a cheap shot on my part.
>
> JACOBS: It was disgusting. *Disgusting!* Oh, you're such fools!
>
> COLUMBUS: Well, *that* opens the dialogue!
>
> JACOBS: I took something that was meant to be used as an abuse of the body, an abuse of even what the *camera* can do, and I transmuted it into something glorious. I took it back to life! . . .
>
> COLUMBUS: That's what . . .
>
> JACOBS: SHUT UP! Don't interrupt me.
>
> COLUMBUS: You're such as elitist, fascist . . .
>
> JACOBS: FUCK YOU! You disgusting creeps!

Jacobs blew up and left the room.

After the brief, stunned silence that followed, filmmaker Willie Varela made a generous remark, which is in part what inspired me to write this essay. Varela, himself a veteran of the '60s/'70s mostly male experimental filmmaking scene, observed that what was going on here was a generational conflict. He framed this conflict in terms of a formal understanding of art versus a social and political understanding. Responding to film on the basis of ideas about the power of the gaze, Varela argued, is a product of the post–"Visual Pleasure and Narrative Cinema" generation.[3] Varela's point was that it is *learned* to respond on these other levels, namely, those informed by feminist theory, psychoanalytic theory, and

the whole ball of wax; one should not expect the filmmaker to anticipate these responses.

Varela's point was well made, and it opened about an hour of animated conversation in our now leaderless group. Nevertheless, I thought it would have enriched the discussion immeasurably if Jacobs himself had evinced a respect for the various "learned" responses that were had throughout the room. It became clear that there were a number of generational splits going on, in terms of types of feminist and nonfeminist reactions to the use of pornography, attitudes toward popular culture, and pro- and anti-theory camps. Mulvey's article had been published seventeen years earlier, and since then a whole scholarly industry had devoted itself to different ways the gaze may be mobilized. So for Jacobs and others to assume that all the feminists in the room responded to his film in terms of notions of the gaze was to conflate a large number of responses. Some people also seemed to want to split the participants into nonfeminists and feminists, corresponding to those who enjoyed the film and those who did not. But, as others of us had to point out, there are feminist pro-porn arguments as well, emerging from a new embrace of popular culture. There were feminists who appreciated *XCXHXEXRXRXIXEXSX*, and nonfeminists who walked out.

The inclusion of a filmmaker like Jacobs at the Flaherty seminar was already controversial, because traditionally the Flaherty centers on documentary film. By now, Flaherty participants are used to imbibing a judicious mix of fictional and experimental approaches with their documentary. However, Jacobs's presentation came at a point when participants were getting to the end of their patience with a section that opened the seminar, organized by MacDonald, which seemed to have nothing to do with documentary. MacDonald programmed a series of films based on the motion study, including Godfrey Reggio's *Anima Mundi* (1991), Chris Welsby's time-lapse nature studies, Holly Fisher's *Bullets for Breakfast* (1992), no-budget Super-8 films by the prolific Canadian John Porter, and two works by Jacobs that employed his mind-altering projection apparatus.

MacDonald's programming at that Flaherty was criticized for ignoring issues beyond formal concerns, to wit: "All of the films [in MacDonald's portion of the festival] were made by white filmmakers and social, political, racial, or gender issues were elided or treated as if they were incidental."[4] However, I found that his choice of works drew attention to the very politics of vision. At the very first Flaherty screening, as we filed into the cushy auditorium at Wells College, animations from *Eadweard*

Muybridge: Motion Studies (1990) were flashing banally on the screen. These animations are the "fun" part of Jim Sheldon's educational video-disc on Muybridge's work: they take the familiar experiments with serial photography collected in *Animal Locomotion* and make them into short movies, as Muybridge himself did with the zoopraxiscope.

I say they were banal because at first it seems pointless to reanimate the motions that Muybridge went to such pains to suspend. But they were also rather profound, because these short sequences revealed the nineteenth-century desire to isolate and analyze that underlies the conventions of synthesis in film. They also reveal the social codes that informed this most basic of visual experiments, for the innate forms of movement implied by the title *Animal Locomotion* are quite distinct for animals, children, women, and men, as well as for people (and animals) of different classes. For example, the difference between Muybridge's images of gleaming racehorses and the workhorses that trudge from frame to frame is a class difference, and the "animal locomotions" of women and men are clearly marked in terms of gender difference. Muybridge's men wrestle, hew wood, and do other sorts of work to which their bodies are integral; while his women tend to do things like pour tea, embrace children, and swing in hammocks. They do not seem to occupy their bodies or master their movements as the men do. In short, it is difficult to look at *Animal Locomotion* nowadays without remarking the overwhelmingly ideological character of cinematic motion.[5] Thus by beginning the seminar with the father of movement analysis, in a way that reveals the relation of Muybridge's still-strange studies to filmic conventions of natural movement, MacDonald inscribed politics into the seemingly apolitical genres of avant-garde and structural filmmaking.

MacDonald's polemical purpose was even more evident in the second work programmed in the seminar, Austrian filmmaker Martin Arnold's *Pièce Touchée* (1989). This six-minute film, now celebrated as a small masterpiece of deconstructive montage, results from Arnold's analysis of a seconds-long fragment from an American '50s melodrama, a shot in which a seated woman greets a man coming into a room, presumably her husband arriving home. Arnold reprints, switches, and staggers the frames, forcing us to focus on individual movements even as he denaturalizes them. Visual relations appear as causal ones. Her deferential gaze up causes him to move toward her, his arm moving causes her head to move as though struck. In part it's a ritual of domestic violence, in part a manifestation of the disturbing way couples sometimes come to behave as a unit, as though connected by invisible rubber bands. MacDonald said

one purpose of his program was explicitly to underscore the relation between gender and film production that motion studies reveal. *Eadweard Muybridge: Motion Studies* and *Pièce Touchée* set up this relation, and Jacobs's performance of *XCXHXEXRXRXIXEXSX* summed it up.

Many films and videos premiere at the Flaherty, and another reason *XCXHXEXRXRXIXEXSX* was controversial is that it was a twelve-year-old work: people were irritated that they were being shown old stuff. But the Flaherty offers an opportunity to reevaluate work or to approach it in new contexts. Although the film community that Flaherty attendees inhabit is a privileged one, within it there is a relatively broad spectrum of attitudes among the group of filmmakers, teachers, programmers and other film-campers. We have our fault lines, our generational and ideological splits, our aesthetic and political disagreements, and our academic rivalries. Any consensus arrived at is tentative, and if you stick around for lunch you will hear the disagreements that didn't get broached in the group discussion. Thus, showing work at the Flaherty is a way for filmmakers to get a useful variety of feedback. A context like this could breathe new relevance into a form, namely '60s/'70s structuralist avant-garde film, that is now slotted into two-week segments in film courses, trotted out for the occasional retrospective, and otherwise historically contained. I could not believe that people who continue to work in this form, such as Jacobs, would reject the opportunity to have their work revalued, and that was why I wrote to him.

Filmmakers, students, and critics who came of age in the '80s and '90s, steeped in identity politics, often have a knee-jerk aversion to the filmmaking practices of the decades preceding us. We often assume that nothing good can come from the hermetic formal experiments of a buncha white men, a self-selected artistic elite, who embodied experimental/avant-garde filmmaking in its formative years. A lot of their premises get on our nerves: the apparent disregard of racial and sexual politics, if not overt racism, sexism, and homophobia; the elitist valorization of capital-A art and its distance from popular culture; the faux-naif distrust of theory. We claim, by contrast, to represent an enlightened, politically informed film practice. This changing awareness informed the programming at the Flaherty: throughout the late '80s and early '90s the seminar showed increasing numbers of works by women, people of color, queer filmmakers, third-world and indigenous artists, and political activists of other stripes.

Yet I continue to believe that the most compelling of these overtly political works draw on experimental techniques. The political messages of artists like Trinh T. Minh-ha, Isaac Julien, Abigail Child, and the late and

mourned Marlon Riggs are compelling partly because they draw attention to the perceptual process itself. As MacDonald said to me, "Avant-garde film still disrupts people's ability to have pleasure. I don't think people deal with avant-garde work any differently now than they did thirty years ago." He contended that the real reason for most of the Flaherty audience's hostile reception to *XCXHXEXRXRXIXEXSX* was that they couldn't hack the sheer hard work of watching a two-hour experimental film. "It's typical of audiences seeing avant-garde film for the first time. They want to say they're shocked because it's porn, but they're really pissed at having their vacation interrupted." He argued, and I agree with him, that works that simply offer the right configurations of politics ready for consumption are boring, safe, and ultimately conservative. MacDonald's program insisted that we need to deal with the very stuff of perception, which is what experimental film does, if we want film to take a political position. "You can't change the world without studying how things work. For me the motion study is a metaphor for one of the steps you need to take in social change." Not only is it a metaphor, but it embodies political relations in microcosm.

Ken Jacobs has been making films since 1956, not prolifically but committedly, since many are works in progress for years: they include *Star Spangled to Death* (1957), *Blonde Cobra* (1963), *Tom, Tom, the Piper's Son* (1969, revised 1971), *The Sky Socialist* (1964–65/1988), and a number of performances using the Nervous System and other apparati. Stan Brakhage narrates Jacobs's progress with extraordinary sympathy in *Film at Wit's End*, evoking the alienation, poverty, and anarchistic politics that characterize a particular generation of New York artists.[6] Jacobs studied with Hans Hoffmann, the European teacher who jump-started the Abstract Expressionist painters, from 1956 to 1959. He was one of the artists Jonas Mekas baptized in *Film Culture* and in his *Village Voice* column, where he called *Blonde Cobra* "the masterpiece of the Baudelairean cinema."[7] At the Flaherty, MacDonald showed a segment of Mekas's epic diary *Lost, Lost, Lost* (1976) that neatly summed up both Jacobs's location on the avant-garde scene and the historical oil-and-water relationship between experimental cinema and the Flaherty seminar. In the segment Mekas, Jack Smith, Jacobs, Flo Jacobs, and one or two other unidentified women travel to the same pristine cloister in Aurora, New York, where the seminar was held in 1992, intending to stage a guerrilla screening of *Blonde Cobra* and Smith's *Flaming Creatures*. As Mekas narrates their attempt, we see the women sleepily pile out of a VW van; later Smith and Jacobs, robed in blankets in their role as "monks of the order of cinema,"

swoop through the early morning mist on the Wells College lawn. The monks' gatecrashing attempt failed, and the films were not shown at the Flaherty until 1992.

P. Adams Sitney refers to the endless self-critique of Jacobs's works as "an aesthetic of failure."[8] Indeed Jacobs's films stress their own lack of closure, from the ironic failed suicide of *Blonde Cobra* to the unfinished or perpetually reworked status of films like *Star Spangled to Death* to the contingent and ephemeral quality of the Nervous System performances. Jacobs put together *Blonde Cobra* from footage that Bob Fleischner had shot with Smith in 1959 for two planned films, *Blonde Venus* and *The Cobra Woman*. Much of the film had been destroyed in a fire, but Jacobs rescued the remainder and edited it with Smith's voice and other sounds over. "Having no idea of the original story plans," Jacobs wrote, "I was able to view the material not as exquisite fragments of a failure, of two failures, but as the makings of a new entirety."[9] Many of Jacobs's films, including the best-known, are made with found footage. Both *XCXHXEXRXRXIXEXSX* and *Tom, Tom, the Piper's Son* use early film reels as their raw material. And other films rework Jacobs's own footage from years past; *Two Wrenching Departures* is an elegy to Smith and to Fleischner drawn from their appearances in Jacobs's films *Star Spangled to Death* and *Saturday Afternoon Blood Sacrifice*. Like his "aesthetic of failure," Jacobs's reworking of previously enjoyed footage opens his films to discussion in terms of appropriation, multiple use, and multiple interpretation. In modernist fashion, this open-endedness seduces a viewer.

Jacobs's approach seems to be to treat the artifacts he works from, be they Fleischner's half-destroyed footage of Smith or "primitive" and vintage porn films, as raw material, which he transforms into art. One line of modernist thinking holds that such a transformation elevates something base, namely pop culture, into something fine, namely art. But another bypasses this hierarchy and enjoys the way pop-culture "pops" out of the work of art. If we don't respect the hierarchy between the raw material and the final product, and many of us who came up in the '80s and '90s learned not to, then this means that we need to give the raw material equal consideration. One way my own response differed from the response that Jacobs seemed to anticipate was that I didn't separate the pop culture artifact from the artwork but appreciated the original porn film for its own sake as well. I examined my reaction to *XCXHXEXRXRXIXEXSX* as a reaction to an erotic film. And, unlike the feminists of fifteen to twenty years before, feminist viewers of my generation have the means to take pleasure in the film.

Doubtless Jacobs was aware of the feminist critiques of the structuring gaze of the cinema. In fact his project aligns with '70s feminist cinema theory that attempted to deconstruct pleasure and the implicitly male gaze. His films and those theories are also aligned in their opposition to popular culture. Jacobs's critique of the apparatus, after all, has many of the same motivations as Mulvey's did in 1975: the destruction of pleasure, or at least pleasure based on identification with a narrative; the foregrounding of the technological means of cinema; the disruption of closure. Yet his film also profited from the pleasures of popular cinema, while disavowing them. At the seminar, Jacobs said that the 2D-3D play of the Nervous System worked best on "rounded objects, curved volumes," hence his choice of the porn film. He added that he wanted an explicit film, he abhorred coyness; and that he loved the little porn film he'd used.[10] Yet in light of the audience's negative reaction, Jacobs distanced *XCXHXEXRXRXIXEXSX* from porn: "I took something that was abusive of the body and transmuted it and made it glorious." He was being a bit disingenuous. I suspect Jacobs picked up the line that porn is "abusive of the body" from the first wave of antiporn feminist arguments when he began receiving flak for the perceived sexism of his work. I don't think he believes porn, or the sort of porn he has here, is abusive.

I think Jacobs actually did a disservice to the creative and critical power of his apparatus by denying the pornographic content of the work. Patricia Mellencamp, writing about *Tom, Tom, the Piper's Son,* calls belatedly on apparatus theorists to let avant-garde film do for them the theoretical work that they expended analyzing Hollywood cinema. "I would argue that this film, like many avant-garde films, is theory, informed by history—of technique, of style, of story," she writes.[11] The apparatus Jacobs designed is an even more perfectly theoretical object. The Nervous System amplifies and changes the experience of watching film in general but pornography in particular.

Linda Williams's argument in *Hard Core* is that the desire to make visible the "secret" of female sexuality drove the fetishistic process of early cinema: on the one hand, this search for visibility was displaced into the "peekaboo" games of narrative cinema; on the other, it became the compulsion of hard-core porn. The problem, Williams points out, is that female orgasm cannot be shown as such (with, I'd suggest, an exception for female ejaculation). Hence the ever more obsessive desire to somehow make "it" visible that informs pornography. "This very blindness, this inability to make the invisible pleasure of the woman manifestly visible and quantifiable, is the hard-core text's most vulnerable point of

contradiction and the place where feminists who would resist a mono-
lithic, masculine, hard-core discourse of sexuality can seek the power of
resistance."[12] Feminist viewers can replace this searching gaze, which mo-
tivates the porn film as it motivated Muybridge's experiments, with other
sorts of inquiring looks.

It was in the spirit of this sort of inquiry that I watched Jacobs's per-
formance of *XCXHXEXRXRXIXEXSX*. And I found the film to be deeply
enjoyable *because* its formal qualities were inextricable from its ability to
arouse me. First off, he chose a rich film to work from—and if the discus-
sion had been open to other things besides transcending the raw materi-
al, it would have been exciting to learn more about how he decided to use
this charming artifact. The anonymous "French" film *Cherries* (a suspect
origin, since the original English titles said something like "The latest im-
port from France," invoking the old convention that French things are
automatically more risqué) has a simple narrative involving two women
picking fruit. They begin to caress each other. A man spies on them as
they pull up their sheer skirts to better hold their cache. He approaches
them aggressively; they at first resist his advances and then assent. The
rest of this short film is a loose montage showing the ménage à trois in
various sexual positions.

Despite the rape connotations of the opening sequence (which, mind
you, lasted for forty minutes in the Nervous System version), the actual
sex scenes in the film are remarkable for their attention to the varieties of
female as well as male sexual pleasure. The women have sex with the man
in a variety of positions, and the camera focuses on their enjoyment; he
goes down on one of them, and the women kiss and fondle each other. Of
course these are all conventions of porn for straight men—the shots
demonstrating the woman's pleasure, the "lesbian" foreplay. However,
films such as *Cherries* suggest that early pornographic film, even though
it was intended for straight male viewers, was generous to different ways
of viewing. These are films made before porn's imagery was coded and its
audiences divided up.

Jacobs's apparatus, by isolating those transitional moments when
sexual meanings seem to slip, exploits this polysemic character of early
porn. Watching the film through Jacobs's lens, I was able to reclaim the
identifications entertained by the early film, which could shift from one
woman to the other to the man, from giver to receiver of pleasure to
voyeur (for often the third person was only rudimentarily involved), and
from voyeur (in long shots) to participant in the scene (in the medium
shots) to fascinated fetishist (in the explicit close-ups).

The Nervous System performance did transform this film. It made single shots not only interminable but rich in infinitesimal variation, each frame pulsing into three-dimensionality, intensifying the viewing experience until it was almost unbearable. The time-based movement of the original film explodes into an extratemporal dimension powered by the imagination. Let me defer to Phil Solomon's exquisitely attuned description of the viewing process: "Here, at last, is the happy union of Eisenstein and Bazin—one can explore the deep space of the frame at one's leisure, peruse underneath an oscillating armpit to a shimmering waterfall of movement behind, privately relish the vibrating illusion of depth between hem and him, study the individual Muybridges of an avid fellatio or cunnilingus . . . and yet this 'static' frame is virtually created by the 'montage of attractions,' the collision between one picture and the next—a dynamic, breathing, living frame."[13] When one of the women takes endless minutes to roll the hem of her chemise an inch further up her leg, that single tiny motion becomes a universe of seen or imagined movements. When, in the final brief shot, one of the women is on top of the man, seen from behind as the shaft of his penis slides into her vagina, it lasts forever: we stare until there is nothing more to see, exhausting our arousal; we get bored, we start to hallucinate faces in the trees.

I should really say, *I* stared until there was nothing more to see, *I* exhausted my arousal; *I* got bored and started to hallucinate—because the Nervous System's aesthetic, intellectual, and erotic virtue was its ability to interact with our individual fantasies, and indeed to resonate within our bodies. Jacobs's performance took a popular-cultural artifact and blew it so far apart that there was room for our desires to play out in the gaps. It was the perfect porn film for people who don't like porn, who find it cold or predictable or boring. It exploited our individual propensities to create images in the abstract play of the flickering frames. If one was willing to look at all, Jacobs's apparatus made pornography more conducive to individual fantasy and actually worked against the notion that pornography forces the viewer to react in predictable ways. It could be used also to show how people other than the original intended audience for a work of pornography—especially women—can view the work appropriatively or in alternative ways.

Amazingly, *XCXHXEXRXRXIXEXSX* posited an alternative to the standard notion of the dominating male gaze. Instead it gave us a gaze that can be seduced, fool itself, get lost in the image, and switch identifications willy-nilly. As Richard Herskowitz put it in the discussion, "The film looks at me, too": the film makes us self-conscious about our own

look. There were no dominating gazes here: looking is really what we were all doing, women and men, as we tried to come up with desiring positions in relation to *XCXHXEXRXRXIXEXSX*.

Indeed a great deal of what is erotic about *XCXHXEXRXRXIXEXSX* is its ability to confound the mastering position of optical visuality. If you try to bring the images into focus, you get a headache. But if you allow these selectively bulging and blurring forms to just do what they do, a haptic universe unfolds in all directions. Part of what was erotic about the experience of viewing the performance is the pleasurable alternation between trying to "top" or master the film and letting the tactility of its images overwhelm me. It is a film that must be completed by the body of the viewer. For Solomon, "My eyes feel swollen and sated, buzzed and dazzled, and I am still quaking from the overwhelming beauty."[14] For me, the aesthetic fatigue of my eyes and brain was indistinguishable from a corresponding erotic fatigue, pleasurably unbearable or unbearably pleasurable, in other parts of my body.

To return to my point about jacking, or, if you like, jilling off. I found that the apparatus radically altered—but did not annul—the function of pornography. A viewer's relation to the porn film has to change when the erotic scenario is stretched from two minutes to two hours. In order to stay turned on, you need what you are watching to have a certain amount of continuity. It becomes debatable whether one can "get off" to this film in the conventional way, because the filmmaker's structural intervention all but destroys the minimal narrative connections from scene to scene and even from shot to shot. For me the Nervous System's transformations urgently raised the questions, At what point in the film do you get aroused? How long can you sustain the state of arousal? What do you do after you've gotten off once?

Jacobs, as I've noted, was appalled at the suggestion that his film could function as pornography. But his own statements about the transformative process wrought by the Nervous System—it creates a "continuous rolling effect where things don't go anywhere"—suggest a strikingly different relation to pornography. It is a state of continual tumescence (and remember, girls as well as boys can tumesce), in which rather than reaching orgasm the viewer is in a constant state of stimulation. I would argue that this is a highly creative state—open-ended, vulnerable, and aware, if a little exhausting. By contrast the orgasmic relation to porn, while it has its virtues, creates closure insofar as it facilitates catharsis. Incidentally, in my extremely informal survey after the screening, a number of other women said they were turned on by the performance, but no men did.

Not only can the experience of *XCXHXEXRXRXIXEXSX* amplify our understanding of the gaze/look; also the baggage we bring to bear on discussions of the gaze/look can retroactively inform the experience of *XCXHXEXRXRXIXEXSX*. The phenomenological language that people were using to talk about experimental film at the time that Jacobs conceived of the Nervous System in the 1970s has been, first, abandoned for the labyrinth of psychoanalysis, and more recently, expanded.[15] Now it takes into account the cultural, social, and psychic situatedness of the viewer. The kinds of comments Flaherty participants came up with synthetically summarized a history of ways of talking about experimental film other than the varieties of feminist approaches, antiporn, anticensorship, psychoanalytic, Foucauldian. Film programmer Ruth Bradley, for example, summarized the viewing experience by saying that in the first twenty minutes she learned to watch the film, and in the next hour and a half she tested what she knew: "I got bored at times, I got turned on at times, I fell asleep once, came back, and enjoyed the whole thing. And the last five minutes were amazing!" Varela referred to the "unique, exquisite tension" between content and form.

As for those of us who dwelled on the "content" of the performance, while most people reacted primarily to Jacobs's use of pornography, it was film programmer Jackie Tshaka who pointed out that the music that Jacobs had chosen to play during the more erotic scenes was "African" drumming. Jacobs had made a connection between explicit sexuality and "primitivism," and between primitivism and a stereotyped notion of Africa, that was thoughtless at best. Others responded immediately to the sexual content of the film, in other ways than the ones I've described. Notably, some assented to the '60s liberationist argument that to show sex is inherently progressive. Macdonald noted, "Ken is coming out of a period when it was ideological and courageous to *represent* sexuality." Filmmaker Holly Fisher simply appreciated *XCXHXEXRXRXIXEXSX* as "a sexy, funny film" and noted, "We have to be careful not to let ideology put blinders on our brains and our sensitivities."[16]

Fisher's comment begs the question, When an ideology prevents a certain form of pleasure, what is the pleasure it does afford that makes us willing to take it up? What pleasures are opened up and foreclosed by the various "ideologies" operating in our several ways of viewing the film? I've been arguing that "ideology" can help you enjoy a film *more*. Theroretical approaches can be like sexual toys, complicating and differentiating the pleasure of the viewing experience. It is a different sort of pleasure, of course, more self-reflexive, more responsive to context. We

theory-heads are a new audience for experimental film: people who have worked through agendas for filmmaking and viewing, including the phenomenological, early feminist, popular-cultural, new feminist, and anti-racist, bring a rich, if different, approach to films made with the agendas of twenty-five years ago. We have given ourselves permission, as therapists say, to make what use we will of the traditions of avant-garde cinema. And if the readings we produce enable new responses rather than close down meanings, then I believe they are acting in the spirit of open-endedness that Jacobs and so many other avant-garde filmmakers upheld and still uphold.

As Willie Varela said at the Flaherty, we learn to respond to cinema in the light of theory. I would say it is a poor theory that destroys pleasure. But it is also a poor film whose pleasure can be destroyed so easily, and it's a measure of a great work that it can reward differently slanted viewings. *XCXHXEXRXRXIXEXSX*, both through and despite the filmmaker's intentions, helped me to begin to discover an embodied response to cinema whose pleasure is inextricably visual, intellectual, and erotic.[17]

5. Love the One You're With: Straight Women, Gay Porn, and the Scene of Erotic Looking

A straight woman who likes to go to gay men's nightclubs knows the peculiar pleasure of seeing men who are on full erotic display, yet being herself practically invisible. The gay club scene is a voyeuristic feast for a woman who wants to look at men, or to *learn* to look at men, without the look back (except maybe to check out what she's wearing). Like many women, I have experienced the special voyeurism of the fag hag at gay clubs, and also at queer film festivals. Sharing space and skin, we also share ways of looking. In the following I would like to extend this fag-hag gaze to a model of looking based on S/M, and ask what its consequences might be for notions of subjectivity, identification, and ethics.

Independent filmmakers are producing a wealth of work that I would call alternative pornography: experimental works that engage with porn conventions to both arouse and provoke. There has been a tremendous amount of lesbian and gay film and video in this genre—indeed, they are what defines it. Yet there is still precious little alternative porn that appeals to a more or less straight female viewer. I suggest that one route for a straight woman to enjoy and learn from porn is by watching some kinds of alternative pornography made for gay men.

Here I will be looking at works by Katherine Hurbis-Cherrier, Curt McDowell, Deke Nihilson/Greta Snider, Ming-Yuen S. Ma, and Karim Aïnouz. They all draw on the codes of hard-core gay porn, but with important differences. They have in common a fragmenting and objectifying

look at a solo male, which makes them seem to parallel the images of women in hetero porn; they include shots of erections or cum shots; and they all assert some kind of relation of power among maker, subject/object, and viewer. That these works are small, independent productions plays a large part in their ability to invite a playful look that oscillates between distance and involvement. Ultimately I will suggest that these works invite multiple sorts of erotic looks confined neither to particular subjects nor to particular objects, looks that, as well as dominating, may be submissive or take some other relation to their object.

It is well established that the male look at men in cinema is not necessarily, indeed not usually, an explicitly homoerotic look. It's the most macho of movies, the *Gladiators* and *Fight Clubs*, that permit men a variety of looks at other men—active, stripped, sweating, suffering, embracing other men—under the pretext of the story.[1] This anxiety over maintaining male characters in active positions extends to pornography.[2] Of course, gay homoerotic imagery offers alternatives in which the construction of masculinity is more complicated—the stereotyped gentleness of the Asian male, the softer masculinity of the bearded "bear," the slim, graceful youth,[3] the erotic subjection of the pierced, tattooed, or bound male body. Sometimes these alternative images of male beauty, arriving from the fringes of film and video production, find a place in commercial porn. Nevertheless, the hard, hairless, and white body with its unmistakable signifiers of masculinity remains the standard, and the deviations are threatening as well as arousing.

Given this volatility, conventional gay porn is a site of crisis not only for conventions of cinematic narrative but also for masculinity. It is fun to see how some gay porn plays with the "action" pretext for looking at male bodies. Using the most minimal signifiers of active, masculine narratives—boot camp, cop stories, etc.—gay porn abandons the story the instant the male body is under specular "arrest," to exploit instead the male body as spectacle. An amusing and surprisingly touching videotape by Robert Blanchon plays on this tension. *Let's Just Kiss and Say Good-Bye* (1995) isolates those micronarratives that set up the sex scenes in gay porn films (a camper meets a park ranger: "Hi. Nice hat." "You want to try it on?") and edits them into a fractured story of hypermasculine intimacy. On the sound track, the song of the title gives these brief meetings a feeling of acute nostalgia.

Until recently, theories about straight cinema that affords a homoerotic look, by Richard Dyer, Steve Neale, and others, tend to rely on a notion of the structuring male gaze from psychoanalytic film theory.[4]

Thus the look, in addition to being male, is still dominating, penetrating. To claim this sort of gaze for women only maintains the phallocentrism around which it is constructed: it's a kind of liberal-feminist gaze. There is still a problem for those who want to look in a different way. To get around this problem—to find a "way in" to the male body, as it were—I want to wrestle once again with the theory that the look in cinema is fundamentally phallic, which in turn is based in a particular model of subjectivity. My chosen method is to begin with the Lacanian doxa and quickly retreat via psychoanalysis's homely stepchild, object relations theory.

A critical Lacanian analysis attempts to posit a nonphallic male subjectivity, a subjectivity that acknowledges its fundamental lack of power.[5] In Kaja Silverman's project, men are just as specular (and as powerless) as women are, and film can help us realize this by literalizing male powerlessness at the same time that it foils the gaze. Hence Silverman champions films in which male, indeed all, characters are de-eroticized and disempowered, for such films would teach us to love and identify with nonideal others.[6] However, something in the psychoanalytic program to reveal the lack at the foundation of male subjectivity makes me uncomfortable. I can't help finding the notion of a sexuality based on detumescence and nonpenetration rather depressing. Videomaker Katherine Hurbis-Cherrier captured this discomfort when she wrote to me, "I have trouble with a desire based on lack, even if it is an equal-opportunity lack."[7] Accepting Silverman's argument, it would seem that there is *no* erotic way to look at the male body, since to make it the object of the gaze is simultaneously to deflate it, castrate it, make it undesirable. According to this view, just as I get the opportunity to look, my object is seized from me!

In Lacanian psychoanalysis, subjectivity is impossible to attain. In psychoanalysis that focuses on the prelinguistic, preoedipal phases, it's just difficult. Working along these lines, Paul Smith introduces an intriguing *scrotal* metaphor of male subjectivity in his essay "Vas."[8] Rather than subtracting the phallus from the equation of the male imaginary, Smith makes it part of a larger "package" that includes the testicles in all their mutable vulnerability. Ejaculation, Smith argues (drawing from Michèle Montrelay), is experienced as a loss of subjecthood. So not only is the erect penis a specific and unusual state of male embodiment, but also the penis is only a relative term in male subjectivity. Men, the scrotum metaphor suggests, carry around a lot of baggage, both desire and anxiety. To this source of male multivalency we may add Gaylyn Studlar's argument that the pleasure of looking is based on the *submissive* pleasure

that an infant has looking at its mother.[9] Spectatorship defined this way is less a matter of aligning oneself with an all-powerful gaze or perish, and more a matter of trying on various viewing positions, not untraumatically but not entirely destructively.

Such psychoanalytic revisions offer ways to think of the male body as open to view, and to think of cinematic looking as one that permits pleasures of domination *and* submission, as well as playing with identity. In gay porn the difference that impels the narrative is often one of power—in myriad, unstable relationships such as hustler/john, black/white, master/protégé. I felt a pang of envy the first time I watched Mike Hoolboom's *Frank's Cock* (1993), when the narrator recounts how, in their first meeting, Frank said, "Are you into fantasies? I do five." "Oh yeah?" "Yeah, rookie-coach, older brother-younger brother, sailor-slut, slave-master, and father-son." That it could be so simple to put on power, and submission, like different outfits! Frank's lover continues, "I picked older brother-younger brother and we've been together ever since"—a sort of tender joke on how to build a successful relationship. For a female viewer to enter such an erotic scene means entering a power relation in some kind of willful, playful way.

Artist Ming-Yuen S. Ma, whom I met while I was working on this essay, asked me to provide a voice-over to his video *Slanted Vision* (1995), describing why I like to look at gay men's images of men. Here is part of it.

> When I look at images of gay men, made for gay men, I can look all I want, I can devour the image, let my eyes move over ass thighs cock nipples, like my eyes are hands or a tongue. I can do whatever I want to this image with my eyes, can fantasize being in that position of domination that would be very hard to do if it were directed to me as a woman.
>
> Looking at gay porn, I borrow a gay man's look at other men, drop in on a man's desiring gaze at another man. Because it's two men, there's a feeling of playfulness I long for between looker and looked at, taking turns looking/being looked, touching and being touched, fucking/being fucked, top/bottom. There's a feeling that they can switch. At the same time the vanquishment of a man, a man giving in to pleasure, to being *done* to, is exciting because it's so rare in hetero images.
>
> I don't want everybody to be disarmed, equal, touchy-feely, always treating each other like full subjects. It's a tedious democracy of looking. It's a bore. What I want is for the power to flow around more. I don't think anything's wrong with dominating ways of looking. But I want to think they're ways of looking that people can trade around, like you trade being

top and bottom. I'm not interested in women objectifying men, to make up for all that history of the other way around. But I do want to see men a little more permeable, subjectable, susceptible.

What I'm implicitly suggesting in this voice-over is a model of spectatorship based on the sexual practice of S/M. Perhaps a rigid division between subject and object underpins the "phallic" gaze. But in an S/M-style erotic look there is a fluidity of movement between these positions. To recognize the contingency of power on position makes it possible to enjoy the privileges of power in a limited way. This includes the privilege of temporary alignment with a controlling, dominating, and objectifying look, with being a spectatorial "top." It also includes the pleasure of giving up to the other's control, experiencing oneself as an object, being a "bottom."

"What distinguishes Eros from perversion is not freedom from fantasies of power and surrender," Jessica Benjamin writes, "for Eros does not purge sexual fantasy—it plays with it. The idea of destruction reminds us that the element of aggression is necessary in erotic life; it is the element of *survival,* the difference the other can make, which distinguishes erotic union, which plays with the fantasy of domination, from real domination."[10] Domination is a necessary part of erotic relations, in other words—and thus so is an "objectifying" gaze. Benjamin's work on intersubjectivity suggests that there can be no erotic relation when there is an *utter* division of subject and object, or in the case of vision, of looker and looked-at. Eroticism depends on a tension between the sense of control and submission on the part of each person, rather than complete domination on one side and complete submission on the other. Similarly, visual eroticism plays with *relations* of looking.

I've chosen a term that describes a bedroom practice, S/M, rather than a psychoanalytic condition, sadomasochism. I define S/M quite specifically as the limited, contractual relation in which two people consent to play out a fantasy relationship of dominance and submission. The arena created, in this ideal definition, is a safe space, at a remove from other patterns of life and of this particular relationship, in which the roles of "subject" and "object" (words that, I acknowledge, are no longer adequate to the situation I am trying to evoke) are acknowledged as roles. An S/M model of spectatorship permits a sort of contingent playing with power.

Theatricality is a central characteristic of S/M. A scene's performative character both requires and permits that the fantasy be built on a fundamental mutual trust. This trust relation is like the intense but transient

relationship of viewer to screen image, where for the duration of the encounter we share a contract of expectations with the film that allows us to fully inhabit the fantasy space it creates.

As play—sex play, or fantasy, or the temporary immersion in the movies—S/M can intervene in the conventional alignments of power and spectatorship. Studlar argues that masochism, by returning the player to a state of polymorphous perversity, "demonstrates the easy exchange of power roles that are rigidly defined within the patriarchal sexual hegemony. In masochism, the power plays of sexuality are made explicitly theatrical and ritualized so that their naturalness is exposed as a construct."[11] To accept an S/M-based spectatorial relation, far from reaffirming cultural power roles of dominance and submission, actually mocks those roles. The masochistic viewer, who is in a position to test out various identities and relations, is again like the participant in S/M scenarios, experimenting within a safe, delimited space. And so, I would argue, is the viewer who assumes a (looking) position of dominance. This is no paradox, for both these positions are possible as role plays within the delimited fantasy space of the cinema.

Equipped with this toybox of ways to look, let us make a few experiments in looking at men on film.

Katherine Hurbis-Cherrier's videotape *You(r) Sex and Other Stuff* (1992) is a rare example of an erotic work that invites a straight female look at a male body, which is eroticized according to certain conventions of pornography. We see shots of a naked male body (but never his face) in different playful settings. While the man reclines in an armchair, little paper balloons gently bombard his genitals from off-camera. While he prepares breakfast, his penis and balls are reflected in a shiny toaster—no doubt an homage to the use of a similar shot in Stan Brakhage's masturbation film *Flesh of Morning* (1956). The man's body is fragmented and overtly fetishized; most of the shots are medium shots of the torso and genitals. Unlike in conventional porn, his penis is rarely shown erect. A voice-over reads a playful ode to the penis of a woman's lover. Calling up Susan Bordo's wish for alternative iconographies of male sexuality,[12] the tape constructs an iconography that is not phallic but *erectile*: a time-lapse science film of unfurling sprouts, the balloons, and the poet's inventive words that celebrate the penis's buoyancy, its retractable quality— "I draw you out like a turtle."

Clearly the fragmentation and objectification of this male body take place within the context of a love relationship, not least because the videomaker credits her spouse at the end of the tape. Nevertheless, the strength

Still from *You(r) Sex and Other Stuff* (1992), by Katherine Hurbis-Cherrier. Courtesy of the artist.

of *You(r) Sex and Other Stuff* is that it makes room for an *unequal* power relation. It overtly turns the tables on conventional sexual representation, putting the male body in the position of object and the female video-maker and viewer in the position of voyeurs. But there is a coyness to this delightful video, which is perhaps inevitable. Watching it, I am keenly aware of the woman behind the camera. The permission that has been granted her by her male subject works against the position of pure voyeurism. Such mutuality is desirable in a world without preexisting configurations of power. Yet given the structures Hurbis-Cherrier must work within—in which it is standard that the male looks and the female is looked at—a viewer who shares Hurbis-Cherrier's aim cannot help feeling that the positions of voyeur and looked-upon in *You(r) Sex* could too easily switch. In *You(r) Sex and Other Stuff*, a female viewer can try out looking in an objectifying way at a man, though the heterosexual exchange implicit in the video means that she still may feel subject to that look herself.

Let us take a look at Curt McDowell's 1972 *Ronnie*, a film in which power relations are at least as complicated as they are in *You(r) Sex and Other Stuff*. Like other vérité films McDowell made about the Bay Area

gay scene in the '70s, as well as some Warhol/Morrissey productions, *Ronnie* explores and exploits the filmmaker's relationship of power to the hustlers he picks up. They are usually poor and black, though Ronnie is white. The short film consists of McDowell's shots of the young man in the filmmaker's apartment, drinking a beer, talking into a microphone, gradually disrobing, submitting to the scrutiny of McDowell's camera, briefly letting the filmmaker fellate him, and jerking off. On the sound track Ronnie describes the afternoon's events and frankly celebrates himself.

A mimic by trade, Ronnie is open to the projections of anyone who buys his time. His disavowal of being gay is part of what makes him available to a variety of fantasies. He tells us, for example, that after the filmmaker "did something" to him, even though it is something he "doesn't do," "I hit my climax. So imagine if I was with a pussy, a nice warm juicy pussy." Even Ronnie's hetero protestations are duplicitous, as in this part of the monologue, which is accompanied by increasingly intimate shots of his body. His excuses for letting the stranger give him a blow job are about performance—you have to act for the camera; women ("cunts") do this all the time. Ronnie both disavows and embraces a comparison to women, particularly to female prostitutes. His specific comparison of himself to a woman makes a viewer keenly aware that it is easiest for a

Frame enlargement from *Ronnie* (1972), by Curt McDowell.

man to place himself as the object of erotic looking if he borrows a feminine position. But Ronnie's own longing to be other than he is makes his mimicry all the more complicated. "I wish I was black," he says. "It's not my favorite color—I'm sorry, sisters and brothers, blue is"—but, he tells us, he's writing a book on relations between black and white people. In this parodic collage of stud, "cunt," wannabe black, and other self-images, Ronnie constitutes himself as a spectacle.

The tension between voice-over and image in *Ronnie,* and between the film's production and viewing contexts, permits a wide and even conflicting variety of looks and desires in relation to the film. The context of production was doubtless exploitative, though the degree to which it was partly depends on the viewer's view of prostitution. The film's gesture of "giving voice" to the hustler can be understood as either generous or cruelly mocking. Thus identification with the look of the filmmaker is already charged with an uneasy awareness of power. While Ronnie makes his contradictory spiel, the film opens his image to a number of ways of looking that both corroborate and undermine his words, making the viewing positions for this film even more multivalent. Even the hustler's tape-recorded address to posterity sets up a means for identification that ironically contrasts with the film's visual information: "I have to go now,

Frame enlargement from *Ronnie.*

so I just want to say I'm a wonderful person, and all youse blondes, just look me up in California, I'll be waiting for you, it's up to you, I'm not forcing you." This appeal to straight, white women, over a cum shot, his spurting penis towering from a low camera angle, is right out of regular porn. Ronnie's last words to his audience are, "A word to the wise: As they say, love the one you're with."

The ambiguity with which Ronnie presents himself—and McDowell, through editing, presents him—makes possible a number of different fantasy scenarios for viewers. We're invited to be with him to the extent that we can accommodate him to our own desires. It is easy for me, a straight woman, to take advantage of this invitation and drop in on McDowell's intimate looks upon Ronnie's body. They include a near-portrait of Ronnie sitting on the floor smoking, talking easily; fetishizing close-ups of his full lips, his dick and balls, his shapely butt, his hands; a rather poetic image with a sheer curtain billowing around him; a survey of his posed, prone body that renders Ronnie an inviting landscape. My pleasure in looking is partly in taking advantage of the filmmaker's privileged view, partly in seeing Ronnie differently through his eyes. I may be an interloper in McDowell's look at the hustler's body, but a place has been created in which I can both borrow that look and use it to see different things, including Ronnie's elaborately disguised enjoyment at being the object of all this attention.

The first two works I have described involve desiring looks upon men that coincided with the look of the cinematographer. Now I offer a look at erotic male nudity that does not explicitly imply any outside viewer. This is a section of Greta Snider's compilation film *Shred of Sex* (1991). To make this film Snider invited her many housemates to enact their fantasies for the camera and hand-processed and compiled the results. Shown at a rent party, *Shred of Sex* later achieved a certain cult status on the independent film circuit. This fragment, which is sometimes singled out for exhibition separately from the rest of the film, is a narcissistic, autoerotic display. Its subject, Deke Nihilson, simply left Snider's camera running while he performed. Nihilson is a muscular young man, naked but for his high-tops, with a Mohawk haircut and, at the time of filming, an impressive erection. Lying on his skateboard, he masturbates (a little awkwardly) until he comes.[13] This hard-core image is aestheticized by the solarizing effect of hand-processing, which makes the young punk rocker's body gleam and flow like mercury. Snider's processing plays up his exotic looks and his muscularity, while also involving the viewer in the erotic tactility of the film's surface.

Frame enlargement from *Shred of Sex* (1991), by Greta Snider. Courtesy of the artist.

Because he is performing alone for a static camera, the way we look at Nihilson is ambiguous. Since we are so far removed from the scene, we enjoy him from a space of extreme voyeurism, as though through a one-way mirror. Yet also we share his own adoring gaze: Nihilson is a self-styled specular male, a punk-rock Garbo, whose beauty is a function of his narcissistic gaze upon himself. Since this film was made in collaboration with Snider, however, we participate in her eroticization of his image, similarly to Hurbis-Cherrier's treatment of her subject. Since *Shred of Sex* was made through her subject's autoerotic look, Snider has a degree of permission to look at him objectifyingly.

Karim Aïnouz's *Paixão Nacional* (1994) is a brief meditation on the many inequalities that underlie erotic fascination. Unlike the other films I have discussed, this film invites a viewer into a fictional narrative. The entire film is shot as though from the point of view of a northern tourist in Brazil, organized around his gaze upon the landscape and upon the Brazilian young man who embodies his "national passion." The tourist himself is never pictured. While the camera sweeps verdant landscapes, the tourist's voice-over describes how he feels the sensuality of this country seeping into him. "His" camera greedily follows the brown-skinned, lightly clad youth, running on the beach, who laughingly eludes it. Finally

he reclines and submits to an intimate pan of his body, the camera nervously moving over his genitals. The overdetermined relations of north and south, rich and poor, john and hustler, tourist and native redouble themselves in these images and the fantasies on the sound track.

The youth's voice, which tells a very different story of the seduction, comes to us only later, in a voice-over over black leader. His words suggest that, throughout these scenes in which he gambols for the camera, his thoughts are elsewhere, with his sister, his friends, his desire to get out of the country. The disparity becomes more violent when the words reveal that the boy has smuggled himself into the cargo of a plane to the United States. Indeed they are his last words. He grows cold; he becomes afraid. We have to assume that he dies in this desperate attempt to trace the route that so easily brought the tourist to Brazil.

In *Paixão Nacional* the power differential between tourist and Brazilian is uncomfortably acute. The boy's objectification is not limited to a few shots in the surf but caught up in the relation between poor and wealthy, south and north, the one who lives in the daily reality of home and the one who abides in the temporary fantasy of travel. Although it is an encounter between hustler and camera-wielding john, as in *Ronnie,* the contractual character of the exchange is less certain, given the international and intercultural dimensions of the relation between tourist and local. One senses that while the exchange is fantasy for the tourist, whose images comprise the film's visuals, it is in deadly earnest for the Brazilian boy. The viewer is practically forced to inhabit the tourist's vision, since he is never seen and all the images of young man and landscape seem to originate from his camera. The individuality of the tourist, and of the viewer insofar as she takes his position, is annihilated in the mastering sweep of the camera across the landscape. Meanwhile the presence of the young Brazilian's subjectivity, expressed only in subtitled Portuguese voice-over, keeps a viewer from forgetting or naturalizing this power relation. A female viewer searching this work for a way to look at a male body is forced to confront the mutually destructive implications of a look of mastery, in a way that probably overtakes the pleasure of looking.

Thus the position of voyeur brings with it a sense that the boundaries on which the S/M exchange depends have been irrevocably breached. The film suggests that some parameters make the power relation between viewer and viewed especially fraught. Power differentials that obtain outside the S/M relationship, such as class and ethnicity, test the participants' ability to play with their mutual boundaries.

Ming-Yuen S. Ma's *Slanted Vision* (1996) takes an equally complex ap-

proach to the gay male look across nations and races, although the tone is not elegiac, as in *Paixão,* so much as manic. This tape is concerned with the image of Asian men in the North American homoerotic imaginary, and the use of porn among gay Asian Americans. Ma points out that Asian men, if they are visible in gay porn at all, are invariably positioned as "bottoms" for studly white actors.[14] Ma's intervention is double: First he slams the way homoerotic representations stereotype Asian men as gentle and receptive. In one sequence, set in a bar, a variety of people address pick-up lines to the camera as though to an Asian man, showing the easy slippage between orientalism, objectification, and domination. "You're beautiful," one man says. "Turn around . . . and over. . . . " In reverse shots, the silent recipient, who is wearing a sort of Madame Butterfly drag, gradually removes his outfit in a nonverbal rebuttal. Later, interviews with a number of Asian diaspora men critique stereotyping by highlighting the range of sexual practices and attitudes among them.

The second aspect of *Slanted Vision*'s intervention is to claim the *pleasure* of being a bottom. One Asian porn actor explains that "it made me feel desirable to be objectified"—he finds pleasure in a renunciative position, even if it is supposed to be masochistic. Another interviewee tells how he enjoyed a sexual encounter in which he was humiliated, because the other man was giving him so much *attention.* To introduce this theme is a bold move, for Ma faces criticism for reaffirming the racist stereotype of Asian passivity. Yet he makes a compelling case that the masochistic, or passive, or feminine position can be a site of pleasure.

The sexually explicit scenes in this tape reframe commercial gay porn to emphasize the question of who owns the look. One complex sequence combines two views of the same scene of two Asian men making love, played by Ma and Napoleon Lustre. The first view is composed entirely of medium and long shots with few edits. It avoids the fragmentation of bodies, a little like the "natural," "unobjectifying" porn films made for female and "couples" audiences by companies like Femme Productions (which I find supremely unsatisfying and sometimes offensive). Its sound track breaks the narrative illusion, though, because it includes the live sound from the video shoot. (Additional sound tracks further complicate the scene, including a prayerlike poem by Napoleon about his mother taking him to Lourdes to cure his AIDS.) The other view, a series of aestheticized images shot so close to the body that particular anatomy is unrecognizable, comes from cameras the lovers are using. Its eroticism is quite different, a haptic intimacy between eye and skin. Music plays on the sound track. The effect of these two sequences is to let the viewer

Still from *Slanted Vision* (1996), by Ming-Yuen S. Ma. Courtesy of the artist.

experience two very different forms of erotic looking, one narrative and one embodied. Halfway through the sequence, the sound tracks for the two sets of images switch. The effect is astonishing: initially, the intrusion of the other sound track deconstructs the naturalness of each scene. Yet ultimately it compounds its erotic effect by playing with the viewer's awareness of the different levels at which eroticism can work.

Ma organizes one erotic scene specifically around a female gaze at a male body. In this scene, a female hand guides the camera's slow pan of a male body. The hand holds a three-inch monitor on which plays a conventional gay porn tape of an Asian man being fucked by a white man, so that, as in the sequence just described, two different modes of erotic viewing, effectively haptic and optical, are presented in the same scene. Over this scene, my voice, as quoted earlier, speaks of my desire to look at men the way gay men do.

In these works, relations of looking are constructed like S/M relations. Domination and submission occur within the consensual and limited space of the viewing situation. A viewer who in other situations might be loath to assume a dominating role is free to try on power. A viewer who associates pleasure with power may be invited to try the pleasure of sub-

mission. In either case, erotic looking takes place within a specific context that relates eroticism to specific relations of power.

To close, I'd like to suggest that independent, experimental porn films of the type I have been describing create a sort of coalition audience for erotic identification. The negotiation that characterizes the S/M looking relation is particularly characteristic of the spectator's relation to independent films. The production context reinforces a particular way of relating to the image. A large-scale commercial film, where the situation of production is effaced as much as possible and was impersonal to begin with, usually invites what Christian Metz terms primary identification: an identification with the apparatus itself, and thus, indeed, identification with an abstract and objectifying gaze. In independent films, with their smaller crews and multifunctional director, the relation of power in viewing is closely tied to a relation among the individuals involved in the production. In *Ronnie* and *You(r) Sex,* as well as works by artists such as Tom Chomont, Thomas Harris, Mike Hoolboom, and Bruce LaBruce, the filmmaker performs as cinematographer in what is more or less a documentary encounter; all the works I have mentioned represent, at some level, the relation between filmmaker and imaged subject. A viewer's identification with the look of the camera is more volatile, because it is more likely to be closely aligned with the look of the filmmaker, partly because many filmmakers are both director and cinematographer, but also because the entire project is more hands-on and more intimate than commercial cinema.

Low-budget porn films often attempt to imitate the anonymity and authority of large productions. However, porn, by virtue of its documentary kernel (attested by a concern with the cum shot, the veracity of female orgasm, etc.), also calls on a relation of identification that is different from the fantasy relations at work in fiction cinema, such as the Sternberg films on which Studlar based her study. Identification in porn is not simply an immersion in fantasy but also a relation to the dynamics at work between filmmaker (director, cinematographer) and actor/subject. Thus the power relations at work in these films are not simply those of the narrative but are structural.

In the independent, quasi-pornographic films I discussed above, these qualities combine to complicate the spectatorial process. Curt McDowell's relation to Ronnie as pickup, patron, and (briefly) lover, as well as framer, offers a complex position with which the viewer can make some sort of alliance. She can occupy the intimate and invasive look that McDowell extends toward his subject, and also identify with Ronnie as someone who,

despite his elaborate disavowal, enjoys being looked upon. In *You(r) Sex and Other Stuff* the viewer takes a position in relation to Katherine Hurbis-Cherrier's playful objectification of her husband's body. Snider's role as impetus, accomplice, bathtub hand-processor, and (in other scenes) actor in *Shred of Sex* invites the viewer to take a position in relation to her while gazing upon Deke Nihilson's gleaming body. Also, when we learn that *Shred of Sex* was made to raise the rent for the group of housemates who act in the film, the scene of the masturbating punk rocker takes on an unexpectedly public-spirited tone! *Slanted Vision* makes it quite clear that the viewer of a porn scene is implicated in its production, through Ma's self-conscious use of the apparatus. Only *Paixão Nacional* puts the viewer some distance from the position of filmmaker Aïnouz: she is uncomfortably aware of her alliance with the invisible tourist's dominating look and loaded wallet, but because this is fiction, she need not trace them back to Aïnouz's camera. Because these films foreground the powerful position of the filmmaker, they make an issue of the elastic, sometimes adversarial relation between filmmaker and subject. Rather than disavow power, these films are produced out of the very process of struggle, negotiation, or pleasurable play.

Like S/M, identification is a contingent, experimental process. The contractual character of the viewing situation I have described implies that a viewer can make a pact with *many* viewing situations, in which one agrees, under limited circumstances, to occupy a certain position. This describes not only the process of cross-identification but the shifting, volatile relation defined by a viewer's membership in a mixed audience. In an audience that is a coalition of different interests, the contract exists not just between the viewing individual and the screen space but among a group. Film festivals are the most exciting examples of such audiences, but a collection of work can also implicitly organize its audience. *Ronnie,* for example, produced by McDowell for the San Francisco gay and underground film scene of the early 1970s, was rereleased in 1992 as part of *Flesh Histories,* a two-hour program compiled by filmmaker Tom Kalin and distributed by Drift Distribution until that company's unfortunate demise. The re-release opens *Ronnie* to new erotic engagements. The entire program of "Flesh Histories" contained about thirty works, ranging from abstract/activist to feminist/punk, that appeal to all sorts of sexual identification. They have in common the interest in redefining desire, and it is with that awareness that the viewer sees *Ronnie.* The "address" of these works is disputable because of the way they abut and seep into each other, changing each other's meanings. Whether or not one knows the

sexual orientation of the makers and characters, they all come out queer. Similarly, the wonderful thing about *Shred of Sex,* of which Deke Nihilson's self-imaging forms a part, is that it is a compilation film representing a dazzling range of sexual preferences and practices. Nihilson shares the celluloid with same-sex and mixed-sex individuals, pairs and groups whose activities range from tender to violent, from partner switching to golden showers.

This mix of identifications and addresses characterizes compilation works such as *Shred of Sex,* "Flesh Histories," and Shu Lea Cheang's "Those Fluttering Objects of Desire" (1991), a collection of twenty works by women involved in interracial relationships. It is also similar to the mixed screenings at lesbian and gay film festivals, such as the late-night "Cruiserama"-type program at the New York Lesbian and Gay Film Festival. As one might expect, audiences at these mixed screenings are extremely volatile. Sometimes there is an exhilarated sense of cumulative eroticism, where, for example, gay male viewers experience the transformation of their codes by lesbian style, lesbians get off on the casual sexual encounters more common among gay men, leather aficionados enjoy the simpler pleasures of vanilla sex, able-bodied people get turned on to the erotic lives of disabled people, and all viewers have the opportunity to experience the eroticism of a sexuality different from their own. At other times, audience members become anxious during the minutes when their own sexuality is not interpellated on the screen, and make catcalls and other protests until images that "speak to" them return to the screen. This is most likely to occur in a context where gay and lesbian representations—especially, I must say, the latter—are relatively rare and embattled, and any lapse in these representations may be perceived as a threat.[15]

All these works and events appeal sequentially to a range of sexual identifications, such that a viewer, rather than wait for her particular practice to appear onscreen, is invited to negotiate a desiring relation to a number of other practices. It is interesting to learn where particular viewers of these compilation screenings draw lines with regard to what turns them on, what they find mildly interesting, and what repels them. The mutual participation of a group of people—an audience—in these fantasy situations enhances the experience of forming identifications *across* identities. Douglas Crimp points out that identity "is always a *relation,* never simply a positivity."[16] The "identification across identities" of which Crimp writes means that identities are never static but always relational, capable of creating links among different groups that *transform*

those groups. At best, it is not only the single work but also the context of screening that invites viewers to experience multiple erotic possibilities and be drawn into the worlds that make them possible.

An S/M model of looking accounts for the specificity of looks, for their contextuality and, most important, the ability to inhabit erotic and political relations that change with the situation. Love the one you're with: look in a way that is contingently "top," contingently "bottom," and contextually erotic.[17]

6. Loving a Disappearing Image

Many recent experimental films and videos, flouting the maximization of the visible that usually characterizes their media, are presenting a diminished visibility: their images are, quite simply, hard to see. In some cases this diminished visibility is a reflection on the deterioration that occurs when film and videotape age. Interestingly, a number of these same works also deal with the loss of coherence of the human body, as with AIDS and other diseases. The following essay continues my research into haptic, or tactile, visuality, here to ask what are the consequences for dying images and for images of death, when the locus of identification and subjectivity is shifted from the human figure to an image dispersed across the surface of the screen.

In defining a look tied to new ways of experiencing death, these hard-to-see works appeal to a form of subjectivity that is dispersed in terms of ego/identity and yet embodied physically. What this look enacts is something like a perpetual mourning, something like melancholia in its refusal to have done with death. Ultimately, it cannot be described by these Freudian terms. These images appeal to a look that does not recoil from death but acknowledges death as part of our being. Faded films, decaying videotapes, projected videos that flaunt their tenuous connection to the reality they index: all appeal to a look of love and loss.

There are many ways that the visual coherence and plenitude of the image can be denied to the viewer. Among these are the ways films and

tapes physically break down, so that to watch a film or video is to witness its slow death. Another is the way significance relies not on the viewer's ability to identify signs, but on a dispersion of the viewer's look across the surface of the image. The works I will discuss reconfigure identification so that it is not with a coherent subject but with nonhuman or inanimate objects, and with the body of the image itself. They compel identification with a process, which is material but nonhuman. Amplifying the melancholy quality of the works I have chosen to discuss, many of their archival images are erotic. These works are Phil Solomon's *Twilight Psalm II: Walking Distance* (1999), *Frank's Cock* (1993) and *Letters from Home* (1996) by Mike Hoolboom; "The Hundred Videos" (1989–95) and *Everybody Loves Nothing* (1997) by Steve Reinke; *De Profundis* (1996) by Lawrence Brose; *The Color of Love* (1994) by Peggy Ahwesh; *XCXHXEXRXRXIXEXSX*, a performance by Ken Jacobs, based on a film recovered in 1980; and the images in Tom Waugh's 1996 book, *Hard to Imagine*.

Cinema's Dying Body

I began this research contemplating the conundrum of having a body that is not one's own, a betraying, disintegrating body. A body that slowly or quickly becomes other, at least insofar as one's identity is premised on wholeness. This happens with all of us as we age, and it happens acceleratedly for people who have AIDS or other diseases that invade and redefine their bodies. In *Letters from Home,* Mike Hoolboom expresses the paradox of having a body that is yours but not, when a character relates a dream that he was taken to a room where a handful of crystals was spilled on a table, each of which, he realized, represented an aspect of his personality. "There was my love of the screwdriver and the universal wrench; the break with my sister; my weakness for men in hairpieces." The man displaying these crystals to him becomes a doctor and tells him he is HIV-positive. "And sure enough, he pointed to an off-color stone that was slowly wearing down everything around it."

To have an aging body, as we all do, raises the question of why we are compelled to identify with images of wholeness, as psychoanalytic film theory would have it; the question of whether this still is, or indeed was ever, the case; and the question of what it would be like to identify with an image that is disintegrating. Following Vivian Sobchack, I suggest that identification is a bodily relationship with the screen;[1] thus when we witness a disappearing image we may respond with a sense of our own disappearance. Cinema disappears as we watch, and indeed as we do not watch, slowly deteriorating in its cans and demagnetizing in its cases.[2] Film and

video, due to their physical nature, disintegrate in front of our eyes: a condition that archivists and teachers are in a special position to mourn. When I open the can of a color film that has not been viewed in twenty years, the thrill of rediscovering these patiently waiting images is tempered by their sad condition, once-differentiated hues now a uniformly muddy pinkish brown. When I watch an analog tape from the early days of video experimentation, the image appears to have lifted off in strips. The less important the film or tape (and by extension, its potential audience) was considered, the less likely that it will have been archived with care, and thus the more likely that the rediscovery of the object will be such a bittersweet pleasure. These expected and unexpected disasters remind us that our mechanically reproduced media are indeed unique.

When I began to teach film studies I realized that the students will never *really see* a film in class: it's always a film that's half-disappeared, or a projected video that just teases us, with its stripes of pastel color, that there might be an image in there somewhere, that there once was an indexical relationship to real things, real bodies. One response to this situation can be to see the actual, physical film or video we see as a mnemonic for the ideal film, the Platonic film, once seen in 35mm in a good theater. This seems to be Seth Feldman's argument in "What Was Cinema?", in which he suggests melancholically that the institution of "cinema" has ceased to exist, given that most film-viewing experiences occur through the medium of video, at home or projected, and will increasingly take place through digital media.[3] A notion of the ideal film, which our viewing experiences can only approximate, is also the basis of Paolo Cherchi Usai's thoughtful argument that cinema history itself would not be possible without the disappearance of its object.

> Cinema history is born of an absence. Since, if all moving images were present in their initial state, there would be no history of cinema, history can only explain why these images had disappeared, and their hypothetical value in the cultural memory of an epoch; it is their manner of disappearance that induces a periodization.[4]

Cherchi Usai suggests that images take on history as a function of loss: if not of their physical materiality, then of their initial conditions of viewing. Cinema history, then, is a melancholic act from the start, for even in the presence of the fullness of the image we are aware that it is disappearing before our eyes. The cinematic object is gradually transformed from what the image represents to the complex of histories of its

destruction. The goal of cinema history is to account for its disappearance and its transformation into another object.[5]

A response to the partial and decayed images that pass themselves off for *Mädchen in Uniform* or an early Ant Farm experiment on our classroom screens can be to accept that *this* film or tape is the one we have, and to deal with its own peculiarities, the way it lays a map of the indignities it has suffered over the represented image. With disappearance, the work accumulates aura. Mechanically reproduced images supposedly lack aura, but as images decay they become unique again: every unhappy film is unhappy after its own fashion. The scratches and unintentional jump cuts on our print of X film are ours alone, and even video decays individually, in response to temperature, humidity, and the idiosyncrasies of playback machines. Of course, independent, experimental, and rare films and videos are already auratic, as anyone knows who has tried to replace lost home movies. Works that are not widely distributed are more like bodies that we protect assiduously than like simulacra.

Many film- and videomakers intentionally work this process of dissolution into their productions, incorporating the halolike colors of deteriorating nitrate, the blurring of multigenerational analog images, or the cruel lines of static on erased video.[6] Examples include Barbara Hammer's *Nitrate Kisses* (1992), which searches eroding footage for traces of lesbian and gay histories; Atom Egoyan's films, many of which play with erased or barely visible video as an analogue for memory; and many art videos that use the decay of the image to refer to memory loss. All these works borrow the aura of the disappearing images on which they meditate. A very poignant example is Ming-Yuen S. Ma's short video *Sniff* (1996), where a man crawls on his bed, inhaling for the smell trace of his departed lovers—perhaps gone forever. As the abandoned man moves with increasing desperation, the image breaks down, losing its identity the way smell particles disperse, taking memory away with them.

These works play on an antagonism between the figurative image and the medium that supports it. Some suggest that if we love the figure, we must hate the medium, because in its mortality it will betray the figure. Peter Delpeut's *Lyrical Nitrate* (1990) works this antagonism by seducing the viewer with fragments of ever-lovelier movies in the volatile medium of nitrate film. We become enchanted by the long-ago stories of trapped miners, shipwrecked lovers, and a cavorting Adam and Eve, cliffhangers all; then the film forces us to witness them being swallowed up by bubbling, crystallizing emulsion. *Lyrical Nitrate* is beautiful, but I find it sadistic.

Frame enlargement from *Nitrate Kisses* (1992), by Barbara Hammer. Courtesy of Frameline.

The life of the emulsion itself, and its embodiment of memory, is the beginning point for much of Phil Solomon's work, including *The Exquisite Hour* (1994) and *The Snowman* (1995). To make the stunning *Twilight Psalm II: Walking Distance* (1999), Solomon chemically treated fragments of film to make the mortal body of the support visible through the figurative bodies in the image. Solomon accelerates film's process of decay, in the manner of marking one's forehead with ashes to focus the act of mourning (or standing under the shower to make the tears come). Human figures, when they are discernible at all, appear to be stumbling through tar, snowstorms, or sandstorms. Sometimes we can make out a tightrope walker, a horse and carriage, the oval of a face in close-up; other times our only hope of a figure is the merest line of light. Low sounds of howling wind and crashing ocean emphasize the thickness of the space they traverse. At a screening of the film, a friend recognized a shot of Harry Houdini struggling to extricate himself from chains while underwater, a more than adequate metaphor for the feeling that images are suffocating in the emulsion.

As in *Lyrical Nitrate*, the people whose presence is marked on the emulsion seem to be struggling not only through viscous space but also through time—the time that has passed between their recording and our viewing of them. Yet watching *Walking Distance* I sense that, through its

Frame enlargement from *Walking Distance* (1999), by Phil Solomon. Courtesy of the artist.

grieving process, some sort of peace has been made between figure and surface—the figurative image and the surface that has now become its own figure. A transformation has taken place, where one kind of life, the human life that lends itself to stories, metamorphoses into an uncanny, mineral life. And the emulsion seems to be alive, the way a sand dune carved by wind is alive. Solomon told me that he was seriously ill when he made the film. "I was thinking of the emulsion having a consciousness welling up like memory," he said.[7] The emulsion itself remembers the passage of time, when the image attempts to live in an eternal present. Loving a disappearing image means finding a way to allow the figure to pass while embracing the tracks of its presence, in the physical fragility of the medium.

To love a disappearing image one must trust that the image is real in the first place; that is, that it establishes an indexical link between the long-ago objects recorded by a camera and the present-day spectator. We mourn the passing of the young lovers/actors because we are sure that they existed: the photograph is a sort of umbilical cord between the thing photographed *then* and our gaze *now*.[8] The real mourning occurs when that umbilical cord is severed. Film historian Tom Waugh encountered insurmountable problems when he attempted to reproduce archival

gay pornography.[9] After his manuscript went through the hands of several editors who refused to publish the explicit images, Columbia University Press finally agreed—on the condition that, in addition to the removal of some images, the faces in nine of the old photographs be altered to avoid potential lawsuits. Bitterly, Waugh describes how he had to hire a computer "whiz kid" to digitally graft new faces onto the archival porn images, and the travesties that resulted. What was lovable about these old pornographic images was their indexical witness of particular individuals, which is destroyed by alteration. In effect, perceiving the images to be insufficiently dead, Waugh's lawyers devised a way to murder them.

Disappearance and Identification

How does one identify with dying images? Recall that cinematic identification was first defined by Christian Metz as identification with a character (secondary), or with the look of the apparatus itself (primary);[10] more recently, secondary identification came to be redefined as an oscillation among many subject positions. Secondary identification remains understood as identification with a person, or a personified being. In contrast, I suggest that secondary identification may be with an inanimate thing or things; and that primary identification itself may be an identification with dispersion, with loss of unified selfhood.

I believe I gained this view of primary identification by attending many screenings in artist-run centers, dank and ill-heated, with projectors rented from the public library. In these circumstances identification with the apparatus is decidedly *not* a position of power. The miserable viewing conditions at many institutes of higher learning also instill this weakened identificatory position.

Primary identification can be an identification across differences, as we have come to understand secondary identification to be. As such it need not attempt to make good the viewer's partial position; instead it invites the viewer to *take part* in a dispersed subjectivity. Identifying with dispersion might seem to resemble the self-destructive process of heteropathic identification; that is, identifying with one who is different even though it may threaten the self.[11] However, where my position fundamentally diverges from the Lacanian psychoanalytic basis of heteropathic identification is that I question whether identification with difference necessarily annihilates the self. Lacanian psychoanalysis posits that identity is built on the dread of alterity. I assert, however, that the confrontation with the other need not destroy the self.

Frank's Cock by Mike Hoolboom is one work that invites the viewer to

relate to an image precisely in its dissolution. The film does this both by having a structure in which each part loses its separate coherence by being juxtaposed with the others, and by using images that are themselves hard to see. The screen is divided into four parts: first, in the upper right quadrant, a man comes on (actor Callum Rennie), telling the story of Frank, his lover, who is dying; then, in the upper left quadrant, shots of wiggling microorganisms appear (they connote viruses, but to me they also look like the Brownian motion of people moving around in a nightclub); then, in the lower right, Madonna's *Sex* video comes on; and in the lower left emerges a grainy dub of gay pornography.

Although the story of Frank's lover commands the space of the film, it shifts from being a confessional AIDS movie where we identify, perhaps condescendingly, with the speaker, to one that divides our attention across four interior movies, each of which disperses the others. Divided this way, the image refuses a single narrative that would comprehend the loss. The film also asks us to celebrate fucking, and the mingling of microorganisms, as we listen to the lover's unapologetic tale. It provides a variety of images of sex: the swimming one-celled creatures compete for attention with the choreographed forms of Madonna and her lovers, begging the question, with which do you identify more? Critics celebrat-

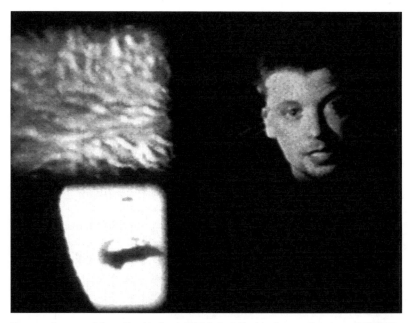

Frame enlargement from *Frank's Cock* (1994), by Mike Hoolboom. Courtesy of CFMDC.

ed the film because it made the figure of a gay man with AIDS "universal," but I would suggest that this means not simply open to universal identification. Instead (or as well), the film moves beyond identification to an acknowledgment of dispersion.

In *Letters from Home,* Hoolboom comes out as a person with AIDS, but this concretization is only partial, for his first-person testimony is spoken by many other people. Hoolboom becomes one actor among others speaking the words of a person with AIDS, at the same time that all the people in the film become people with AIDS. I believe this is a more appropriate way to deal with AIDS than the heroic narrative centering on an individual's suffering.[12] The lack of closure in the "fight against AIDS" becomes a lack of closure for the viewer.

In *Letters from Home,* not only is the identity of a person with AIDS dispersed across many subjects with whom one might identify. Also, meaning is dispersed throughout the film onto a great variety of archival images and sounds: Hoolboom as a teenager, wiping his face with his shirt as he walks toward the camera; a 1920s film of people trying in vain to unstick a car from the mud; the spectacular crash of a biplane from the period, accompanied by Billie Holiday's "You've Changed." And finally, the look itself becomes dispersed, in the way many of the images themselves break down or lose legibility. The battered, sepia-toned film of a stumbling bride suggests an unrecoverable past time; the face of the last speaker (Callum Rennie again, reading Mike's words) is half-obscured by a flash of light; the faded clips of old home movies seem to have been watched one too many times.

Old pornograpic images are a logical place to look for lost love. Filmmakers Peggy Ahwesh and Ken Jacobs turn their cherishing techniques on these profane images, using optical printing and frame-by-frame projection to draw out their nuances, searching for real gestures of intimacy in between the choreographed performances. I discuss Jacobs's film/performance *XCXHXEXRXRXIXEXSX* in detail elsewhere in this volume. Here let me note Jacobs's technique of projecting the reprinted images through an apparatus called the Nervous System one frame at a time, manipulating the projector to create a sense of movement and changing light within each single frame. The film in question is a ninety-second hard-core porno from the 1920s, called *Cherries.* In Jacobs's projection, the images of two women and a man cavorting and fucking in an orchard are in part rendered abstract, a Sternbergian play of pattern and light. But the time Jacobs creates for contemplation also allows the viewer to reflect on this long-ago performance, and to imaginatively create new

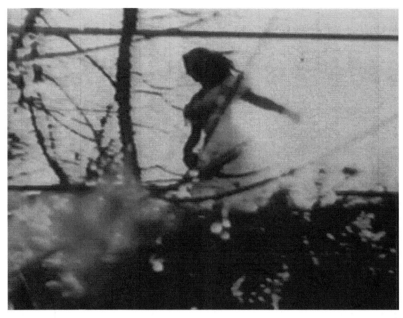

Frame enlargement from *Letters from Home* (1996), by Mike Hoolboom. Courtesy of
the artist.

narratives, sexual or not, from the pornographic set piece. In this Jacobs
shifts the viewer's engagement with the images from a prescriptive, "ac-
tion" mode to a contemplative one.

The Color of Love began when experimental filmmaker Peggy Ahwesh
found a Super-8 amateur porn film in the trash. In it two women straddle
the disturbingly passive and bloodstained body of a man, tease his flaccid
penis with a knife, and then make love to each other in straight-porn
"lesbian" style, the camera moving in on their genitals. The film had de-
teriorated badly, its emulsion bubbling around the remains of the image,
rendered by the artist's hand-processing in garden-party hues of rose,
turquoise, and green. Ahwesh tenderly exploits the effects of this dete-
rioration, slowing and stopping the film at points and accompanying it
with a lugubrious tango. In slow motion we may watch as one of the
women lifts her head in real or simulated pleasure as the other woman
kisses her breasts, while the deteriorated emulsion curtains and reveals
them. Given the mechanical quality of the performance, the man's flaccid
penis, and the disengorged labia of the women, it seems that the real
erotic activity in *The Color of Love* is not between the actors but in the
game with death taking place on the surface of the film. Choreographed

by the tango, the film's emulsion flowers and evaporates, giving itself up to bliss and to death.

Lawrence Brose, like Solomon, Hoolboom, and Ahwesh, has for years used hand-processing to eke out what is precious in the image. His recent work, *De Profundis* (1996), uses Oscar Wilde's aphorisms and his searing letter from prison, emphatically performed by Agnes de Garron, as a basis to explore the figure of the homosexual outlaw. These texts are laid over a vast array of imagery, including vintage gay pornography and contemporary Radical Faerie gatherings. Step-printed, the archival porn films are presented a couple of frames at a time, so that a contemporary viewer can contemplate the gestures and expressions of, for example, a man in a sailor cap who teasingly lowers his pants and then, grinning, pulls them up again as he walks toward the camera. A man swimming naked in one recurring image appears, when printed in negative, to be running in quicksand—a counterpart to the despair of Wilde's letter to the lover who betrayed him. Brose's hand- and chemical processing mimics and exploits the effects of the vintage films' deterioration, and as in Ahwesh's film, the result is sublime. Explosive colors and texture glorify the long-ago illicit love scenes, with a defiance that matches Wilde's words. Indeed Wilde's advocacy of perversion as an ethics and an aesthetics seems to influence the film's ethos of contamination: figures bleed

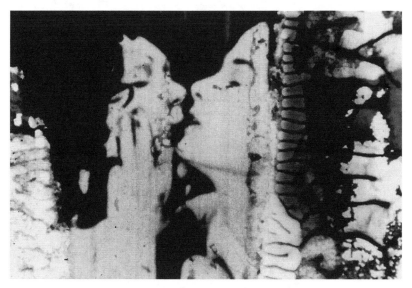

Frame enlargement from *The Color of Love* (1994), by Peggy Ahwesh. Courtesy of the artist.

Frame enlargement from *The Color of Love*. Courtesy of the artist.

into the surface patina as a final voice-over whispers, "It is so easy to con-
vert others—that is why they find us dangerous." *De Profundis* is about
coming through unbearable anguish and surviving, and the gloriously
wounded images metaphorize Wilde's descent into and return from de-
spair: "While for the first year of my imprisonment I did nothing else . . .
but wring my hands in despair and say, 'What an ending—what an ap-
palling ending.' Now I try to say to myself, and sometimes, when I am
not torturing myself, do really say, 'What a beginning—what a marvelous
beginning.'"

Melancholia

In revaluing melancholia, I would like to argue that the mourning sub-
ject need not rediscover his/her coherence at the cost of ceasing to love
the lost loved one, which is how Freud describes "successful" mourning.
Rather, I suggest, mourning can involve the *loss* of self and its reconfigu-
ration and redistribution. Freud wrote in "Mourning and Melancholia,"

> Each single one of the memories and situations of expectancy which
> demonstrate the libido's attachment to the lost object is met by the verdict
> of reality that the object no longer exists; and the ego, confronted as it
> were with the question whether it shall share this fate, is persuaded by the
> sum of the narcissistic satisfactions it derives from being alive to sever its
> attachment to the object that has been abolished.[13]

With some regret, Freud argued that this process of separation from
the loved one, indeed killing the loved one again in memory, is necessary
for the survival of the ego. The alternative to mourning, according to
Freud, is melancholia, in which the subject never gives up its investment
in the lost loved one, and thus becomes incapable of transferring its love
to a new object. Unlike mourning, in melancholia the lost object is hid-
den from consciousness: "the patient is aware of the loss which has given
rise to his melancholia, but only in the sense that he knows *whom* he has
lost but not *what* he has lost in him."[14] Perhaps this describes the melan-
cholia that one feels when viewing an image of an unknown person. We
cannot know who this person was, but we mourn his or her passing and
feel a generalized sense of loss in the wake of history's rough treatment of
the forgettable.

As William James noted, the melancholic diminution of the ego comes
close to being an acknowledgment of the actual human condition, against
which a healthier person has ample defenses. James wrote that melan-
cholia has a quality of realism, for if one conceives of the world "*as it is,*

Frame enlargement from *De Profundis* (1996), by Lawrence Brose. Courtesy of the artist.

purely in itself," stripped of one's emotional investment, "it will be almost impossible . . . to realize such a condition of negativity and deadness."[15] James quotes Tolstoy: "One can live only so long as one is intoxicated, drunk with life; but when one grows sober one cannot fail to see that it is all a stupid cheat."[16] Lacanian theory amply supports the theory that the ego is a sturdy bulwark against our fundamental self-less-ness.

Roland Barthes's meditation on the "Winter Garden" photograph of his mother in *Camera Lucida* suggested that photography itself is a melancholic medium. "Nothing in [the photograph] can transform grief into mourning."[17] Photography, he suggests, blocks the act of memory. It fixes the past and substitutes the signs of the image for the creative engagement of memory. To view a photograph of a lost loved one, then, is a melancholic act in which the viewer "knows *whom* he has lost but not *what* he has lost in him."

> The only way I can transform the Photograph is into refuse: either the drawer or the wastebasket. Not only does it commonly have the fate of paper (perishable), but even if it is attached to more lasting supports, it is still mortal: like a living organism, it is born on the level of the sprouting silver grains, it flourishes a moment, then ages. . . . Attacked by light, by humidity, it fades, weakens, vanishes; there is nothing left to do but throw it away.[18]

Barthes finds that the mortality of his photographs, their blurriness, fading, and decay, render them unbearably abject. When not only the "what" being mourned but the "whom" becomes illegible, the photograph must be rejected, lest its mortality contaminate the life of the viewer. In what seems an understandable and "healthy" conclusion to mourning, Barthes throws the old photograph away.[19]

I would like to suggest that the very blurriness and illegibility of the photograph that Barthes finds abject may *aid* the process of memory. As I argue in "Video Haptics and Erotics," in this volume, an image that is grainy, indistinct, or dispersed over the surface of the screen invites a haptic look, or a look that uses the eye like an organ of touch. This is how *love* works into this sort of identification. A tactile look does not rely on a separation between looker and object as a more optical or cognitive look does. Because it does not rely on the recognition of figures, haptic looking permits identification with (among other things) loss, in the decay and partialness of the image. This sort of look, then, is not just about death, but about loving a living but noncoherent subject, an image that contains the memory of a more complete self. This look is a kind of reverse

mirror stage: we identify not ("jubilantly") with a self that is more uni-
fied than we are, but with a self that is aging and disappearing. Perhaps a
fading photograph of one's own lost loved one is too violent to contem-
plate: the image that robbed one of memory itself being drained of life.
But I do believe the melancholia evoked by a dying image may produce
not dread but a loving regard.

Many of Steve Reinke's short works included in "The Hundred
Videos" (1989–1995) are devoted to found footage of anonymous or fic-
tional boys and young men, on whom the artist lavishes the perverse af-
fection of a habitual seducer. In *Artifact,* clips of a 1970s CBC documen-
tary called *The Children of Sri Lanka* are re-presented in "the edited
version that desire has consigned to my memory." Reinke eroticizes the
brown-skinned boys of the documentary as one rides a water buffalo, an-
other rebuffs the phallic attentions of an elephant's trunk that reaches in
the window toward where he is sleeping. The handsome young bowling
champion of *Corey* is rescued from cable-television oblivion by the
videomaker's voiced-over amorous fan letter. But what Reinke returns to
most insistently is the damaged young men to whom he would be doctor
and lover. *Wish* examines an archive of medical photographs of skin dis-
eases, supposedly from the collection of a Philadelphia doctor in the
1930s. Each photograph is fetishistically divided into parts that are mat-
ted into the black screen: the rosaceous ears of one young sufferer, the
skin rash covering the chest of another. "Be my leper," the artist pleads in
voice-over; "Be my love." These diseased skins attract the artist's sympa-
thy in the same way that decaying images do in other tapes: they are signs
of passing beauty that must be revived in the memory of the viewer, for
the people and images themselves are now dust.

In *Everybody Loves Nothing* Reinke again turns his possessive gaze to
various kinds of found footage: medical films, home movies, an Air Force
training film. Reinke edits these, or pairs them with text or voice-over, to
make explicit their sense of mourning a passing. He pays special atten-
tion to a 1950s medical film documenting treatments for hypogonadism
in male adolescents. The officious voice-over of the found film narrates
one chubby, effeminate boy's emergence into "a normal man" thanks to
testosterone injections: new body hair, deeper voice, increased muscula-
ture, and enlarged genitals. Reinke edits the footage to construct an un-
comfortably long close-up of the youth's tiny "before" penis, tucked like a
rose in the folds of his flesh. This might seem prurient, except that the
original voice-over is so certain in its condemnation of the boy's "abnor-
mal" state that we get a sense that Reinke is on the side of the image

against the voice-over. He cherishes the young man in his insufficiently male state, caressing the image of a youth who will disappear into the ranks of the heathily (heterosexually) male. This exchange shares with the other sequences of *Everybody Loves Nothing* an ardent desire to revive the lost past from a disappearing image. In a later sequence, we see a tourist film of a Punch and Judy–type puppet show, so faded that one can barely decipher its bouncing and grinning, vaguely terrifying figures. Reinke's gentle voice explains, "If I were to offer a synopsis of the play, it would be, 'Do not come for me, Death, for I am just a tourist.' But really, it is probably, 'Do not come for me, Death, for I am just a child.'"

Devotional Melancholy

In the accounts of Freud, James, and even Barthes, melancholia is seen as morbid and suspect in that it eats away at the ego. The melancholic cannot love, Freud argues; s/he cannot have healthy religious experience, James argues; and her/his condition is exacerbated by the decaying images of the beloved, Barthes adds. Is there any way to imagine an act of perpetual mourning that is at the same time an act of love? The works I discuss here turn their attention to images that were *not* precious but merely efficacious: the porno, the medical film. Loving a disappearing image can be a way of rescuing something that was not loved in its own time.

Freud's understanding of melancholy, and Barthes's as well, seems symptomatic of the Western conviction that the world revolves around the ego. The Freudian definition of love is also tied up with the ego's coherence. Yet if we can imagine a subjective state in which the self manages to exist without investing in the illusion of its own completeness (a big "if" for Freudian and Lacanian psychoanalytic theory), then we can imagine that mourning might persist without morbidity. We can imagine that melancholy does not preclude love but merely maintains love in the face of knowledge that the object of love is (always being) lost.

Here I would like to call on another definition of melancholy, which James attributes to the "sick soul" in his *Varieties of Religious Experience,* but which in other religious traditions is a sort of divine ecstasy. Devotional poetry addresses the deity in the melancholic tone of a lover addressing the unhearing beloved. As one example, consider the *bhakti* movement, or way of devotion, begun in South India around the sixth century c.e. I could also mention the writings of Christian and Sufi mystics, in which the union with and separation from the deity are as passionately anticipated and regretted as earthly meetings and partings with

a lover. Bhakti, or "self-less devotion to God,"[20] would seem to run against the cultivation of a healthy ego. Indeed, as with other Eastern and mystical faiths, its goal is the dissolution of the ego, which is considered an illusion preventing the devotee from becoming one with the infinite.

> Where do I go from here?

> I can't stand the soft bells, the gentle breeze,
> the dark water-lily, the darkness that conquers day,
> the dulcet notes, the jasmines, the refreshing air.

> The Lord, my beguiling one,
> who creates, bores through,
> swallows, and spews this earth,
> who measures here and beyond,
> does not come.

> Why should I live?[21]

The devotional poets' pleas for divine grace despite the unworthiness of the petitioner[22] are comparable to the self-abnegation of the melancholic. Indeed the abject longing of the mystical lover for the beloved is its own reward. The Sufi poet Rumi (1207–1273) told of a man who stopped praising God when a cynic asked if he'd ever heard anything back:

> He quit praying and fell into a confused sleep.

> He dreamed he saw Khidr, the guide of souls,
> in a thick, green foliage.
> "Why did you stop praising?"
> "Because I've never heard anything back."
> "This longing
> you express *is* the return message."

> The grief you cry out from
> draws you toward union.[23]

Can this form of religious devotion be a model of the melancholic subjectivity of the mere filmgoer? I suggest it can. In recent years the ego has lost its position of supremacy both in psychoanalytic theory and in film theory (with its emphasis on masochism, fluid identification, etc.), as well as in postmodern theories of the subject. In light of this revision, one may review Freud's rueful claim that the ego chooses survival over

love. It seems to be easier, in the age of AIDS, to give up a unified subjectivity that we are less convinced we had in the first place. Melancholia, the refusal to discard the dead loved one from our selves, makes sense if our selves are composites anyway. Devotional poetry offers a model of love of the absent beloved in which the ego is, indeed, dispersed. This dispersion is claimed as a joyful reunion with the beloved rather than a fearful annihilation.

Let me push my argument that it is possible to identify with a dispersed subjectivity without dread, by pointing to the recent hype of protease inhibitor drugs, released in 1996, that "cure" AIDS, supposedly rendering it just another chronic disease like diabetes. The flare of media excitement around these drugs—and the media silence concerning AIDS that followed—clearly reflects a desire to get AIDS off the screen and back into the lives of those *other* people who have it. The rush to celebrate the "cure" is an act to contain AIDS and to separate the infected bodies from the clean ones, to make AIDS a minority issue again.[24] The works I have discussed, which still love the disappearing bodies to which they are devoted, argue the opposite: that we all have AIDS.

Clearly one appropriate response of mourning is fetishism: in the case of AIDS, the Names Quilt, the many loving documents and documentaries of individuals who have died permit a hypercathexis and then detachment from the beloved one. In this essay, however, I am suggesting another response of mourning that is antifetishistic: it does not concretize the loss in an object but expresses the loss through the dissolution of objects. If this is melancholia, then I suggest that melancholia can be a subject-dispersing, loving response to loss.

Mourning the death of an image is far less traumatic, of course, than mourning a loved one. Yet I argue that engaging with a disappearing image has some results for the formation of subjectivity, or, precisely, a subjectivity that acknowledges its own dispersion. These works of disappearing images encourage the viewer to build an emotional connection with the medium itself. We are not asked to reject the images on their surfaces, themselves precious indexes of long-ago events, but to understand them to be inextricable from another body whose evanescence we witness now, the body of the medium. An idea of the self emerges from this exploration of love and loss that is not the anxiously insulated subject of Lacanian psychoanalysis, but a self that is deeply interconnected with others. Engaging with a disappearing image invites a kind of compassion and open-ended love that can also be a way to engage with people and with death. The response to death in these works is not one of

fear but an embracing; not the morbid embrace of death, but an embracing of the self's relations with others and with all matter—which is, after all, in a state of constant dissolution. Loving a disappearing image draws us into a deep connection with all things, absent and present. "The grief you cry out from draws you toward union."[25]

III. Olfactory Haptics

7. The Logic of Smell

In 2000, DigiScents, a software company based in Oakland, California, was beta-testing its iSmell platform to deliver odors in interactive media. DigiScents promised computer-game developers that games could be equipped with environmental scents, entity-based scent cues (e.g., the smell of Lara Croft in Tomb Raider), event-based scents (e.g., the odor of burning flesh when Duke Nukem blasts a predator), prize scents (the smell of bananas for Super Mario), and even the "smell of fear." These smells would be delivered by a software-activated spraying device called iSmell that custom mixes from 128 basic smell oils and gently wafts the resulting odor to the gamer: bananas, sweat, burning rubber, what have you. Despite its pun-laden PR—a Web portal called the Snortal, a science link called the Ol'Factory—DigiScents was no joke: it received $20 million from investors as well as from Pacific Century CyberWorks, which planned to introduce the product to the Asian market, and it formed alliances with Procter and Gamble, known for the branded odors of Crest toothpaste, Pampers diapers, and Pringles potato chips, and with RealNetworks, makers of the streaming media software RealPlayer.[1]

As it happened, DigiScents had the staying power of rose water. The company went public in October 1999 and a year later won the "Best New Technology" award for the iSmell device at the "Best of RetailVision Awards." But a few months later, in April 2001, the company closed its doors and laid off all seventy employees.[2] The company's heady premises

overwhelmed the shaky dot-com market, at least for the time being. Nevertheless, DigiScents' brief flowering speaks to a corporate hunger to bottle the volatile sense of smell for marketing purposes.

Smell is the most immediate of sense perceptions. Until recently it has escaped most efforts to regiment it in the realm of signs. But as the iSmell example shows, smell too can be harnessed for instrumental purposes: not only computer games but fragrant online marketing, mood control for office workers, and neo-smellorama movies. In the following I would like to make the simple argument that the value of smell is its materiality, which makes it inherently resistant to instrumental uses like those described earlier. My title is a play on Gilles Deleuze's *Logic of Sense,* in which he takes on the bugaboo of idealization and insists on the particularity of phenomena. Smell is the sense perception that resists idealization above all others. Smell asks to be sensed in its particularity, in an engagement between two bodies, chemical and human.

I will suggest ways that the cinema can draw on the power of smell while preserving its particularity. Smell is already a movie, in the sense that it is a perception that generates a mental narrative for the perceiver. We may also understand smell as what Deleuze would call a fossil image, or a kind of image that contains the material trace of the past within it. Smell is a powerful thread of connection to histories, like Hansel and Gretel's trail of breadcrumbs. When we smell, we are able to re-create this sense of past in our own bodies—lucky for us, because these are memories that often can't be apprehended any other way; unlucky, because the memories smell brings us can be overwhelming. As well as discussing how movies in their normal audiovisual form may invite an olfactory response, I'll suggest how an unusual kind of movie making, olfactory montage (as opposed to the usual audiovisual montage), can activate our own individual fossil images.

Yet, as the DigiScents example shows, smell is also a sense image amenable to symbolization and thus idealization. Recently smell has been mobilized as a marketing tool through the popularization of aromatherapy, olfactory computer terminals, and other commercial applications of what Constance Classen, David Howes, and Anthony Synnott call "olfactory management."[3] It is my view that these methods exploit smell as a symbol, rather than an experience. They play on people's cognitive, cultural associations with smell rather than with our rich, individual, memory-driven responses. This impoverishes the experience of smell.

Smell is a radical example of what Deleuze calls the *affection image,* an image that connects directly to the body. My remarks will build on

Deleuze's cinematic philosophy, as well as on his notion of particularity from *The Logic of Sense.*

For my purposes here, I define smell as that which is perceptible. A controversial topic in the study of human olfaction is pheromones, odorless hormones. Scientists do not agree on whether all humans have the capacity to process pheromones. In other mammals, these molecules signal gender, reproduction, and social status. Being odorless, they are not perceived. But they speak directly to the most primitive part of the brain, the hypothalamus or "reptilian brain," without ever making contact with consciousness.[4] If this is true for humans, then perceptible smells may also be harnessed to pheromones, which to some degree predetermine their meaning. However, to analyze olfactory experiences that lack a perceptual component is an exercise in paranoia. Also, it arguably takes us away from the study of communication, in which it's assumed that subjects *perceive* that which communicates to them.

Smell as a Mimetic Sense

I posit a continuum between kinds of images that are symbolic and those that are mimetic. Of all the senses, smell is most likely to operate mimetically. Mimesis, from the Greek *mimeisthai,* "to imitate," suggests that one represents a thing by acting like it. Mimesis is the body's way of reading signs. A child sees an airplane and zooms around with its arms outstretched (in Walter Benjamin's example from "On the Mimetic Faculty"). The gleam of the knife edge in G. W. Pabst's *Lulu* makes you flinch.[5] When the smiling-computer icon shows up on my Macintosh screen, I grimace back instinctively. Mimesis presumes a continuum between the actuality of the world and the production of signs about that world. Any sense perception can be mimetic. But smell is the most mimetic of the senses, because it acts on our bodies before we are conscious of it. Smell requires a bodily contact with the world, which in turn is mediated in the brain in an especially instinctual fashion.

The semiotic system of Charles Sanders Peirce presumes that there exists a continuum between more immediate signs, or signs that have what he calls Firstness, and more symbolic signs, which have Thirdness. Among signs that have Firstness he mentions smells: "the odor of attar"; "the stink of rotten cabbage"[6]; while Thirdness is reserved for abstract signs that we agree stand for the thing they represent, like the word "duck" or the Pringles potato chip (which stands for an idea of a potato chip more than it actually tastes like a potato chip). The continuum between Firstness and Thirdness in Peirce closely parallels that between

mimetic and symbolic signs, because Firstness must be perceived by the body, while Thirdness is general and abstract.

Urban, postindustrial, mediated society is dominated by symbolic signs, signs of Thirdness. This is because corporate capitalism needs meanings to be abstract, exchangeable, and easily consumable. Capitalism relies on symbolic signs. Capitalism seeks to disembody meaning in order to make it generalizable, marketable, and consumable (not a potato chip but a Pringle; not real fear but the "smell of fear"). But this disembodiment comes at the expense of severing ties with the material world. Human communication begins in materiality: embodied, precognitive, and sensuous. As Sean Cubitt points out in *Digital Aesthetics*, one of the most effective ways to sever ties to the material world is to reify communication into information, and this is what corporate capitalism endeavors to do.[7]

But there are many ways that we can reestablish a sense of the materiality and fragility of communication. Smell is one of them. Smell forces a contact among bodies: chemical bodies, our own bodies that act in sympathy with them, and the social body in which we all partake.

Olfactory Cinema

In *The Skin of the Film* I suggested several ways that cinema, the audiovisual medium, can call on the sense of smell without recourse to scratch-

Frame enlargement from *The Five Senses* (1999), by Jeremy Podeswa.

and-sniff or Smell-o-Rama.[8] The first and most usual means is identification: we watch someone smell something and we identify with them. For example, in Jeremy Podeswa's *The Five Senses* (1999), each character is associated with a sense perception. The "smell guy," Robert, is having a life crisis which he resolves by meeting with former friends and lovers and smelling them, to determine whether they still love him. In one remarkable scene, he reaches across a café table to smell his ex-lover's watch. How much smell we get out of this image is a function of how much we are able to identify with this character. A close-up on the fragrant object helps, in part because it can elicit an identification with the object itself, as much as with the person smelling it.

A second way that films can evoke an olfactory association is through the use of sound, especially in association with a close-up. Sound is a sense perception that is "closer" to the body than sight. Sound brings us closer to the image, almost close enough to smell. Interestingly, offscreen sound also emphasizes the sensuous quality of an image. Tranh Anh Hung's redolent film *The Scent of Green Papaya* (1993) makes frequent use of close-ups paired with closely miked or offscreen sound to evoke the sensuous quality of the image. Over a close-up of Mui's curious finger stirring the glossy seeds of the papaya, a knocking sound like a woodblock creates a temporal suspension that invites the viewer to linger in the multisensory moment.[9]

Frame enlargement from *The Scent of Green Papaya* (1993), by Tranh Anh Hung.

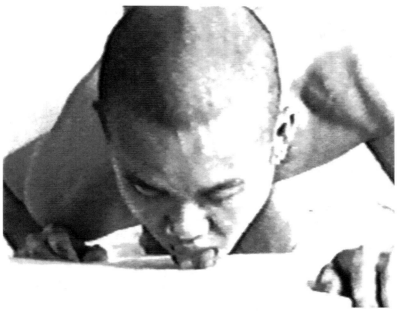

Still from *Sniff* (1997), by Ming-Yuen S. Ma.

A third way to call up a sense of smell is to bring us closer still, by using what I call the haptic image. In "Video Haptics and Erotics," in this volume, I argue that certain kinds of images appeal to the sense of touch as much as vision. By resisting the control of vision, for example, being blurry, haptic images encourage the "viewer" to get close to the image and explore it through all of the senses, including touch, smell, and taste.

Movies usually consist of an audiovisual montage. This is not only because sights and sounds can be recorded, but also because sight and hearing are the most public of the senses. Along the continuum of mimetic and symbolic images, visual and sound images tend to be symbolic signs. While we experience their rawness, their immediacy to perception, images and sounds tend to quickly resolve themselves in our understanding, so that we are pulled into their symbolic, quasi-linguistic meaning. Usually we can all agree on what an image represents—for example, that curvy brown form with a beak is a duck; or what a sound represents—for example, that splashing, honking sound is—a duck. Visual and sound images call up, to different degrees, a shared cultural symbolic. And this is what narrative filmmakers depend on: that viewer/listeners will have a common understanding of visual and sonic signs, so that we can experi-

ence a common story. Smell, however, provokes individual stories, calling upon a semiotics that is resolutely specific.

As individual memory triggers, smells function better than audiovisual images. As *communication,* however, an audiovisual evocation of smell is, I believe, a more faithful representation than the physical smells themselves. I'd like to test this thesis on you, the reader, by performing an olfactory-verbal montage. This experiment will call attention to the ways we process different kinds of sense information, and to the difference between shared narratives and individual memories. In the rest of this essay I'd like to share with you a very modest, three-part smell movie. Please put down the book for a moment and ask a friend to collect for you the easily obtainable substances listed in the following footnote. In order to prevent any symbolic prejudice about the meaning of these three smells, do not read the footnote yourself. Get your friend to put the three substances in opaque, numbered plastic bags.[10]

Okay. At points during the essay I will prompt you to smell one of the substances. Be aware of your immediate emotional response, then of any memories or associations that follow; you might want to jot them in the margin.

Please smell substance number one.

Smell as a Material Sense

Can smell can be harnessed for the expression of communal memories, along the lines of language and audiovisual images? The current experiments with olfactory media like iSmell depend on establishing a language of smell, so that we should all call up common associations from the same smell. I argue that such attempts to harness smell result in a dematerialization of our individual olfactory knowledges, in favor of a shared smell bank.

To explore this question, let's take a brief whiff of the neurophysiology of smell. Research into olfaction has shown that odor is processed uniquely among all the sense perceptions. Vision, hearing, touch, taste, and kinesthetic perception are all processed at the top of the brain stem in the thalamus, where sensory information is integrated, and then relayed to the frontal cortex. Conscious thought occurs in a feedback loop between the cortex, where separate sensory inputs are stored, and the thalamus. Smell takes a different pathway. The tremendously sensitive and receptor-rich olfactory bulb is already "thinking" when smells activate certain receptors. From the olfactory bulb, some neurons go to the thalamus, but

others go straight to the cortex. Specifically, they go both to an ancient center called the olfactory cortex, and to an overlapping area called the limbic system. The olfactory cortex recommends certain kinds of immediate action in an almost instinctual way. The limbic system is responsible for emotion and some kinds of memory: in it, for example, the amygdala excites instinctual responses such as fear, and the hippocampus integrates short-term memories.[11] From these centers, information is then relayed to the thalamus and frontal cortex: so after it connects to our emotions and our memories, it connects to cognition. What all this means is that smell has a privileged connection to emotion and memory that the other senses do not. We smell, feel the jab of emotional memory, and only then may we name the substance: Ivory soap. Experiments in sensory memory show that while we recall equally well from looking at an image or smelling an odor, the odor memory is much more likely to be accompanied by a blast of emotion.

There's little doubt that smell is the communication medium most intimately associated with memory. A recent article in *Nature* on the physiology of smell, by Mark Stopfer and Gilles Laurent, discloses the results of their experiments with the olfactory networks of locusts.[12] They found

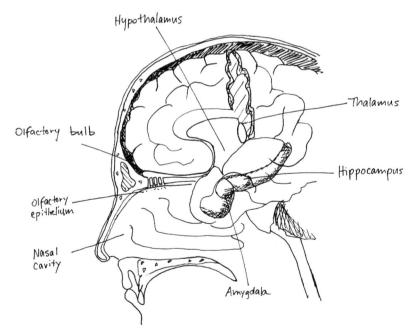

The human olfactory system.

that each odor activates a particular olfactory neuron, and that repeated exposure to an odor reorganized the locusts' neurons; that is, it becomes a memory. New, unusual smells excite the building of short-term memory, while familiar smells activate established memory circuits. In other words, the more we (or at least locusts) smell something, the more its associations build, and the more it forms a basis for communication. DigiScents relied on the same process of building memory associations with smell: it told game software developers that, over many hours of playing the game, users would learn to associate certain smell stimuli with dangerous situations, creating the "smell of fear."[13]

I believe that one of the faculties that distinguishes higher mammals like us from locusts (and computer game players, as imagined by DigiScents) is that we are genetically prone to invent rather than rely on instinct. The origin of human culture is our ability to behave in ways that our genes do not anticipate. Rather than respond instinctively to situations, that is, to rely on genetic memory, we use our individual and cultural memory to guide our actions. Our associations with smell tend to be highly individualized. Unless we have strong, shared collective memories associated with a smell, our associations will be resolutely particular. Thus for humans, memory often works at odds with communication.

Moving up from locusts to humans, research on human subjects shows that our smell memories are best encoded when there was a strong emotional charge to the original experience.[14] Say you were making your first gingerbread cookies at Christmas as a child and your mother slapped you for spilling the cinnamon. You would thereafter have a strong and emotionally negative association with cinnamon. It will also be different from most people's *emotional* association with cinnamon. Your association with Ivory soap is probably very different from my association with a controlling grandmother (who at the age of 93 had mellowed considerably, bless her heart). The associations we have with odor are strongly individualized and context-dependent, and will be as long as humans have different life experiences. Even if the memories themselves are different, smells build communities around remembering. British smell therapists found that a concoction called "Air Raid Shelter" unleashed a flood of reminiscences from Londoners who had lived through the Second World War.[15] Indeed, my own interest in smell memory began as a search for collective memory that remained elusive from images and words.

Smell follows a path to symbolization. Interestingly, discriminating among smells activates the right hemisphere, the language center. In addition, when people are asked to judge whether they are smelling something

edible, visual areas of the cortex are activated.[16] In other words, fine discriminations about smells start to merge with the processing of language and images. These findings suggest that our wonderfully flexible brains do not make a hard bifurcation between "low" instinct and emotion and "high" cognition but place them on a delicate continuum. Experiments have also shown that we are better able to remember smells when there is a linguistic or symbolic cue associated with the olfactory cue. For example, a test subject may smell wintergreen and say "Life Savers": this would be especially true in a culture where people did not regularly smell the plant wintergreen but did know about wintergreen Life Savers. This is an example of the "branding" of olfactory associations. This sort of branding is accelerating with the globalization of product marketing. Think of all the smells that we know by brand name—Life Savers, Starbucks, Ivory. Globalization is beginning to substitute these brand names for the generic terms mints, coffee, and soap. As this process escalates, we may well begin to have common linguistic associations with smell. This will allow smell to be processed cognitively just like language or well-codified images and sounds. However, and luckily for us, we will continue to have individual and contextual emotional responses and, sometimes, individualized memories of when we first smelled that odor.

Smell Makes Sense

Elsewhere I have described how the cinema activates circuits of memory in the viewer.[17] These memories are embodied and multisensory, so that watching a movie can awaken memories of touch, smell, taste, and other "close" senses that cannot be reproduced as sound and visual images can. Because movies engage with our embodied memories, each of us experiences a movie in an absolutely singular way. Meaning is made in the material connection between our bodies, the body of the film, and the bodies, animal, vegetable, and mineral, recorded by the film.

This absolute singularity of meaning is what Deleuze calls making sense. Deleuze loves the affection image in cinema because it is a moment of singularity (of Firstness), it resonates in the body of the spectator before, or instead of, extending boringly into action. Similarly, in *The Logic of Sense*, Deleuze valorizes the kind of meaning that can only be experienced in its haecceity: *this* meaning that is unlike any other. Deleuze abhors idealization, such as the Platonic notion of essences, because idealization makes us lazy, it enslaves us to abstractions. The goal of thought should be to replace all idealism with particularity, with *sense*.[18] "To re-

verse Platonism is first and foremost to remove essences and to substitute events in their place, as jets of singularities."[19]

Deleuze argues that the crack between ideal and particular (virtual and real) experience occurs in the body. Very movingly, he uses the example of drinking. Drinking is to both experience this crack and, destructively, widen it, for when we are drunk we have an acute sense of our own perception of the passage of time.[20] Drinking destroys the movement-image, the necessity of sheltering ourselves from experience in order to move on and get things done. Drunkenness suspends the flow of time in order that we may scrutinize it and experience it fully, in the *passé composé* tense of "I have loved," etc. You have probably had the experience when you are drunk—I have—of being acutely aware of the present moment, even to the point that you are immobilized. This is the experience of making sense. Deleuze seems to think this destructive experience is worth it, as it rescues moments of particular existence from the abstract, encoding machine of the symbolic.

Outside of the realm of drunkenness, aesthetics is a privileged interface between the ideal and the sensible. Deleuze writes, "Aesthetics suffers from a wrenching duality. On one hand, it designates the theory of sensibility as the form of possible experience; on the other hand, it designates the theory of art as the reflection of real experience."[21] The work of art is torn between its ideal representation and our embodied response to it. Similarly, smell is rich in the logic of sense because it resists idealization and instead fosters a dialectic between the present moment, in which we smell, and the embodied memories that the smell evokes. Smell plays on the cusp between material and symbolic.

Please smell substance number two.

Smell, as well as being an affection-image, is a special category of what Deleuze calls the recollection-image, an image that encodes memory. When we succeed in activating the memory encoded in a recollection-image, the image comes to generate a narrative. This is why, strictly speaking, an orange peel or our lover's shirt can be considered a kind of movie. Smelling it, we create a story. When we fail to connect the image to memory, it remains what Deleuze casually called a fossil-image; it indicates a meaning that our own bodies and memories fail to call forth.[22] Currently you may be succeeding in drawing forth a narrative from the smell I've presented you with, in which case it's a recollection-image. Or you may not, in which case it's a fossil-image. Your narrative is likely to be very different from the story I've assigned to it: a childhood memory of rebellion.

Symbolic, Simulacral Smells

Smells typically generate unique stories, according to the idiosyncratic ways our bodies remember them. But smells can also defy their embodied nature and become symbolic. It's interesting that the smells that have been used successfully in movies, such as John Waters's *Polyester* (1981), are synthetic smells—new-car smell, air freshener. These smells may be understood as symbolic scents the way certain sounds, such as car alarms, are symbolic sounds. In perception they bypass Peirce's Firstness, the raw experience, and Secondness, the jolt of recognition, and leap to Thirdness, the symbolic. We experience them in conventional ways.

DigiScents and other virtual-smell programs seek to unify smell experience like visual experience. The company's PR gave the example of following a recipe for apple pie; when it calls for cinnamon, the iSmell platform would shoot out a jet of cinnamon smell. For all users to have the same association with cinnamon, iSmell needs to override our deeply held associations with the spice—from the generically pleasant memory of cooking lessons with mom, to the culturally particular—the scent of cinnamon in a Moroccan b'stilla, for example—and the individually particular—being beaten in the kitchen during the Christmas holidays. Or perhaps the smeller was a cinnamon harvester and associates the smell with hours of back-breaking labor.

What the DigiScents company was counting on is smell's symbolic component, the Thirdness of cinnamon overruling the Firstness of cinnamon. Smells are more amenable to symbolization when our prior experience with them is symbolic: people selling their homes are advised to simmer cinnamon sticks on the stove to entice potential buyers with the

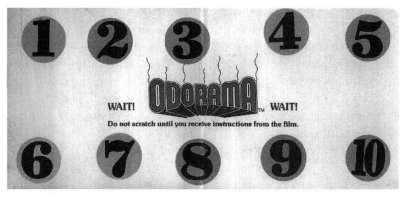

Scratch and sniff card for *Polyester* (1981), by John Waters. Courtesy of AAAtomicBob Greenberg.

smell of baking, and there are air fresheners that have the same effect. These marketing strategies want to give everybody the same associations with smell, namely the comforting, homey smell of baking, imbued with nostalgia for a time when people really did bake. If there ever comes a time when we all have the same associations with cinnamon, then cinnamon as a physical object will cease to exist.[23] Cinnamon will become ideal, a word you can smell. It will lose its logic of sense.

An experiment in olfactory engineering that is more "tailored" to individuals is the aroma shirt devised by artist/engineer Jenny Tillotson at the Imperial College of London. This shirt, lined with a perfume reservoir, would sense changes in the wearer's body chemistry and deliver spritzes of scent at the neck and cuffs—when the wearer is sweating anxiously, soothing vanilla; when the wearer seems chilled with lassitude, energizing geranium; when the wearer needs to be turned on, a whiff of her or his partner's pheromones.[24] Presumably the aroma shirt would be geared to the smell associations of individual users.

Yet the aromatherapeutic notion that we all respond in the same way to geranium ignores the evidence of individual olfactory memory. According to a survey of smell research conducted by Rachel Herz and Trygg Engen, there is no evidence that certain odors are therapeutic in themselves; we have to learn good or bad associations with them.[25] All these examples of olfactory engineering exploit the symbolic aspect of smell at the expense of its mimetic aspect. They replace the Firstness of smell with the Thirdness of smell; they replace smell's logic of sense with idealization; they divest our bodies of one of the sources of meaning that is most preciously particular.

Please smell substance number three.

What we lose in the instrumentalization of smell, as of any sense perception, is vast. Mimetic and sensuous knowledges are almost infinitely rich in meaning, in comparison with the impoverished communication afforded by information. As Danish science writer Tor Nørretranders argues, "The capacity of consciousness is not particularly extensive if measured in bits, the unit of measurement for information. Consciousness contains almost no information. The senses, on the other hand, digest enormous quantities of information, most of which we never even become conscious of."[26] Our nose receives 100,000 bits/second of smell information, but our consciousness is aware of only about 1 bit/second of smell. Converting sense perceptions into information, the goal of the new smell-codifying practices like aromatherapy and iSmell, severs the

link between sensuous knowledge and information. Currently this research is at the absurd stage, for example in DigiScents' online survey: "What is the smell of suspense? Cola, eucalyptus, smoke, vinegar, sweat, medicine, ozone, gunfire, or other?"

My association with the third substance is a combination of comfort and eroticism. Is yours different?

For the most part, I am glad to say, smells remain aleatory and unpredictable in their effects on individuals. No doubt this is why, when Marcel Pagnol accompanied the 1935 premiere screening of his *Angèle* with scents pumped into the theater, the audience rioted. That is what I hoped DigiScents' clients would do. And in a way, that is what I am hoping what you have wanted to do in the course of this reading.

My hope is that we can find ways in which the complex knowledges of the senses might be understood, not for the end of control, but for the end of increasing our awareness of the role of preconscious, mimetic knowledge in human life. The smell movie in which you may have just partaken, which I hope took you away to fragrant stories of your own, is a first attempt to bring together all our intensely felt, individual sense memories into a shared material and communicative web.[27]

8. *Institute Benjamenta*: An Olfactory View

In liquid slow motion, a bullet moves through a dense pine forest, curving impossibly through the syrupy air, until it finally lodges in a pinecone. In a flea's-eye-view, a gigantic length of thread snakes through the tiny needle hole in a nightshirt, producing a sort of disciplinary garment whose neat column of thimbles will prevent the sleeper from lying on his back. A group of seven men, attending at the door of their ailing mistress, sways as one in a luminous swath of light, which dances and swirls about them.

These are three images from *Institute Benjamenta, or, This Dream People Call Human Life* (1995), the first feature-length film by the Brothers Quay. They convey some of the sense in which nonsentient life seems to take precedence over human life in the film, but perhaps they do not convey the film's sense of *smell*. How does a film leave a viewer with an overwhelming impression of fragrance, as though she has been inhaling it as intensely as seeing it?

The Quay brothers, Timothy and Stephen, have developed a style in which a film, which is of course an audiovisual medium, offers itself as richly to the senses of smell and touch as it does to vision and hearing. *Institute Benjamenta* takes smell, and the knowledge afforded by smell, as a theme, and it employs the Quays' trademark uses of miniature photography and haptic imagery to convey the sense of smell to viewers. Not coincidentally, the film appeals to a subjectivity that is not human, or not

only human; it lingers on the lives of inanimate objects and unseen things, dispersing the subjectivity usually reserved for human characters over the entire image. What connects the film's sense of smell with its dispersion of the subject is aura, or the animate force of objects organic and inorganic, human and filmic. The novel on which the film is based charts its characters' gradual loss of selfhood. The Quays do this as well, but they counter this deathful path with a tide of nonhuman life. While the characters seem to sleepwalk, the objects and the space among which they move are endowed with a vibrating, tactile life.

The Quays are known for their exquisitely detailed animations, in works such as *The Cabinet of Jan Svankmajer* (1984), *Street of Crocodiles* (1986), *The Comb (From the Museums of Sleep)* (1991), and *In Absentia* (2000), which also includes a human actor. With *Institute Benjamenta,* the Quays bring their obsessive abilities with animation to the live-action feature. *Institute Benjamenta* is a sort of fairy tale based on a novel, *Jakob von Gunten* (1909), by the eccentric Swiss writer Robert Walser. The Institute is a school for servants run by siblings Lisa Benjamenta (played by Alice Krige) and Johannes Benjamenta (Gottfried John). When Jakob von Gunten (Mark Rylance) enrolls in the school, he disrupts its somnambulistic rhythm, like the prince in "Sleeping Beauty" awakening the sleeping princess, and brings the castle into rusty motion. The plot is slim: The seven male students endlessly go through the motions of servanthood. The head student Kraus (Daniel Smith) keeps a watchful eye on his mistress as she begins to lose her composure. Both sister and brother fall in love with the new student. Jakob narrates the process of losing his identity in this machine for producing human machines, the school for servants. Lisa dies from repressed longing. Herr Benjamenta dissolves the Institute, and in the penultimate scene he and Jakob are walking away from the school, strangely giddy, snow whirling around them as though inside a glass snow-globe.

Quay films are produced by Atelier Koninck, which comprises Stephen and Timothy Quay and producer Keith Griffiths. The film's score, by Lech Jankowski, uses jazz, orchestral, and antique instruments in brilliant, spare combinations. Like other experimental feature films, *Institute Benjamenta* was difficult to fund and ultimately found international coproduction. Past Quay films have been funded by the British Film Institute and Channel Four. The first financial support for *Institute Benjamenta* came from Image Forum, the Tokyo-based center for avant-garde cinema; then Channel Four offered major sponsorship, together with British Screen, and finally the German-based Pandora Film kicked

Frame enlargement from *Institute Benjamenta* (1995), by the Brothers Quay. Courtesy of Zeitgeist Films.

in. The Quays support their more experimental work by producing cultural documentaries and "graphic interludes" for commercial television, and they design theater and opera productions for director Richard Jones.

Criticism of *Institute Benjamenta* has tended to represent it as a chilly, inhuman film, a parable of alienation, alienated labor, and sexual repression.[1] Critics may be forgiven for being anthropocentric, but I would argue that the Quays' works are not so much inhuman as *unheimlich* in their attention to nonhuman and nonorganic life. In this filmic space teeming with life, humans, the Quays say, are just "no more important than anything else."[2] In this the Quays share much with Walser, whose attitude toward objects was not so much fetishistic as animistic. That is, objects in his writings have a life of their own not by virtue of their contact with humans, but for their own sake. In stories like "An Address to a Button" (1915) and "A Cigarette" (1925), Walser addresses lowly objects with respect and even envy. To the button he says, "You, why you are capable of living in such a way that nobody has the slightest recollection you exist. You are happy; for modesty is its own reward, and fidelity feels comfortable within itself."[3] This attention to the most negligible of objects animates the Quays' films as well, with their herds of tiny rolling screws, their twanging comb-teeth, their lively heaps of dust.

The Institute Benjamenta is a school for training servants. Servants, in Walser's writings, aspire to a state of nothingness. The writer himself enrolled in a school for servants and briefly worked as a house servant in a castle in Upper Silesia.[4] In *Jakob von Gunten,* the head servant Kraus inspires this speech in Lisa Benjamenta: "There isn't a single person alive who understands that there is some delicate meaning behind this nameless, inconspicuous, monosyllabic Kraus. No one will ever be grateful to him, nor is gratitude necessary. Kraus will never go to ruin because there will always be great and loveless difficulties confronting him. I think that I am perhaps the only person who realizes what we have in Kraus." Certainly one could say that the novel, and the film, is about alienated labor, the sort of work that demeans people and strips them of their humanity. Yet this slightly misses the point, for in Walser's writing this self-abnegation is perversely and knowingly desired. Like Jakob, all the students have "no high hopes in life"; yet even so their education seems sure to teach them little. Lisa walks the seven apprentices through absurd, repetitive exercises: folding napkins, arranging spoons in perfect circles, shifting their weight from one foot to the other. (Jakob, still too zealous, disrupts the class by practicing phrases such as "Be careful Viscount, the steeple, it is wobbling!") The seven men move together in leaden synchrony, each doing his best to abandon any trace of individuality. When Herr Benjamenta sees a bite mark on the new student's hand, evidence of his self-repressive struggle, he smiles approvingly.

The task of a servant is to efface himself or herself, to become part of the engine of a house. The film's human characters are at work to still their senses and silence their will. But the living building surrounds them with its fragrant traces. Time in the film is organized around what the Quays call the "masturbatory ritual" of feeding a fish that swims in a globe-shaped bowl in the house's inner sanctum. The magnetic force that flows through the house seems to be channeled by its only female inhabitant, Lisa Benjamenta, who lies in her room perspiring and breathing heavily in a sort of sexual catatonia. In the room above hers, Kraus sluices bucketfuls of water on the floor so that it will run down the walls and cool her. The entire building is an erotic machine, of which the people are only parts.

Although the film is inspired by a novel, the Quays are quick to say that "it was always conceived from the camera's point of view; not an adaptation from a novel but always as images first, closer to the domain of the silent film."[5] Like a silent film, *Institute Benjamenta* relies on the expressiveness of gesture, camerawork, and editing to convey meaning,

and the few words uttered by its characters hang in the air, I am tempted to say, like perfume. The magic of *Institute Benjamenta* is the way it uses film to evoke a possessed, animistic world. The dark quality of Czech, Polish, and Russian animation influences the Quays' manipulation of objects. In Nic Knowland's cinematography, the light too has a life of its own: the black-and-white film is full of exquisite images where light pours in one side of the frame or (when a tram passes outside) speeds across the walls in tracery patterns while the rest of the space is submerged in velvety darkness.

The Quays describe animation as "an experiment with what the camera can do choreographically." Their animations work with small-scale models populated by small objects. Focal length and lens choice create a sense of space in which the most interesting events do not occur in human scale. The camera moves delicately among these tiny theaters, creating a point of view that seems to belong to one of the objects or something even smaller and more ambient—the point of view of dust, or of the air. In *Institute Benjamenta* it is interesting to see these animation sets worked into live-action scenarios. Rather than acting as objects for the human characters, the miniature sets create the point of view for the entire film. The live-action sequences play into the tactile space established by the Quays' animations, reversing the usual anthropocentric

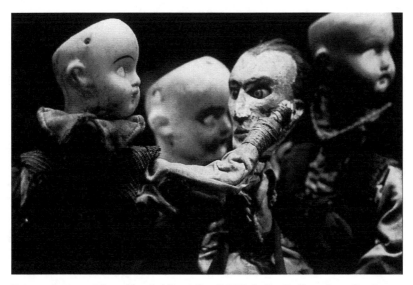

Frame enlargement from *Street of Crocodiles* (1986), by the Brothers Quay. Courtesy of Zeitgeist Films.

hierarchy of scales. The animation sequences create a densely populated miniature world, of which the bulky humans seem only obscurely aware.

In one scene Jakob has been shown to his bedroom at the Institute by Lisa Benjamenta. Jakob is already overcome by the conflict between his desire for his teacher and his stated wish to nullify himself by becoming a servant. In the room he finds a table piled with pinecones, which we see close-up like a miniature forest. Kneeling, he takes one in his mouth; still holding it, he pours a glass of liquor, and the camera moves in for one of those impossible close-ups of the bottle's label (it is the pine-scented schnapps that Walser liked). The combined gigantism and miniaturism of the scene make Jakob's act almost unbearably erotic, in the eroticism of an "unsuitable" match. What can the pinecone have that Jakob wants? Perhaps he is using the pinecone as a gag; perhaps it is a substitute for some human part. But his tentative, interested approach makes it seem not as though he were simply using the pinecone, but as though he suspects the pinecone knows more than he does.

How does the eroticism of this hard and fragrant object replace the better-known eroticism of human bodies? The film, like the novel, is powered by thwarted sexual desire. Yet *Institute Benjamenta* is not simply a film about sexual repression. Sexuality is abundantly expressed in the film, if not in the usual human ways. The pinecone scene is only one of several in which sexual expression is displaced onto plants and animals. The characters seem to be fumbling with erotic codes well known to other creatures but only dimly, clumsily remembered by humans. One of these codes is smell.

Haptic and Olfactory Space

How does film express the sense of smell? What sort of image invites olfactory perception? For one thing, a haptic image may. The work of the Brothers Quay provides an example of film that is haptic not because the image is blurred or hard to see but the converse, by virtue of pulling the viewer into a richly textured space—or perhaps it is better to say, pushing texture out to meet the viewer. In works such as *The Comb* (1991) and *Anamorphosis* (1991), as well as *Institute Benjamenta,* their elaborate, miniaturist sets create a world richly populated with inanimate objects— dolls, cutlery, a comb, pinecones. This overwhelming presence of detail invites the sort of look that would travel along textures of detail.[6] All the surfaces in Quay films have a heavy patina of tarnish and decay, so that even floors and furniture have a sense of aura, that is, the marks of a long-gone, living presence. These richly textured, miniature scenes com-

pel a viewer to move close, yet at the same time they multiply the points of contact all over the screen.

I've argued that haptic images have the effect of overwhelming vision and spilling into other sense perceptions. This is in part because they do not provide enough visual information on their own to allow the viewer to apprehend the object, thus making the viewer more dependent on sound and other sense perceptions. This shift of sensory focus may be physical, or, as in film, through associating the available audiovisual information with other, remembered sense experiences. Film cannot stimulate the precise memories associated with a smell: only the presence of the smell itself can call them up.[7] Yet a haptic image asks memory to draw on other associations by refusing the visual plenitude of the optical image. In addition, because haptic images locate vision in the body, they make vision behave more like a contact sense, such as touch or smell. Thus haptic images invite a multisensory, intimate, and embodied perception, even when the perceptions to which they appeal are vision and hearing alone.

The Quays' films have always played with the haptic dimension of vision, by drawing vision into a miniature scale in which the image is filled with small, lively things, all competing for attention. With *Institute Benjamenta* this tactile vision expands to encompass the sense of smell. They do this not only by using smell as a narrative element but also by inviting the embodied, haptic vision I have described. Smell, another sense based on contact, is the basic animating force in the film. Interestingly, the Quays decided to locate Walser's Institute in a former perfume factory, which still contains exhibits of the deer whose musk was used as an ingredient. Deer haunt the Institute (in another addition to the book), their antlers protruding from the walls, an anamorphic painting of rutting deer on the wall of an interior garden. In one hidden room there is a bell jar containing powdered stag ejaculate, labeled "Please Sniff." In *Institute Benjamenta,* deer are magic creatures because their sexuality is contained in their smell—something that most contemporary humans disdain, for our being is defined by our verbal, visual, and intentional activity in the world.

Smell, Sexuality, and Chemical Communication

The filmmakers appear to have been quite obsessed with certain smells as they were making the film. In an interview with Thyrza Nichols Goodeve, there is a fascinating discussion (in a bit of a detour from the interviewer's concerns) of the connection between deer, deer testicles, and perfume.[8]

Male Himalayan deer secrete musk in a sac located behind the testicles; they must be slaughtered in order to extract it. It is well known that musk and a very few other animal sexual/excretory fluids (or their synthetic analogues) are used as the base notes in many perfumes. Top notes of perfumes, those that the nose first receives, are usually floral; middle notes may be heavier florals or resins (such as myrrh and benzoin); base notes come from resins and animal products. Tom Robbins's delightful 1984 novel *Jitterbug Perfume*, a romp through the centuries in search for the base note of a legendary perfume, peaks when the scent is discovered to be—not to spoil it for you—a common but quite unexpected sexual odor. And of course the scandalous *Perfume* by Patrick Süskind turns around the theft of the body odors of beautiful and nubile women, supposedly the essence of human sexual desirability. As Tasmanian zoologist D. Michael Stoddart puts it, "The perceiver's attention is drawn to the more volatile and active floral notes much as one is drawn to a newspaper by its headlines. The real message is in the fine print."[9] Top notes are extracted from the sex organs of flowers; the middle notes often have odors similar to sex steroids; the base notes, which have a urinous or fecal odor, are chemically similar or identical to human sex steroids. In other words, we tend to wear perfumes that communicate on an unconscious level the same smells that we consciously wash away. (This practice is not universal: for example, Dassanetch men in Ethiopia traditionally bathe their hands in cow urine and rub their bodies with cow manure, which connotes prosperity and fertility for this cattle-raising people.[10]) There is debate among psychologists and neurologists about the role of the unconscious in human smell: some assert that smell is an entirely plastic, "soft-wired" sense, that is, we learn which smells are pleasant or unpleasant through association.[11] How much of this association is unconscious, and thus might be connected with infantile attraction to body odors, for example, is not clear. It is different for humans than for other animals, since in humans odor sensation connects to both cognitive and precognitive areas in the brain, while for animals the connections are only precognitive.[12] Yet since for millennia perfumes have been manufactured to evoke those odors, it is probable that some of the pleasant associations with bodily smells are learned and maintained at an unconscious level.

The Quays compare the light surrounding Lisa Benjamenta to "liquid myrrh."[13] The metaphor not only captures the feel of a viscous, golden afternoon light but also literalizes the atmosphere of sexuality, and indeed the sense of religious sublimation, that surround her. For centuries myrrh has been an ingredient in incense, used for religious purposes by

ancient Egyptians, Greeks, Jews, and (after some debate over whether the Divine, being incorporeal, had a sense of smell) Christians.[14] Like other resins used in incense, its chemical composition is very similar to that of animal steroids that contribute to human body odor.[15] By pushing the references to smell, the Quays are appealing to a sense that makes a sublime connection between the human, the animal, and the divine. The rich sensory lives of animals and plants appear in the film not as a primitive existence that human evolution has overcome, but an alternative way of being in the world, forking away from the vision-centered and humanistic modern cogito. *Institute Benjamenta* willfully reinvents the possibilities of human nature by turning decisively away from it. Hence the erotic lesson Jakob might learn from a pinecone (whose odor, incidentally, is shared by some male sex steroids).

After the encounter with the pinecone, Jakob murmurs, in sentences from Walser's book, "Perhaps I shall never put out roots and branches. One day I shall put out fragrance, and I will flower. I will be dead. Not really dead, but in a certain way—dead." Jakob's wish to disappear becomes an aspiration to sainthood, to emit the odor of sanctity. As though only by losing his individuality could he become part of something larger, something mediated by smell.

Although psychoanalysis explains why humans tend not to wear perfumes whose top notes denote sexual/excretory smells, instead communicating these smells at a subconscious level, we need not rush to psychoanalysis to explain why these odors should be attractive at all. Chemical communication is the most ancient form of communication. It is also a form of communication based on contact: contact between chemicals and receptor cells, such as those in our noses. In us higher mammals, our main form of chemical communication with the outside world occurs through the sense of smell. Yet the chemicals that carry all this information are remarkably few, since these communicative systems have not evolved much at all.[16] Thus what attracts insects to flowers is chemically almost identical to what attracts does to stags and humans to humans. What I hope to demonstrate in this digression into olfactory evolution is that a sense based on (chemical) contact is also a sense that we humans share with all other living creatures. Research is young on the chemical communication systems of plants; but we can speak of the sense of smell of maple trees, which can, for example, release hormones warning other maples of predators or signaling insects that they are ready to be pollinated. Smell, then, is a fundamental leveler, a warning system, delight, and physical contact shared by all living beings.

In one scene in the failed romance between Lisa Benjamenta and Jakob, she blindfolds him and takes him to the forest (saying, "It is so beautiful here, Jakob. If only you could see it"). Telling Jakob to "try to find the warmth," Lisa turns her body upside down, so that he can be guided to her by the warmth and smell of her sex (clad in thick woolen tights). Since in most cultures humans apparently find the smell of women's genitals unpleasant,[17] Lisa's appeal to Jakob is metaphoric, a willful appeal to the sense memory of other animals. She bypasses the usual visual and auditory cues in an attempt to communicate to him the way the deer memorialized on the garden murals communicated to each other. Lisa's act reverses the famous evolutionary act of standing upright that, in Freud's famous overstatement, displaced human sexual attraction from the olfactory to the visual.[18]

Extrahuman Subjectivity

The reaction to Quay films is often a sort of morbid fascination, a paranoia that the world of things has taken on a life of its own. Even the dust is alive. Quay films are full of ghosts, life in things that ought to be dead: this is both disquieting and, in a certain way, reassuring. Earlier films surprise the viewer with a pocket watch that, assaulted by little screws, springs open to reveal wet, pink flesh *(Street of Crocodiles)*, or walls that suddenly leak blood *(Rehearsals for Extinct Anatomies,* 1988). These images suggest that life is everywhere—not a benign life force but myriad, peculiar, sensible lives. Many viewers find these films unbearably disturbing, perhaps because the Quays' films threaten the preeminence of the human (and, perhaps especially, male) body by endowing inanimate objects with the ability to suffer.[19] But Quay films only inspire paranoia if one finds nonorganic life threatening. And what is animation but to make animate—to impart life, or to divine the interior life of objects? In other words, animation acknowledges the aura of things, the life they contain whether imparted by humans or somehow inherent.

Late-twentieth-century critics turned nervously away from the notion that objects and works of art might have aura. This was in part a necessary rejection of the irrational, of the idea that power might reside in nonhuman entities. Walter Benjamin's famous essay was decisive in this regard. Yet the German writer was also reluctant to completely abandon the mystical notion that the nonhuman and nonorganic world is also alive and somehow operating, indeed acting, in synchrony.[20] As we begin to perceive the annihilating capacity of the simulacral image in a world whose objects are increasingly produced by mechanical reproduction,

Frame enlargement from *Street of Crocodiles.*

there seems to be a new urgency to rediscover aura. Can this be achieved without an automatic regression to the fascist and religious mystification that Benjamin rightly feared? I cannot tell whether the aura with which the Quays endow nonhuman life is a warning against hubris or a kind of game with annihilation. However, I do think their films provoke because they redefine subjectivity and who is allowed to have it.

When subjectivity is so thoroughly decentered from human characters and onto animals, plants, inorganic beings, and air and light themselves, it seems necessary to ask how one identifies with such a film. Identification is certainly possible if one gives up some degree of anthropocentrism and seeks to feel a sympathy, born of respect, with these other objects. Yet, as with Walser's servants, this respect implies a reduction of the human to nothing: the film's second subtitle is "The Beatification of Zero." Identification with *Institute Benjamenta* involves a decision whether to identify with the humans who are in the process of dissolution, an exercise in self-erasure; or to move beyond anthropocentrism and find common subjectivity with animals, plants, and even less visible and organic "life" forms.

The willingness to pull away from individual human subjectivity that is a theme of the film may well have to do with the constitution of the

The Quays. Courtesy of Zeitgeist Films.

Quays themselves. Reviews of the Quays' films tend to take a prurient fascination in the fact that they are identical twins. It is true that they finish each other's sentences, dress similarly, sign their beautifully handwritten letters "Quays," and exhibit other twinlike eccentricities. Yet talking with them, I had the impression that their bicephalic identity was not a willful public hoax but a sincere lifelong experiment in the meaning of subjec-

tivity. Using the willfully antiquarian term "atelier" for their production company connotes a devotion to anonymous craft rather than authorship. This explains in part the filmmakers' unwillingness to be examined as auteurs, let alone analyzed as identical twins. Certainly, when each director knows instinctively what the other has in mind, the production process becomes organic: this may explain the intimacy between the camera and its world in Quay films. Other things could be inferred about the nature of authorship when the author is two people. Yet simply, the brothers seem to practice in life what they seek to do in their films; namely, distribute subjectivity. Why must a subject be contained in one individual? Why not shared between two, the way electrons jump from one atom to another? For that matter, why can't a whole space have a personality, like the interconnected miniature passages and breath-filled rooms of a Quay animation? Quay films remind us that we biological creatures are surrounded by nonorganic life. The reaction to this may be fear; or it may be a sort of animistic humility that attributes subjectivity and will to pinecones and motes of dust.

9. J's Smell Movie: A Shot List

Band-Aids™. Only that brand. And *Bactine™ antibiotic spray*. Begin with a brief, crisp medium shot, like a product shot, against a gray-green background. On the soundtrack, air stirring, a light breeze. Move the camera in on hands (the clean, heavy hands of a sixty-year-old man) gently and competently tearing open the Band-Aid (note: find the old kind with a red string that rips down the side of the package). On the sound track, the barely audible tearing of the package. Close-up of "fleshtone" bandage. Then fill the screen with a color: a cool, grayish turquoise, like a '60s bathroom. Sound of tap water.

Band-Aids and Bactine, the clean smell of latex emerging from the ingenious crackling package; the sweet tang of alcohol. When J smells either of these she is filled with a profound sense of peace. Her maternal grandfather, who died when she was seven years old, used to put Bactine and Band-Aids on her many scrapes. He was appalled at all the cuts she got on her legs from broken glass in the alley. J didn't know this then; she only knows that she felt safer with him than with anyone in the world.

Ivory™ soap. First, a brief shot of the Ivory Snow box with its tubercularly flushed child. Then a pan of white tiles in the shower stall. On the sound track: static.

Grandmother's house. Cleaner than their house. Ivory is a sign of good housekeeping, of scrubbing your skin until the layer that touched

141

the world that day is stripped away. It's a brainwashing smell. The summer after their granddad died, when they went to her house, their grandmother gave J and her brothers, all addicts of *The Three Stooges* and *Gilligan's Island*, a paper bag full of something that looked like candy, like toffee. Then she laughed and explained that it was the television cord, which she'd cut into little pieces.

Here's a hard one: *freon, melted plastic, and cigarette smoke.* Try panning the beige dashboard of a 1967 Dodge Dart. Before you shoot, polish it up well so it gleams. Follow with a shaky close-up on a crack in the asphalt with grass growing through it. Sound track: Elvis, "Fools Rush In," on a radio with bad reception.

Last summer the air-conditioning in J's car sprang a leak. It was hot driving, the plastic upholstery heated up, and the sun through the car windows was hot on her skin. J lit a cigarette, and to her surprise she burst into tears. At that moment she had the clearest memory of her grandfather, his kind smile, his big round stomach, his endless patience. Granddad smoked; he smelled of smoke but clean, like a dentist. In the hot Texas summers they would drive around in his car, sweaty hot in the backseat despite the blast of a/c up front. She used to hide his cigarettes from him. Only after he died did J start to understand her grandfather's shyness, resignation, and suffocated love. Now she thinks of him going outside to smoke to be free for a few minutes.

The summer their grandmother made candy of the television cord, J and her brothers read stacks of *Reader's Digest* in their granddad's old study, inhaling cigarette smoke from the cushions.

Cumin. Cooking with turmeric and onions. Begin with an unfocused close-up on the spices cooking in a frying pan, steam clouding the image. Pull back slightly and focus; then again close-up and out of focus; repeat. Sound track: a raga, or the Beatles' "Yellow Submarine," with the squashy sound of a tuba on the refrain, and the line "And our friends are all aboard, many more of them live next door." A man's and woman's voices, indecipherable but irritated, in the distance.

Her mother cooked with cumin and listened to ragas. In 1972 she had a dress with a complicated pattern of orange and purple sunbursts. J would sit on her mother's lap, feeling her prickly legs through the pantyhose, and stare at the pattern trying to figure it out. J's mother cooked mulligatawny stew, the British version of curry with lamb and potatoes. For her it was the taste of rebellion, for J it was the taste of home.

Burnt sugar. The camera should slowly pan the surface of a canvas rough-ly painted bitumen color, with volcanolike pockmarks. Sound track: hiss-ing steam. (Foley artist: Leave a dry pan on a stove element until it's red hot. Then throw it in a sink full of water.)

The acrid smell of burning sugar. Before J's mother left him, her fa-ther used to spoil the children's appetites with chocolate-sauce experi-ments in the kitchen. They burned their tongues eating it by the spoon-ful. Years later, J's husband would spend hours in the kitchen when it was his turn to cook dinner. As she waited tactfully in another room, the scent of stir-fried vegetables would give way to the caramelized, burnt smell she remembered. The meal ruined, again, he would be frustrated and angry, she soothing and cautious. They would eat warily at 10 P.M., saying little.

Burnt sugar: the smell of divorce.

Mildew. For this shot, pan a few square inches of a ticking-striped mattress, slightly stained. Then pull out of focus and stay there. Sound track: crickets and frogs. Forty seconds into the one-minute shot, a bell rings once.

Mildew is the smell of her paternal family, of the house on the bay in Alabama, where everything was always rotting and turning into some-thing else. Cast-off furniture came there to decay in peace. Lichens and vines felled the cedar trees, which rotted fragrantly on the damp ground. Barnacles ate the posts until they collapsed in the bay. Metal screens rust-ed into lace. Mildew filled her with fear, associated with her wild-eyed preacher grandfather, the fear of passion and shouting and things falling apart.

Lavender. Projectionist: Ask the audience to put on the blindfolds pro-vided. At the back of the auditorium, heat dry lavender flowers over a hot plate. Place a fan in front of the hot plate and turn it to the lowest setting. At this point the film is composed, in the style of Paul Sharits, of alternat-ing purple and green frames. If anybody peeks, the screen will look gray but luminous. Sound track: a soft, low woman's voice singing "My Favorite Things."

J's great-grandmother grew lavender. She was J's mother's mother's mother, and her name was Moo. She lived in Texas, and she had a tiny concrete pond with two goldfish and lots of snails. After Moo died, J's mother smuggled her lavender into Canada, hiding the plants in her lug-gage with soil on their roots and some worms. The silvery bushes thrived,

and when J trod on them in the night the scent billowed around her. They would stand in the yard and crush the flowers between their fingers.

Later J would shake lavender oil on her pillows. The visitors to her bed smelled of sex and lavender. Now the smell both calms her and makes her want to masturbate. She feels a bit strange about this, but not enough to stop.

Brackish water. Just show it: a traveling shot, late afternoon, along the edge of the shallow, golden-brown water to where a hermit crab rocks in the small waves. (This has to be one continuous shot: be patient.) Then (in a cheap version of the virtuoso swimming-pool shot in *I Am Cuba*) the camera plunges into the water and turns slowly. Ambient sound.

Half-fresh, half-salt water has the tang of salt and seaweed and the murky smell of decaying leaves, tiny fish and bits of flotsam. The rotting stuff in the shallows is inviting to bottom-feeders and interlopers. In Alabama J gradually learned to love mildew, rot, and transformation, and to admire the hermit crabs who took over dead creatures' shells.

Shit. Close-up, slightly out of focus, on a shimmering brown mass. Use a polarized lens for a starry glamour-shot look. Then pull back slightly, slowly, until it emerges into focus as a soft, well-shaped turd. A wisp of steam rises. On the sound track, the moist impact of turning over the soil in a flower bed, with an overlay of chimes.

After thirty-odd years, J began once again to enjoy the smell of her own shit.

IV. Haptics and Electronics

10. Video's Body, Analog and Digital

Video seems to have come of age as an art form[1] only at the time when technically it has been upstaged by the standards of the faster, more "interactive," and more virtual digital media. In this, video follows the time-honored pattern in which forms of aesthetic expression are valued most highly when they become obsolete or threatened. Video is dead; long live video!

It is easy to say that analog video had a body, insofar as it depended on the physical support of the cathode ray tube and electronic broadcasting. By contrast, given that it is common for critics to say that digital media exist only virtually, digital video seems to have given up its body. However, developments since the advent of digital video show that artists are taking the opportunity to reflect on the nature of the new medium. To gain a sympathy with the video medium as a perceiving and communicating body, I take a phenomenological understanding derived from the work of Vivian Sobchack.[2] How does analog video perceive the world and use its body to communicate? How do this perception and communication change in digital video? How do our own perceiving bodies respond to each medium?

Many digital video works seem to be in disavowal of the lost analog body and attempt melancholically to recuperate it. Others are exploring the structure of digital video in an attempt to isolate its own typical embodiedness. Digital video is asserting its particular embodiment through

147

a nostalgia for the analog; by reasserting early analog techniques; through a perverse celebration of the medium's unnaturalness; by exploring the digital medium's particular way of decaying; and through live mixing. Through their particular styles of embodiment, these works also reflect on the state of human bodies in analog and digital worlds.

I follow the common definition of an analog medium as one that creates an indexical representation of reality. As I argue in "How Electrons Remember," in this volume, the body of analog video is constituted from flows of electrons that maintain an indexical link with the physical world. For example, a certain wavelength of purple is captured by a corresponding configuration of electrons on tape. Thus analog video has a body that is analogous to the visual and electronic reality to which the video camera or videotape was exposed. It perceives the world and expresses its perception to viewers.

Traditionally, video artists explore the embodiment of analog video by interfering with the electronic signal: introducing feedback and other effects that disrupt the flow of electrons from transmitter to receiver, even selectively demagnetizing the tape itself. Our bodily relationship to the medium consists in "identifying" with the attenuation and transformation of the signal, the sense of passing of time and space during transmission, the dropout and decay that correspond to our bodily mortality. As analog video perceives and embodies the world, so we in turn share video's embodied perception.

A digital medium, by contrast, is one that translates reality into a series of 1s and 0s. While the basic matter of analog video is color and sound waves, hard-core structuralists will conclude that digital video's structuring principle is the vast database of *information*: of frames, pixels, or 1s and 0s (choose your unit). More generally, Lev Manovich argues that the database is the symbolic form of the computer age, which has its own poetics, aesthetics, and ethics.[3] In digital video the wavelength of that purple mentioned above is approximated as a string of 1s and 0s. What makes digital editing and storage so attractive is that image and sound are rendered as information, easily manipulated. One of the key sites of digital video's nostalgia for analog video's relatively innocent perceptual relationship can be described in C. S. Peirce's terms as a longing for Firstness. Firstness takes place in that microsecond when something appears to perception, but before it has been distinguished from other phenomena (Secondness) and related to symbols and other general rules (Thirdness). By being analogues of the things they perceive, analog media retain that sense of dumb wonderment in the face of the world.

Digital media, by definition, render all they perceive in terms of Thirdness. Yet since the purpose of computers is to carry out tasks that are too boring or cumbersome for humans, tasks that are specifically cognitive, it doesn't necessarily follow that because the digital medium experiences all its objects symbolically (as 1s and 0s), so too must the human viewer. The sense that digital media are hypermediated, that they are thinking very hard and very consciously, arrives more from the human-made programs that encode their thoughts. A work edited on a platform like Avid XPress or Adobe Premiere often seems more cogitated than works edited linearly. Especially if the editor is new to the digital medium, special effects often overwhelm the immediacy of the images and sounds themselves. So the Firstness of contact with the world that is afforded by analog video is diminished.

A new Firstness emerges, however, that is a function not of the intrinsic relationship to the external world but of qualities immanent to the digital medium. Central among these qualities is the medium's tendency to deactualize. Digital video's virtuality is always hovering at the limen of its audiovisual manifestation. When we see and hear a digital work, we are witnesses to the artist's *decision* to render this information in a form more or less like that from which it derived. The range of choice possible in digital rendering, the number of ways the database can be made manifest, is vast. Rather than generating an analog-looking audiovisual image, one could choose to use simple software that generates sound from visual information; or convert sound information to instructions to motors; or indeed stream that information over the Internet to be reconstituted at the end, one hopes but never knows, into visual and sound images. These conversions are achievable through a number of hardware-software platforms, including David Rokeby's The Very Nervous System.[4] The existential connection with the physical world is therefore quite attenuated in digital video. Digital video art explores the medium's embodiedness by playing not with the signal, but with a discrete set of information.

In principle, digital video, by "knowing" everything that it holds in memory, offers a weaker link to the phenomenal world it records. In practice, since both media retain so much more than we human perceivers grasp, each is capable of acting as our surrogate audiovisual preconscious. Digital phenomena also have properties that mimic our bodies' exceptional abilities. Synesthesia, for example, our own bodily way of translating information among modalities, is a kind of embodied thinking that can be accomplished by a translation program acting on a database. "Whenever I hear the name Francis I taste baked beans";[5] and whenever

The Very Nervous System detects light it operates fans (if that's what it's been programmed to do).

One of the most striking differences between analog and digital video is in the editing. Analog editing, also called linear editing, enforces that images be positioned sequentially according to a carefully preconceived script, so that the result is additive, 1 plus 1 plus 1. Digital editing allows the editor to return to any point in the work and change the order of images, insert a sequence or a single frame. Digital editing works with what Milan Kundera called the small infinity between 0 and 1, adding density without necessarily increasing the work's length. While analog editing temporalizes, digital editing spatializes.[6] Numerous recent works exploit the nonlinear medium's ability to extend into space rather than time. A video by Kika Thorne, *Work* (2000), exploits nonlinear editing to "tell" the story of an artist who gets fired from her crummy day job but finds fulfillment in other kinds of work. Each scene is shot from slightly different angles, sometimes with a time shift, and presented on adjacent screens, so that rather than following a story from a particular point of view we experience a series of slightly disjunct affective moments. Thorne uses the open form to multiply the intensity of each moment rather than extend it into narrative. *ASCII Alphabet* by Dorion Berg (1999) pushes the database logic of representation to an extreme. Berg creates a series of paired binaries drawn from the quaint images of a 1960s children's encyclopedia and assigns each a corresponding sound, along the lines of cow and "moo," ambulance and "Augh!"[7] These are strung together according to the encoding rules of ASCII code, engendering a digital universe in which a highly circumscribed image-sound vocabulary comes to stand for everything it is possible to represent, in a logic both wacky and inexorable.

Given the extreme manipulability of digital video, Manovich suggests we understand the history of art as a long history of painting, in which

Still from *Work* (1999), by Kika Thorne. Courtesy of V Tape.

Still from *Work*. Courtesy of V Tape.

photography and live-action movies constitute a brief indexical blip. "In retrospect, we can see that twentieth-century cinema's regime of visual realism, the result of automatically recording visual reality, was only an exception, an isolated accident in the history of visual representation, which has always involved, and now again involves, the manual construction of images. Cinema becomes a particular branch of painting—painting in time. No longer a kino-eye, but a kino-brush."[8] Manovich's provocative assertion emphasizes the voluntarism of creativity in a painterly medium. In the database medium, the image's origin is less important than the decision to actualize the virtual image in a particular way.

Because it is a database manipulation, digital video erases the difference between editing, animation, and special effects. Most spectacular among these is the digital animation known as morphing, which is achieved by mapping one set of information onto another. If you map points on an image of a tomato to points on an image of a child's face, for example, you get an animation of a tomato metamorphosing into a child. People often find morphing *unheimlich* or uncanny precisely because it transcends our body's selfsameness.[9] Sobchack notes that while the long take so beloved of André Bazin corresponds to the body's duration in time, "morphing and the morph deflate in humanly meaningful temporal value proportionate to their inflated spatial display of material transformation as both seamlessly reversible and effortless."[10]

The morph effaces mortality and replaces it with the endless recuperability of the database. Reflecting the ultimately rational, or at least knowable, quality of the database, the most interesting of video artworks that use morphing draw attention to the rhetorical quality of the morph, the visual *argument* it makes by suggesting that one object can be transformed into another. Commercial examples of morph-arguments abound,

from Michael Jackson's *Black or White* music video (1991) to the trans-forming bodies in *The Cell* (Tarsem Singh, 2000). Art examples include Steina's *A So Desu Ka* (1995), Daniel Reeves's *Obsessive Becoming* (1997), Philip Mallory Jones's *First World Order* (1998), which "argues" that African diaspora cultures are fundamentally connected, and Robert Arnold's *Morphology of Desire* (1998), which "argues" that all Harlequin romances, if we can judge them by their covers, are iterations of an ab-surdly similar theme. A virtuosic work of digital editing, *Locked Groove* by Caspar Stracke (1999) cycles through a series of shots of people doing repetitive manual labor. Stracke digitally compresses each shot temporal-ly and accelerates the sequence, until all the workers' actions morph to-gether into one grotesque movement, lurching into the simulacral realm of the morph. Stracke too is using digitization rhetorically, to compare rationalized labor to the rationality of the database: *Locked Groove* sug-gests that not only the medium but human behavior itself is becoming more digital.[11]

The uncanniness of morphing speaks to a fear of unnatural, trans-formable bodies. If digital video can be thought to have a body, it is a strikingly queer body, in the sense that queer theory uncouples the living body from any essence of gender, sexuality, or other way to be grounded in the ontology of sexual difference. Untroubled about its naturalness (is it indexical or simulacral?), digital video refuses the doomed search for origins. Like the choice to render the database of information audio-visually, digital video reflects a voluntaristic choice to have *this* kind of body, for now. Rejecting the linear structure that leads inexorably to an end, digital video celebrates its brief desiring connections in the here and now of each surprising edit. Flaunting the images and sounds plundered from commercial media's closets, digital video recombines them with campy panache, in a sort of digital drag. What digital video loses in in-dexicality, it gains in flexibility.

Analog Nostalgia

Paradoxically, the age of so-called virtual media has hastened the desire for indexicality. In popular culture, now that so many spectacular images are known to be computer simulations, television viewers are tuning in to "reality" programming, and Internet surfers are fixating on live web-cam transmissions in a hunt for unmediated reality. Among digital videomakers, one of the manifestations of the desire for indexicality is what I call analog nostalgia, a restrospective fondness for the "problems" of decay and generational loss that analog video posed. In the high-fidelity

Still from *Locked Groove* (1999), by Caspar Stracke. Courtesy of the artist.

medium of digital video, where each generation can be as imperviously perfect as the one before, artists are importing images of electronic dropout and decay, "TV snow" and the random colors of unrecorded tape, in a sort of longing for analog physicality. Interestingly, analog nostalgia seems especially prevalent among works by students who started learning video production when it was fully digital.

Related to analog nostalgia is the brave attempt to re-create immediate experience in an age when most experience is rendered as information. There is a new performativity in digital video, a yearning to have perceptions that nobody has perceived before. My favorite example of the longing for Firstness in an age of Thirdness is Steve Reinke's *Afternoon, March 22, 1999. Afternoon* is a virtuoso performance for Reinke's brand-new digital camera, which he manages to tuck in his armpit so that he can speak into the microphone while testing the properties of the lens. Edited in camera, it pays no mind to the medium's postproduction potential. In one sequence, Reinke holds up a slide of a painting to the camera and asserts that the test of a good artwork is whether it's more interesting to look at it or to look out the window. Doing the latter, from the window of his high-rise apartment, reveals a bleak view of more high-rises flanked by asphalt and a couple of bare trees. Sharing this view, we perceive the simulacral quality of much of everyday life and understand

that Reinke is patiently searching for a flash of unmediated, quietly existing life. Later, when the camera discovers a robust ball of dust under the artist's desk, we feel that we're in on a discovery as important as the helical structure of DNA: Life! Longing for the material in a virtualized world, Reinke finds it by waiting, and by transferring to us viewers his own embodied relationship to the new camera.

Another sign of the search for analog life in digital video is the general resurgence of the performance video form popular in the early 1970s among artists such as Hannah Wilke, Vito Acconci, Lisa Steele, Joan Jonas, and John Watt. Now that the medium is so easily manipulated, performance, with its dependence on the fidelity of the video witness, celebrates the performer's body not because of the physicality of the medium, but despite its lack of physicality. Many contemporary performances for video are unedited and single shot, mimicking the technology-driven duration of early '70s tapes. While Reinke's tape is a bravura example, many recent works look like they could have been produced in 1972, except for that giveaway digital shimmer: single-shot sight gags for camera; intimate, improvised performances; endurance feats that require indexical witness; feedback experiments that take advantage of machine randomness. As in the earlier generation, many of these performers are

Still from *Afternoon, March 22, 1999,* by Steve Reinke. Courtesy of V Tape.

women: they include Alex Bag, Pipilotti Rist, Ann McGuire, Emily Vey Duke and Cooper Battersby (a man), Cathy Sisler, and Jennifer Reeder. Vey Duke and Battersby's stunning video *Rapt and Happy* (1998) tests the highly mediated and spatialized digital form against the bodily mediation of performance. The artists' bodies are ever-present: Vey Duke sings her voice-overs; they black out their teeth with licorice as she relates the thrilling experience of punching her boyfriend in the face in a restaurant; they illustrate the complexities of a ménage à trois with simple line drawings. After so much photographic mediation, the indexicality of a line to the hand that drew it embodies the artists' presence in a refreshing and compelling way. The young artist Benny Nemerofsky Ramsay combines the complexity of the digital image with the immediacy of performance in his karaoke-style videos *Je Changerais d'Avis* (2000) and *Forever Young* (2001). In each, the frame is divided into multiple sites, each of which interprets the tender words of the pop songs: a sign-language interpreter, translations running along the bottom of the screen, and sublime found footage of data streams and satellite weather reports. They compete for our attention, but the winner tends to be the small frame of Ramsay, singing sincerely and well. In *Forever Young*, trembling slightly in a sequined halter top, he cries real tears as the song ends: "Do you really want

Still from *Afternoon, March 22, 1999*. Courtesy of V Tape.

Still from *Rapt and Happy* (1998), by Emily Vey Duke and Cooper Battersby. Courtesy of V Tape.

to live forever? Forever young." The bland popular-culture images, digitally recombined, generate a smooth surface, a tabula rasa, on which Ramsay writes with his own body and voice the promise of the new.

A disturbing work that combines the shock of indexicality with the deliberate liveness of performance is Miranda July's *Nest of Tens* (1999). This complex work documents performances in several registers of self-awareness, including those of July herself. But July draws on the discomfort of watching performers who presumably aren't in control of their representations: children, and a mentally retarded man who holds a press conference on his book listing common fears. It's similarly disturbing to watch the performances of children in this tape, for even if they are following direction, their innocence gives their actions a performative quality, as though they become what they enact in a way adult actors cannot. In one sequence, a young boy places a female infant on the carpet and proceeds with a sort of surgical ritual, outlining her naked body with cotton balls, carefully soaping, cleaning, and fanning her (she cries nonetheless); he spits a gum bubble on her belly. Then the boy draws a sequence of 0s and 1s on paper, which he proceeds to *play* as though it were a remote control connected to the baby. Like Stracke's *Locked Groove*, this sequence literalizes the way people embody digitality in the world. But its documentary quality emphasizes the irrevocability and shared responsibility of performance: the baby is truly vulnerable and her cries are real.

Digital Mortality

Digital media are as fragile as analog, if not more. Digital video's vulnerability is most evident in low and obsolete technologies. Consider Quicktime: a low-res digital video recording suitable for real-time transmission. Sobchack notes that Quicktime marks a specific point in the development of the medium, already obsolete and all the more important.[12] Winston Xin's gritty little video *Boulevard of Broken Sync* (1995), in the obsolete medium of Quicktime 1.0, reminds us how ephemeral digital media are. It's a letter to an ex-boyfriend who insisted that Xin not show his picture in his work, and Xin complies by exploiting the pixellation and random effects of early Quicktime. While Xin's voice-over tells how his ex requested the artist not use his image, we see the silhouette of a man, evidently the boyfriend, infilled with the moiré patterns symptomatic of the low-res medium. In its decay and tendency to overlay images with the random interjections of the medium, *Boulevard of Broken Sync* is more like a memory of a love affair than a document of one.

While analog video suffers from bodily decay as the tape demagnetizes, digital video decays through "bit-rot," William Gibson's evocative term for lossy compression, information loss that renders images in increasingly large and "forgetful" pixels.[13] Crime TV shows use digital forgetting to blur faces into pixels. Artworks use it to metaphorize memory

Still from *Nest of Tens* (1999), by Miranda July. Courtesy of the artist.

and information loss. In *Déconstruction* by Rémi Lacoste (1997), a shot of a building being demolished is rendered virtual by digital editing: the building reassembles, deconstructs again, and then deconstructs more terribly due to image compression, a kind of digital Alzheimer's where the image is saved as just a few bytes of memory. Anthony Discenza's *The Vision Engine* (1999), *Phosphorescence* (1999), and other works exploit the ability of pixellation to render the familiar strange. *Phosphorescence* begins with Rothkoesque images, gorgeous scumbled forms in deep red, lemon yellow, and blue-gray. Stripped of the digital algorithm that transformed them, the source images turn out to be banal evening news broadcasts. Plundered images are manipulated so as to give us the immediacy of presymbolic perception: again, wresting Firstness from the jaws of Thirdness.

Following the innovations of electronic musicians, video artists now provoke the digital image to stutter and break down in ways only a digital image can. Many works mimic digital errors like the skipping of a CD, and are structured around the resulting rhythm. Also, in what Tess Takahashi calls "hand-processed" digital video, artists are intentionally messing with the hardware: turning the computer on and off, or plugging the "audio out" into the "video in," liberating the electrons to create random effects.[14]

The recent phenomenon of the live video performance also meditates on the ephemerality of digital video. Live video artists use digital cameras, pro-sumer mixing boards, homemade hardware-software platforms, and sometimes their own bodies to produce one-time audiovisual events. Images are synthesized live or translated in real time into other sorts of information, such as sound and movement. Live video celebrates the ephemeral body of digital cinema, for it can only exist live; live-to-tape video documents are just that.[15]

Scrappy analog-digital hybrids are emerging as live video artists take advantage of both the physicality of the analog interface and the storage and retrieval capacities of digital media. One of these, the video jukebox *Triggers* (2000) by Benton Bainbridge, aka Valued Cu$tomer, has a bulky interface that stresses the work's physicality. It's a four-foot-long Plexiglas box threaded inside with a web of red and white wires. Each connects to one of sixty backlit buttons at one end of the box. Pressing a button signals a computer to retrieve one of sixty short videos from a hard drive, through software for DJs called VidVox Prophet. Although it would be easy to play a new video each time somebody presses a button, Bainbridge reprogrammed the software to wait until the previous video is finished, like a jukebox and unlike the mindless "interactivity" of many video games.

The videos themselves are compulsively enchanting exercises in hard-core analog synthesis. Their style varies tremendously but each instills synesthesia, as the image is generated from the artist's electronic music. The video's scan rate can vary with the pitch of the sound; the CRT can act as an oscilloscope; or a video switcher can generate effects in response to loudness, such as strobe, color, negative, and feedback. Bainbridge practices the image synthesis, performs it live, and shoots the result off an oscilloscope. This may sound tech-driven, but each video has a distinct character. *Saw Zall,* for example, dedicated to Naval Cassidy (aka Jon Giles, Bainbridge's live-video performance collaborator), generates from the twitchy, flatulent music a hairy oscilloscope thread that tangles back on itself, together with frantically pulsing negative shapes; yet all in understated tones of gray and sepia. It's an affectionate summary of Naval's personality.

Digital culture is a narrative theme in numerous recent videos as well as commercial films. Fewer are the works that meditate in their *form* on the ways computer-mediated life alters human experience, such as those I've discussed here. Digital video reflects both on the database as the outer boundary of knowledge and on the mortal life, the human and machine error, that cannot be contained in a database. Flaunting artifice, it paradoxically allows artists to restore authenticity and embodiment to their performances. Yet digital video's virtual body becomes physical as soon as one pays attention to the hardware-software platform on which it was built. At this level, the faulty interface corresponds to human efforts to make do with imperfect resources. Machine error creates new opportunities for randomness, which is the source of life. Digital video knows its body is not natural but is nonetheless mortal. It perceives for us humans the uncanniness with which it is possible to slip out of life and into virtuality.

11. How Electrons Remember

Viewing a thing from the outside, considering its relations of action and reaction with other things, it appears as matter. Viewing it from the inside, looking at its immediate character as feeling, it appears as consciousness.

—**Charles Sanders Peirce**

This essay will argue that digital images are existentially connected to the processes that they image, contrary to common understanding. Thanks to the ability of subatomic particles to communicate along traceable pathways, we can fairly say that electrons remember. The two fundamental questions on which this argument is built will prompt exciting forays into quantum physics and electronic engineering. First, what is the material basis of electronic imaging? Second, is this material basis significantly different for analog and digital electronic imaging? I invite the reader to assume a subatomic empathy as we look at the life of the electrons in electronic imaging. Readers familiar with theoretical physics or electronic engineering may find the following annoyingly simplified, but they may also appreciate the enthusiasm of a neophyte, me.

The activity of electrons exemplifies what Manuel De Landa calls nonorganic life. De Landa argues that supposedly inert matter, from crystals to the rocks and sand in a riverbed, exhibits self-organizing behavior and even acquires experience, which entitle it to be considered nonorganic life.[1] In effect, De Landa is saying not that rocks are like humans

161

so much as that humans are like rocks. Yet the reverse is implicit: he effectively rearticulates life as something that is not the sole property of organic creatures. I suggest that the same nonorganic life exists at the level of subatomic particles. The memory that I attribute to electrons does not have to do with will or self-consciousness, but with an emergent self-organizing principle.

We might also say that electrons have life insofar as they communicate, and they communicate insofar as they are interconnected. This is true of all of us, according to Charles Sanders Peirce's notion of *synechism*, the basic principle of connectivity. Peirce held that all reality is interconnected through the never-ending process of semiosis, of utterance and interpretation. By Peirce's account, ultimately there is no distinction between matter and thought. "All 'signs require at least two Quasi-minds: a Quasi-utterer and a Quasi-interpreter,'" Peirce wrote. "Thought is not necessarily connected with a brain. It appears in the work of bees, of crystals, and throughout the purely physical world; and one can no more deny that it is really there, than that the colors, the shapes, etc. of objects are there."[2] By this account, trees certainly fall in the forest regardless of whether any conscious being is there to witness the event. A tree's falling is an utterance, which is interpreted by the ground on which and the air through which it falls. Subatomic particles, too, are continually uttering, or at least Quasi-uttering. They only truly come into being—and the same is true for all of us—when their effects are Quasi-interpreted.

It is common for critics to note that in digital media the indexical link between image and represented object, the existential connection between them, is irrevocably severed. In photography, film, and analog video it is possible to trace a physical path from the object represented, to the light that reflects off it, to the photographic emulsion or cathode ray tube that the light hits, to the resulting image. In digital imaging this path is not retraceable, for an additional step is added: converting the image into data, and thereby breaking the link between image and physical referent. Any iteration of the image may be altered, and there is no "generational" difference to alert us to the stage at which the change occurred. For many people (usually, media theorists more than practitioners) this qualitative change occasions fear for the status of the image as real. Practically, as a result of the potential digital alteration of any electronic image, video and photography can no longer serve as indexical evidence, for example in the courtroom. Theoretically, the semiotic foundation of photographic images in the real world is thought to be destroyed in digital media.

These concerns are accurate, though it is exaggerating to see the advent of digital media as a watershed between truthful and constructed image making, as historians show that photographic media have been tinkered with since their inceptions. What I question in the current rhetoric about the loss of indexicality in the digital image is that it assumes a concurrent loss of *materiality* of the image. As a result it is assumed that digital images are fundamentally immaterial, and that, for example, to enter cyberspace or to use VR is to enter a realm of pure ideas and leave the "meat" of the material body behind. Digital and other electronic images are constituted by processes no less material than photography, film, and analog video are.

When we look at the physical process whereby electronic images are constituted and transmitted, we find that it is indeed possible to retrace the path traversed by the image. Electronic imaging is indexical in the broadest sense, in that the medium is the physical trace of the object whose image it transmits.[3] I will argue that the analog or indexical relationship is maintained insofar as the activity of electrons can be traced to a wave function. When the wave function is broken, the indexical bond is lost as well. Yet we can still trace digital information to interconnected matter.

Certainly the electronic image, both analog and digital, would seem to be a physical object insofar as it is constituted by barrages of electrons and photons. Gene Youngblood enthusiastically made this point back in the analog days: "On the most fundamental level electronic visualization refers to the video signal itself as a plastic medium, as the 'material' of electronic presence. . . . This isn't visual art or picture-making; it is the thing itself, the visible process of the electronic substance."[4] Yet in my plunge into the world of physics I have found that the field is still fraught with questions concerning the entity of the electron. Roughly put, is it a particle or is it a wave, is it a thing or merely a symptom, and does matter as such exist or can it only be approximated by equations?

Do They Exist, and Can We Know Where They Are?

To trace the various electronic pathways through cathode ray tubes, silicon chips, copper cables, optical fibers, and other media, it is first necessary to look at the behavior of individual electrons. This means entering the world of quantum physics. The excursion that follows cleaves to the minority "realist" interpretation associated with Albert Einstein, Erwin Schrödinger to a degree, David Bohm, and John Bell, as opposed to the dominant "positivist" argument associated with Werner Heisenberg and

Niels Bohr. This division in physics is remarkably similar to the camp differences in semiotics about the relationship of the sign to reality, and hence the question of whether reality is knowable in itself or only through signs. Realists like Bohm are more like Peirce, while positivists like Heisenberg are more like Saussure. The former argue for a material connection between reality and the description of reality, while the latter argue that the connection between the two is entirely symbolic, or at least can only be *understood* in symbolic terms. A realist myself, I choose to learn from Bohm's theories for the same reason that my semiotic loyalties lie with Peirce.

It may surprise other readers, as it surprised me, that quantum physics is now considered not a radical theory but an orthodoxy among physicists, to the degree that an acronym, QUODS, has been coined for members of the quantum-orthodoxy-doubting subculture.[5] Since we humanities scholars are supposed to mistrust orthodoxies of all sorts, this news may invite us to look more sympathetically on the continuing debates among the last century's physicists.

Most physicists, following Schrödinger (as interpreted by Neils Bohr), Werner Heisenberg, Max Born, and others, believe that at a quantum level we cannot know matter as such.[6] Orthodox quantum physics is nonobjective, that is, does not assume that its mathematical models have a physical counterpart in the world. In contrast, the pocket of "realists" represented most strongly by Einstein and Bohm posited an ontological theory of quantum mechanics: quantum mechanics does not simply provide a mathematical model for the world but describes how things are. For the realist minority, there is continuity between classical and quantum physics, in that both describe actual material events.

Quantum physics dates to early twentieth-century confirmations that subatomic particles can also be described as waves. In 1905 Einstein demonstrated that light behaves in the manner of particles having energy $E = h\lambda$, where h is Planck's constant and λ is the wavelength of light. His special theory of relativity, the famous $E = mc^2$, argued that space and time must be treated similarly. From these two discoveries Louis de Broglie, in 1926, calculated that photons must have wave properties, and that their momentum, p, can be calculated by $p = h/l$. De Broglie termed his discovery the "pilot wave theory," because it implies that every particle is accompanied by a wave.

That same year Schrödinger suggested an answer to the question, if a particle was a wave, how could that wave change with time so that it satisfies these two equations and still move as a particle? His answer, a dif-

ferential equation for the wave form of a subatomic particle, is still the cornerstone of modern physics. This equation gives the probability of where a particle (an electron or a photon) will be observed at a given moment, if an observation of its position forces it to become localized. To predict where an electron is likely to be, look at where Schrödinger's wave function has a large amplitude. Where the amplitude is small, electrons will be scarce. Where it's large, there will be lots of electrons. Schrödinger's equation was revolutionary because it combined particle and wave functions, making it possible to interpret the behavior of matter as both wavelike and particlelike. What takes the equation out of the realm of materialism (describing physical matter) and into positivism (describing only what can be observed) is that the electron's position remains unknown, and the wave equation can only predict the *probability* of where it will be seen if observed.[7]

In 1927 Heisenberg took this development further in the direction of positivism with his uncertainty principle. When an electron that has been struck by a gamma ray emits a photon, whose momentum is designated p and position is designated q,

$$\delta p \times \delta q \geq h$$

—the product of the uncertainty of the electron's momentum and of its position exceeds Planck's constant (h). Using this equation we can calculate the photon's momentum with great precision if we give up knowing anything about its position, and vice versa. Further, the equation implies that we can't know either of these quantities independently, just their statistical spread δ. (The same equation describes the relationship of time and energy.)

According to the Heisenberg uncertainty principle, the measurer of subatomic particles is part of the experimental situation and influences its outcome, for electrons behave differently when they are being "watched."

 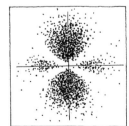

8.0 Å

Electron probability distributions for hydrogen.

It would seem that the wave only collapses into a single electron when it is being measured. If it's measured with a wave detector, waves are detected; if with a particle detector, particles are detected.[8] This finding supported the emerging belief that said the electron (or photon) is epistemologically unknowable.[9] Heisenberg's uncertainty principle has filtered into popular culture in a slew of metaphors, for example the argument that people behave differently when they are observed by a camera than they would if the camera were not there. But physicists continue to debate how to interpret it, and whether to bother.

At the history-making Solvay conference in Brussels in 1927, de Broglie, supported by Einstein, proposed the pilot-wave theory. However, at the same conference, Heisenberg and Born introduced their theory of quantum mechanics, a theory of particles that explains discrete or "quantal" properties observed on the quantal scale. Their theory was embraced, despite Einstein's complaint that it did not fully explain the physical world, and became the hegemonic position in theoretical physics.

Mathematician David Wick points out that quantum mechanics is unique within physics in that its equations are known but not its principles.[10] Orthodox quantum mechanics does not presume to be an ontology, but simply an explanation of our experiences. Hence the common interjection FAPP, "for all practical purposes," in quantum conversations. For most physicists, the fact that quantum mechanics works FAPP deters them from investigating further. The quotable Einstein once compared the "'Bohr-Heisenberg tranquilizing philosophy' to a soft pillow on which to rest one's head":[11] it cannot explain matter, but it successfully describes it. For the most part, quantum mechanics has gone on to other things, with this unknowability tucked away in its fundamental equations.

One of the fundamental paradoxes of quantum physics is *nonlocality*. This principle was first demonstrated in a thought experiment devised by Einstein, Boris Podolsky, and Nathan Rosen (EPR). Two charged particles (atoms or photons) are separated and sent to two devices that detect the particle's "spin," up or down. The direction of either particle cannot be known until it is measured, that is, until the wave function is collapsed.

After many runs,

> detector 1 reads UUDUDDDU . . .
> detector 2 reads DDUDUUUD . . .

In other words, the particles continue to behave as though they are related. The EPR experiment suggests that each particle "knows" what the other is doing. In effect one particle must "wait" until the other particle is mea-

sured, and then take the opposite value accordingly. A classical explanation would require some local hidden variable to "tell" each particle what state to assume when it was measured and then to communicate it to the other, which would assume the opposite state. This is impossible because the particles would have to communicate at faster than the speed of light. The realist Einstein worried about this "spooky action at a distance"[12] that cannot be explained classically. Later thought experiments by John Bell determined quantum theory could explain nonlocality; "Bell's inequality" was popularized in Gary Zukav's *The Dancing Wu-Li Masters,* which fed a burgeoning interest in finding correlations between quantum physics and Eastern mysticism.[13] Nonlocality has been confirmed experimentally. Most strikingly, in a recent experiment at CERN in Geneva, photons separated by an EPR device have traveled over 10 km.[14]

Meanwhile, realist physicists were not satisfied with the mere practicality of quantum equations. They wanted to explain the nature of matter, and thus had to return to the wave-particle relationship. Beginning in the 1940s, David Bohm developed de Broglie's pilot-wave theory to argue that a single electron is a member of a whole of many electrons, joined in a common wave. Electrons are like corks bobbing on waves in the sea. If one electron moves, the paths of the other electrons that are entangled with it on a shared wave will be modified. This hypothesis follows from Schrödinger's equation, which although it is used to calculate the probability that the electron is doing certain things, also describes a relationship between electron and wave. Bohm held that each electron on a given wavelength has the wave function encoded into it. It "remembers" where it came from, and thus remains linked to other electrons sharing the wave even when they are physically far distant. This means that the photons of sunlight that warm our faces are physically connected to the star that emitted them, arriving on a common wave.[15]

Quantum theory's principle of nonlocality means that even distant objects affect each other as part of a single system. The whole cannot be reduced to an analysis in terms of its constituent parts. Individual electrons act as a whole in their connection with other electrons. Not only electrons in proximity to each other, for example, those coursing to their demise on the video screen, but electrons as far apart as those in my hands typing in Ottawa and your eyes reading in Cairo share a common wave.

Bohm explains these relationships in terms of his theory of the *implicate order,* which explains nonlocal connections in terms of implicit patterns. We may think of nonlocality as a specific example of Peirce's synechism, the theory that reality is interconnected through constant

acts of utterance and interpretation. Bohm uses the terms *explicate,* or unfolded, for that which is apparent in a given system, and *implicate,* or enfolded, for that which is latent in the same system. Bohm argues that the universe contains an indefinitely large set of fields that may never be known in their entirety, but that become explicate through movement. Thus the forms that we can identify are contingent unfoldings of a vast, implicate order. "Whatever persists with a constant form is sustained as the unfoldment of a recurrent and stable pattern which is constantly being renewed by enfoldment and dissolved by unfoldment. When the renewal ceases the form vanishes."[16] His elegant illustration is a model of two glass cylinders one inside the other, with a layer of viscous fluid, like glycerin, between them, but otherwise airtight. When a drop of ink is put in the liquid and the inside cylinder revolves, the ink drop is drawn out into a thread or unfolded; when it is revolved in the other direction, the thread of ink is enfolded back to a dot. The line is implicate in the dot.[17] A more controversial example of implicate order is the idea that when I stick pins in a figure representing my enemy, my enemy, wherever he or she may be, suffers as a result. This magic might be explained in terms of nonlocal connections between the two of us. (Not to say that Bohm would have believed in voodoo.) What Bohm's principle of the implicate order means for physics is that we need not distinguish between particle and wave, saying we can measure only one or the other. According to the implicate order, the particle is enfolded in the wave that carries it, and unfolds or expresses itself when necessary—for example, when a light wave hits the surface of a cathode ray tube. In Peirce's terminology, we'd say that the photon stream utters and the CRT surface interprets.

Bohm's ideas were ridiculed or dismissed by most physicists. His intellectual exile was compounded when in 1949 he was called before the House Un-American Activities committee. Because he refused to testify, he was kicked out of Princeton. With a recommendation letter from Einstein, he got a job in São Paulo, but his intellectual death sentence was delivered when the U.S. State Department revoked his passport. Rendered stateless, Bohm was unable to participate in the discussions around quantum physics.[18] Recent research in quantum computing and the "entanglement" of subatomic particles, while not exactly proving Bohm's theories, is evidence that the field is beginning to entertain the idea of nonlocality again.[19]

Analog Pathways

If all matter is intimately interconnected by wave-surfing electrons, then all electronic images have an indexical or analog connection to—matter.

But to what degree do they keep an indexical or analog connection to the object of which they are images? Taking a tip from Gene Youngblood's materialist enthusiasm, let me trace the electronic pathway for an analog video image and then for its digital counterpart.

Say we have a camera, any camera. The light that reflects off an object and is focused on the camera lens is composed of waves. Say it's light reflected from a purple flower, embodying its color in the wavelength defining purple. "Purple" photons, photons with wavelength purple, will converge on the lens, producing an image that is the analog of the purple flower.

Inside the vidicon tube of an analog video camera, the image is focused not on a lens but on a photoconducting layer.[20] Incident light excites electrons in the photoconductor, dislodging photons at wavelengths that continue to correspond to the color of the object being recorded. Then the photon beam from the vidicon's cathode scans the phosphor-coated surface of the photoconductor, stimulating the phosphor to release photons, which are what we see. To "recognize" the light intensity, the beam takes on the charge of the waves ejected by the photoconductor.[21]

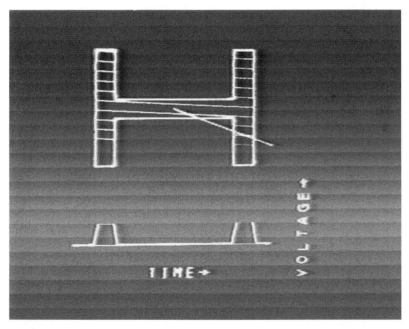

Frame enlargement from *How TV Works* (1977), by Dan Sandin. Courtesy of Electronic Arts Intermix.

All this means that it is individual electrons that travel all the way from the cathode to the screen, where they crash and die a brilliant death in the release of thousands of photons, forming the light patterns on the phosphor-coated surface of a video monitor. In consumer NTSC format, at the rate of 250 pixels per scanline times the same number of lines, this means that each video frame is composed of 625,000 electronic pulses, 60 times a second. So in a conventional analog video image we know that 37,500,000 electrons are giving up their existence every second in order to bring us an image. Or, to speak synechistically, 37,500,000 electrons are Quasi-uttering, and the cathode is Quasi-interpreting them, as photons. In synechism there is no death, only interpretation.

The point of this analog map is to show that a calculable number of electrons move along a set of common wavelengths all the way from the object to the image. In broadcast, the same set of waves disperses into the ether, perhaps to be received by a satellite transponder. When the image of the purple flower is broadcast, its indexical likeness undulates to the ends of the universe on the waveforms that compose it. Images may also be transferred along wires or optical cables. When energy is applied to a wire, a wave populated by hordes of electrons conducts electricity by equilibrating the changing pressure of electrons pushed to one end of the wire. Here their motion is governed by the overarching wave function, as foot traffic in Grand Central Station is governed by the arrival and departure of trains.[22] In all these forms of transmission, thanks to the particle-wave relationship, the images retain an indexical relationship to the object they represent.

Digital Pathways

Now let us imagine an alternative electronic path, this time for an image produced by a digital video camera, stored on a hard disk, and digitally projected. We will see that this activity continues in large part to be wave-driven, that is, constituted by streams of electrons and thus indexical as in the analog situation. But there are two important differences, based on the fact that most computers, being digital, rely on approximations.

What happens when an image is digitized?[23] Say we have a still, color image. A program divides the image surface into small areas (also called pixels) and calculates for each a set of numerical values. These correspond to the intensity, or number of photons per second, for the frequencies of red, green, and blue. The resulting values are translated in turn to a string of 0s and 1s. In this process there are two ways that the richness of the analog information may be diluted. One is in the number

of pixels assigned to the image. The other is the amount of memory devoted to calculating the intensity per pixel. When you set your monitor to calculate "256 colors" or "thousands of colors," you are assigning how long those memory strings are allowed to be.

Loss of Indexicality 1

This simple step is the first crucial challenge to both the indexicality of the image and the individuality of the electrons. It is here that the image loses its existential connection to its referent. Light waves, whose frequency and intensity physically represent the color and brightness of the object, are translated into symbols when the image is encoded in strings of numbers. At this point loss of indexicality is not a question of image quality—a digital image may have higher resolution than an analog image—but of the physical relationship of image to object. Digitization breaks the analogical relationship between object and image, henceforth rendered as information. We shall see that there is another point, perhaps more crucial, where the indexical relationship is broken.

However, within digital circuits, electrons continue to exert themselves in analog ways. To demonstrate this, let me trace the electron's path in the most workaday medium of digital calculations, the silicon chip. Silicon, which is cheap and can be highly refined, is the most popular medium for digital calculations in applications from coffeemakers to smart weapons. Like other elements in the fourth column of the periodic table, silicon is indifferently promiscuous: the four electrons in its outer valence allow silicon atoms to form an extensive network of electromagnetic bonds.[24] Silicon's four-electron bonding produces a crystal structure that is both stable and ductile. While the metals are conductors, meaning that metal atoms catch and pass electrons with the energy of a high-speed, unidirectional soccer game, silicon, which moves electrons more sluggishly, is termed a semiconductor.[25] Controlled impurities in the silicon cause electrons to flow in only one direction through the material. Where negative, there are more free-floating electrons than can be held by the silicon atoms in the crystal lattice, which rush to distance themselves from a charge; where positive, there are a few "holes" to which electrons eagerly migrate when a charge is applied.

An electron can occupy only a given band in the "orbit" of an atom. When voltage is applied to silicon doped with phosphorus, the extra electrons are only too willing to make the quantum jump to a higher state of excitation—chemistry's anthropomorphic term for electrons with no place to go but up.[26] Within the silicon chip, then, electrons continue to

ride waves in a microindexical way. In any transistor-reliant device, hordes of excited electrons are speeding through gates and causing other hordes of electrons to get excited and seek a wavelength of their own, in a ceaseless, frantic relay race. Digital computers by definition work with the binary difference of on and off signals or positive and negative signals. Their OR, AND, NOT, and NAND circuits are operated by combinations of these signals. These circuits are themselves electron pathways.[27] Thus the behavior of electrons in silicon chips continues to index their associated wave.

Loss of Indexicality 2

The crucial characteristic of digital computers that breaks the indexical relationship is the same characteristic that makes computers accurate. Digital computers cannot tolerate intermediate states between 0 and 1. Every circuit contains a "flip-flop" circuit that eliminates intermediate states by ignoring weak signals. Only a strong signal, the cumulative behavior of masses of electrons, registers a change in the circuit. It is at this point that the wave-particle relationship is overridden. The circuit pays attention only to massive hordes of electrons and quashes the efforts of the few. Any change in the state of an individual electron is obviated by changes in the whole. Thus in digital computers, quantum nonlocality, the shared properties of electrons on a common wave, is not observable. Our friend the electron gets lost in the herd.

In each pathway I have described, analog and digital, the transmission of electronic data can be traced to the actions of electrons, or, depending on your point of view, to the wave pattern that organizes them. These road maps show that an electronic image, *whether it is analog or digital,* is implicate, or enfolded, in the interconnected mass of electrons that transmit it along common waves. In digital imaging, however, two steps intervene to break the indexical bond: one that approximates analog information to a symbolic number, and one (repeated in every circuit) that obviates the wave-particle relationship.

The Enfolded Image

In the analog electron pathway, according to Bohm's theory of the implicate order, the image remains enfolded in the waves that carry it from source to transmission. In the digital pathway, *information* is enfolded in the pulses that travel through the computer, but the initial indexical relationship is lost. Yet one does not have to agree with nonlocality to argue that a digital image is enfolded in its code. In digital computers the image

is doubly enfolded: once when it is encoded as strings of 0s and 1s, and again when this information is enfolded in the charge of particles or the length of waves. Analog electronic imaging involves only the second process of enfolding.

To explore the difference between encoding in a language (such as a computer code) and enfolding in a wave, let me describe an artwork for computer by Thibaud Beghin, a Muslim artist who lives in Lille, France. His work *Virtual Prayers* (1996) represents Islamic prayers in the abstract and decorative Arabic script typical of traditional Islamic visual art. But this is only the visible aspect of the work, as manifest on a computer screen or printout. Here the image is the explicate form of an implicate order, the computer code. Beghin also transmits these prayers in encoded form over the Internet or in digital files. In this version the prayers are "enfolded" in ASCII code and thus inscrutable. A religious person would say that the digital code is itself the explicate manifestation of an implicate order, that of prayer.

This encoding seems an appropriate means of transmission for a religious message that is subject to censorship and tends to spread clandestinely. One can imagine these prayers being received by a Muslim in a secular state or one where Muslims are persecuted. As an image their status is very tentative—they are virtual prayers, potential prayers, prayers that the code retains even when they are not manifest in an image legible to humans. Beghin does produce them as ink-jet prints, where each dot represents a translation of the electronic memories. But these are merely manifestations of the prayer; they are not the prayer itself. Encodement or enfoldment is *Virtual Prayers'* most typical state. I would suggest many digital works exist typically in a state of latency, and when they are visible to us this is a rare case of unfoldment.

Quantum Indexicality

The example of Beghin's work emphasizes the distinction between the role of the electron and the role of the code in electronic imaging. The former is physical, while the latter has an aspect that is purely virtual, because it approximates physical reality into symbolic information.

Computers are coming along in which the role of particular particles matters very much. Quantum computers would use a minimum number of electrons, instead of the millions herded into formations of 1 and 0 by digital computers. Quantum computers would work with the superposition of the discrete states, such as orbit or polarization, of single particles. Thus they could make calculations based on the controlled excitation of

ions. They could also use nuclear magnetic resonance (NMR) to detect the nuclear spin of atoms in small organic molecules.[28] If digital computers are like herders of sheep, quantum computers are like flea circuses: they rally a very few, very tiny actors whose individual behavior, though somewhat limited,[29] makes a perceptible difference in the whole.

It is my indexical fantasy to witness an image produced by a quantum computer, perhaps an animated image produced from the varying combinations of two or four electrons in varying states of excitation. Such an image would not be a simulacrum or a mathematical model, but the index of a physical referent, the tiny dance of subatomic particles. Of course quantum physics tells me that such an image cannot be produced, because observing or measuring a quantum system renders the objects mere statistics, destroying the indexical relationship. But nanotechnology is already producing quantum objects, such as the "quantum corral" produced at IBM's Almaden Research Center. A scanning tunneling microscope induces forty-eight iron atoms to share their outer-valence electrons in a standing wave, producing a sunflower-shaped mandala fourteen nanometers across.[30]

I have argued that in the analog electronic image, because of the enfolded wave-particle relationship, a strongly indexical relationship is maintained between object and image through all stages of recording, transmission, and reception. Although it no longer bears an analog relationship to its initial object, the digital image relies for its existence on analog processes and on the fundamental interconnectedness of subatomic particles. Electronic images, like all of us, owe their material being to electrons and their associated wave forms. We are physically implicated in the virtual realms we inhabit, and far from divorcing ourselves from the world when we enter electronic spaces, we are more connected than we may imagine.

Postscript: Analog Leaks from Digital Streams

The technologies in which I have traced the marvelous interconnected life of electrons have been largely developed for military and commercial applications that enslave as well as liberate. At a time when all of space and all objects of perception are claimed as corporate property, we must note that certain encodings are occurring at practically the subatomic level. Nanotechnology is being developed as an applied science by military and biotech companies, and some of their first experiments have been to sculpt atoms into corporate logos.[31] The first applications of quantum computing will likely be bank security and espionage.[32] We

look to the subatomic level for evidence of a new uncharted territory or a new sublime, at the risk of ignoring how all that is perceivable may be or has already been encoded as a proprietary interest. The electrons can play all they want, but we aggregates may find ourselves seduced by the apparent immateriality of electronic media.

When our computers "fail" us, they are closest to reminding us of the physical, fundamentally analog state of the digital medium. When a digital operation fails at the machine (as opposed to programming) level, it is usually because its switches, rather than falling nicely into the on/off positions, register a "maybe." That "maybe" is the product of electrons that abandon their regimented paths, attracted to impurities in the silicon, like workers to a bar. This produces dire results for networked computers and guided missiles, of course. But the noise of a failed Internet connection, for example, is a declaration of electronic independence. It grabs us back from virtual space and reminds us of the physicality of our machines. Noise reminds us not only of the wave-hugging electrons that interconnect all matter, organic and nonorganic, but also of our connections with other humans and our shared less-than-perfect, less-than-virtual circumstances.[33]

12. Immanence Online

In this essay I will describe how we can understand online space not as virtual, transcendent, and discrete, but as material, immanent, and interconnected. I've chosen a number of low-tech and parodic artists' web sites that assert their own materiality and the economic and social relationships in which they are embedded. I'll suggest five levels, from the quantum to the social, at which online works can be an index of material existence. These works offer alternatives to the discourse of transcendentalism that animates corporate-futurist understandings of digital media. They insist that electronic media occupy not a "virtual" space but a physical, global socioeconomic space. It all comes down to interconnected bodies: subatomic bodies, the linked bodies of our computers, our own bodies that act in sympathy with them, and the social body in which we all partake. These works invite us to relate to online media in terms of our shared fragility, corporeality, and mortality.

In contemporary media we are witnessing a bifurcation between, on the one hand, increasingly mediatized and virtualized experience, and on the other, an increasing desire for immediacy, the actual, or the material (more on the distinction between these terms in a moment). From cinema to television to the Internet, some of the most popular images appeal to the desire for the real and for the indexical: evidence that what the image represents actually exists or existed. Reality TV shows, webcam sites, and the celebrated shot of a floating plastic bag in *American Beauty*

all attest to a popular desire for what seems to be immediate. This renewed popular interest in the material, in the physically existent, occurs even as the desire for ever-greater verisimilitude supports the construction of ever more elaborate virtual worlds.

My political critique lies not with virtuality itself but with the assumption that what is virtual must be immaterial, transcendent. Digital media, because they necessarily abstract experience into information, invite us to mistake their information worlds for reality. They invite us to believe that we, too, exist in an abstract realm. For this reason, the discourse of transcendence is always set a little bit in the future, as AT&T's promises suggest: you cannot now but you *will* be able to send a fax from the beach; you cannot now but you *will* be able to tuck in your child from an airport pay phone (should you want to). These promises cannot be made good in the present, for that would require acknowledging that in the material world few people can or will ever be able to take advantage of the promised virtual existence.

The problem with transcendentalist understandings of cyberspace can be understood in the good old terms of dialectical materialism. The recent stock market crash/"adjustment" to the overrating of dotcoms, for example, indicates a misplaced faith in a virtual superstructure, at the expense of understanding that e-businesses are material enterprises like any other. More profound, and underlining the basic mistake of capitalism as well, is the belief that virtual "value" can be created independently of the material world. The transcendental discourse around digital media is based on a desire for immortality that comes only at the expense of severing ties with the material world: this is Sean Cubitt's thesis in *Digital Aesthetics*. Life is analog. The abstraction of communication into information is an attempt to hold mortality at bay, but it takes place at the expense of our own dematerialization.

In seeking a materialist understanding of "virtual" media, I have had to consider the value that I have assigned to materiality. Materialism is, of course, a Marxist remedy to reification, and can simply remind us to perform an economic analysis of who profits and who suffers in the production and exploitation of online space. It also informs a phenomenological interest in the immediacy and irreducibility of lived experience. It is informed by the feminist valorization of bodily existence over disembodiment. Materialism, because it appreciates the world in its transient and corporeal state, is willing to look death in the face. But what unifies my materialist approach to virtual media is a belief that reality is interconnected in multiple ways, and that it is valuable to restore the com-

plexity of these interconnections to the false transparency attributed to digital media.

This essay will mostly be taking an old-fashioned, that is, Marxist, materialist approach. But it's worthwhile to consider a deeper foundation for the nondualism that motivates this writing. The universe is not a material entity, but it is real, according to the views I've adopted from Deleuze and Guattari, Bergson, Peirce, and Bohm. We might call it the plane of immanence, following Deleuze and Guattari: that which contains all that exists and all that could exist. So how is it that some things exist and not others? Bergson would say, the actual emerges from the virtual when someone or something perceives it. Peirce would say, what is actual is what has an effect, in that it produces belief that leads to action. Bohm would say, certain things are explicated from the universe, which remains largely implicate.[1] With such a wealth of ways to understand the relationship between what we know to exist in this world and what remains potential, there is clearly no need for dualism. Marx might spin in his grave at these remarks, or he might take comfort in inverting Peirce, as he inverted Hegel, to say not "Matter is effete mind" but "Mind is effete matter." In a way it doesn't "matter" which formulation we choose; as for Peirce, even if mind comes first, matter is mind on which we can act.

So when I argue that the Web is a material entity, I hope you will keep in the back of your mind the pullulating plane of immanence, full of bodies, ideas, feelings, and dreams waiting to be born, of which our thickly connected material life is the surface layer. There's no need to say anything transcends this material life; it's enfolded in it. What does not exist with us here in the world—what remains immanent—gives us hope for the future.

In the following I will examine five levels of materiality that online artworks index. These are, from micro to macro: quantum, electronic, hardware, software, and social levels. Web art evolves and disappears quickly, but I trust these levels for analysis will come in handy for a while to come.

The Quantum Level

I argue in "How Electrons Remember," in this volume, that even digital images are existentially linked to the physical states of subatomic particles, if one believes a minority position in quantum physics. Thinking of subatomic particles as bodies need not be anthropomorphic, though it does endow all levels of materiality with an uncanny liveliness. Peirce's doctrine of synechism, with its bracing nineteenth-century air of total explicability, attempted to understand the connectivity of all matter in

terms of shared "feeling."[2] This would include the way electrons feel and how they attain knowledge (a mimetic, or embodied kind of knowledge), in their interaction with other particles. At the subatomic level, we may embrace the living materiality that exists on the World Wide Web in terms of what Manuel De Landa calls nonorganic life.

The Electronic Level

At this level we encounter unpredictability: errors, breakdowns, true randomness. The myth of transparency would have us believe that electrons behave the way they do in diagrams. Toronto robotics artist Norm White points out that electrical engineering imagines digital media to produce a square wave, its two poles reflecting 1 and 0. But in reality, those square waves are very wobbly, because the electrons can never be fully tamed by the electronic circuits that herd them around.[3] At a microlevel, then, our digital media are actually analog media: errors occur analogously with these tiny declarations of electronic independence, and it is the errors that remind us of the physical existence of the medium.

The Hardware Level

A well-running platform, for those who have the cash, has a false transparency that makes it quite easy to believe we are operating in a virtual realm. Software, hardware, and server corporations have a deeply vested interest in this myth of transparency and the dependency on their services it creates. But anyone who has a less-than-perfect system, who is working with low bandwidth and obsolete machines, is likely to be reminded often that all this stuff exists at a material level. When our computers fail us we are most forcibly reminded of "virtual" images' physical being. Many artists fall into the hardware upgrade trap, making works that require fast computers with lots of RAM. Others, however, make virtue of necessity by exploiting the aesthetic and communicative potentials of "obsolete" hardware and slow modems.

Redundant Technology Initiative (www.lowtech.org) is a British activist organization devoted to recycling computer hardware that corporations deem "obsolete." In 1998 a page on the organization's Web site revealed a memo circulated by Microsoft to its subscribers, encouraging them to stop using the amateurish and unpredictable ASCII art and instead use Microsoft's clip art. Microsoft's goal is to ensure dependency at every level and to eradicate individual, creative, and unauthorized uses of its software.

The Software Level

The materiality of software asserts itself through viruses, program incompatibility, obsolescence, lack of money for upgrades, and cost. The myth of transparency would have us believe that everyone is working with optimal software—and using it for instrumental, often commercial purposes. Here too, many makers of digital media art fall into the upgrade trap. Those who can afford to, use the newest technologies to produce online works that are inaccessible to audiences who lack the necessary bandwith, memory, servers, and plug-ins. In contrast, works that use low and obsolete electronic technologies may be considered an act of corporate refusal and an insistence on the materiality of the medium.

First among these are works that are intentionally low-tech *or* that mimic a low-tech interface, in a nostalgic reference to obsolete platforms. What deserves to be considered the folk art of the digital age, ASCII art, exploits the text-based interface that graphical interfaces have superseded. ASCII art uses the limited technical means of keyboard characters to produce a great creative variety. For a single example, Veronika Carlsson, at http://www.ludd.luth.se/users/vk/pics/ascii/ASCIIM.HTML, renders beautifully modeled naked men, their angularity recalling the drawings of Egon Schiele, in a sort of digital chiaroscuro. We may consider ASCII art to be an electronic variant of traditional art forms identified with women, such as textiles and embroidery. In their amateur status and private circulation among friends, ASCII sites function as another form of community-based, rather than professional, art practice. Rather than invoke a hierarchy between "low" and "high" arts, I'd like to suggest that ASCII art is not only a legitimate art form outside the professional art world, but a political refusal of the upgrade trap.

People operating within the art world also make reference to the low aesthetics of ASCII art. As well as Vuk Cosic's well-known ASCII music videos, proudly created on an old 386DX, there is Juliet Martin's ASCII-style Web site "oooxxxooo." Martin achieves a sensuous tension between the limitations of the text-based interface, its characters formed into ribbons and teardrops in the style of concrete poetry, and the expressions of longing of the words. "Why can't I find love on my hard drive?" one page asks.

A certain woozy materialism characterizes interface nostalgia, and computer programmers are its best archivists: see programmer Nathan Lineback's extensive archive of obsolete graphical user interfaces.[4] Artist/programmers followed suit: recently, some quite sophisticated artists'

```
            YMMMMMMMMMMMMMMb.::::MMM\
            |....:88MMMMMMMMM...::MMb\
            |....:88MMMMMMMMMb.....:8MMMb\
            bo..do8MMMMMMMMMM .....:88MMb\
            ..|8.8MMMMMMMMMM\ \.....:8MMMb\
            ..|MMb:88MMM*MM\ \.....:8MMM\\
            VMMM8888MMMJMM\ \.::.:8MMMMM|
            \::8888MMMMMMM|\ /.::8MMM|
            \-888MMMMMMMM|:\ /.:::8MMMMM|
            --8MMMMMMMMMMMb/...::8MMMMM|
            --8MMMMMMMMMMM...:8MMMMMMM|
            __--:::::88MMMMMM/..:::8MMMMMMM|
            /...::::....8888MM/..:..::8MMMMMM\
            /....:::....888M/...:..::88MMMMMM|
            /...::................:::::8888MMMMM)
            /...::::...............:::::\8MMMMMM/
            |.................:::::...8MMMMMP
            |.................:::::::8MMMMMP
            |.................:::::::::dMMMMMM/
            |.................:::::::::::8MMMM88|
            |...........*:::::::::...:8MMMM8P
            |...:.............:::::...88MMMP
            |...:............:::::...88MMMM8/
            /....:..............:::888MMMMM/
            /..|..:.............:::::88888MMM/
            /..|..:............:::88888MMMMMP/
            /...|..:...........::::88888MMMMP/
            /...|..:.........::::888MMMMMM/
            /...:|..:.........::88888MMMMM/
            /....|..:......:..::88888MMMM/
            |.::.:|..:...::/....:88888MMMM|
            /..:::.|..:.........:::8888MMM/
            /..::::|..:.........::888M8/
            ...::.|..:..........::888888P
            |...::::|.::.........:.8888888|
            /...::::|.::..:.....::88888888|
            /...::::|.J..:.....:::88888888|
            |...:::::/........::/::888----b
            |...:::://|...::..../dMMMMMMMMMb
            |...:::; ...::../dMMMMMMMMMMMMb
            /...:::/ |....dMMMMMMMMM"""""""""Y
            /.:::::/ |8MMMMMP"""".......888::\
            :::::::/ |8MMMMMP..........8MM8:::\
            |:::::/ |MMMMMP.......:::8MMMM8::\
            /.:::::/ /MMMMMP:......:::8MMM8MMM8::
            ....::/ /.MMMMP.......::88MMM888MMM::
            ......( /..MMMP.......:888MMM888MMM8:|
            ......\ /.dMM|:.......888MMM888888VK:|
            |,,::..) /.|MMM|:.......:88MMMM888888MM:|
```

From "Some naked men . . ." by Veronica Carlsson.
Courtesy of the artist.

Web sites reject the graphical interface in favor of what appears to be an old-style text-based interface, right down to using green or orange text on black screens. They include the celebrated jodi.org, programmed by Dirk Paesmans and Joan Heemskerk, and the mysterious m9ndfukc.com, programmed by the pseudonymous Netochka Nezvanova. These sites make it appear that we've run into the source code. In modernist style, they index the structure on which they are based. We might say that the graphical interface is the superstructure, where source code is the material base; though of course there are several levels of materiality below this one. Theirs is a knowing nostalgia for a cruder interface, for in fact these are some of the most densely coded sites on the Web. On m9ndfukc in particular, the minimalist green-on-black graphics animate into hypnotic images unthinkable in the early days of the text-based interface. This programming is materialist in its acknowledgment of the history of interfaces, and the military applications for which they were developed. However, as I'll discuss later, it is important to distinguish between formal transparency and economic transparency.

Scores of interfaces meet their comeuppance every year as the software companies encourage us to upgrade. Outdated software suddenly calls attention to itself as a physical entity. Losing currency, old software gains a body. (Currency, or cash, equals the ability to translate objects into information; currency is transcendental, while obsolescence is material.) Hence Vivian Sobchack's nostalgia for the wobbly forms and poor resolution of Quicktime 1.0, whose refusal to be "quick" reminds us of the fragility of the interface.[5] A number of artists' Web sites now employ primitive graphics reminiscent of early NASA and the computer games derived from its applications. The Tron-style figures in David Crawford's "Here and Now," for example, evoke the history of the medium, from its military development to the first commercial applications of shoot 'n' kill software. Similarly, Yael Kanarek's "World of Awe 1.0" employs a nostalgic, bug-ridden Windows interface, for an interactive mystery story. Appropriately, it's set in Silicon Canyon, a landfill of obsolete computers. Like the Redundant Technology Initiative, "World of Awe" asks what happens to all that hardware that (like the characters in the '70s science-fiction movie *Logan's Run*) obediently dies upon meeting its obsolescence date. Like other sites mentioned above, "World of Awe" only appears to be low-tech: it's a nostalgic, but not a transparent interface. The site uses Flash as a plug-in, a program that normally hides all its code and links.

Many sites use software for purposes for which it was not intended, in the political practice of "appropriate technology." These sites comment in

structuralist style on the commercialized form of off-the-shelf Web-authoring software like Adobe PageMaker, Macromedia Dreamweaver, Flash, Shockwave, and so on. Commercial software colludes in the corporate attempts to turn the two-way medium of the Web into a one-way medium, as occurred with television in the 1930s. In place of the equal exchange of early days of the Web, a supplier-consumer relationship has been set up, and Web-authoring software is complicit in this unilateri-zation of the exchange. I've identified a few ways in which Web artists subvert the commercial purpose of Web-authoring software: the radio button/click box, the confirmation window, the hotlink, the warning, the pop-up window, and the survey. While these works do not draw atten-tion to the materiality of the interface as ASCII art does, they do point out the commercial purposes built into seemingly innocent software.

Online forms help marketers gather information from consumers, such as credit card numbers. Radio buttons (whose name itself is nostalgic for an analog interface) and click boxes automate the "interactive" process into a series of consumerist choices. Alexei Shulgin claims credit for the invention of Form Art, and sponsored a Form Art contest on easylife.org in 1997. What the genre of "Form Art" does is deinstrumentalize the form and check box, by reconceiving the consumer Web-page template as an aesthetic medium. Commercial Web pages' "content," which is basically a medium for online shopping, is rendered all form, as a random click yields a clattering display of blinking dots—aesthetically pleasing but useless for shopping. A page on Michael Samyn's entry www.zuper.com/form/, "you and me," eroticizes the options of a paired button and box. As they flash in alternating states of arousal, the radio button becomes a vaginal concen-tric circle, the check box a cutely alert phallic symbol.

The hotlink is perhaps the defining form of the graphical user interface. The competition for choice domain names means that a hotlink is already a form of advertising, whether one follows it to the linked page or not. Easylife.org, for example, in 1997 built poems of hotlinks to sites with sug-gestive names—"birth.com, life.org, sex.com, death.org," and so on—hi-jacking their commercial and informative intentions for aesthetic purpose.

Confirmation windows, those little boxes we must click in assent be-fore we can proceed, remind us of the commercial guts of the "free" space of the World Wide Web, as they often index expiry of licenses, encryption programs, and other commercial software. Similarly, warnings (recog-nizable by the yellow triangle containing an !) can be a powerful reminder that all these graphics come to us courtesy of programmers with varying degrees of time and experience. As you know, some sites become inacces-

sible because they have so many errors; to me this creates a material link to the harried programmer working late at night and making mistakes. Both well-running sites and frequently crashing sites index how much time and money they cost to make. As Godard said, "Money is the film within the film," so we may say that money is the true source code of the Web. Warnings become found poems in sites such as m9ndfukc, where we must assent to a series of messages that go, "juzt 1 clik"; "juzt 1 clik"; "bizt du gluchl!ch?+" "ja?+", before getting dumped onto the mysterious e-commerce site "Kagi."

John Hudak's "Short Work," on turbulence.org, combines Form Art and the Warning poem, making these impoverished forms the indexes for sensuous experiences one cannot have online. A tiled image of wintry bare branches and a repeated sample of birdsong ironically invoke the distance from nature. When you click one of the matrix of radio buttons, the warning comes up in the form of a little haiku: "Coughing in the wind"; "the dog's hind legs"; "My son imitates the ferry horn"; "nose in peat and ivy." Here Form Art rejects verisimilitude in order to point past the sensuous limitations of the interface, asking us to imaginatively call up a multisensory narrative.

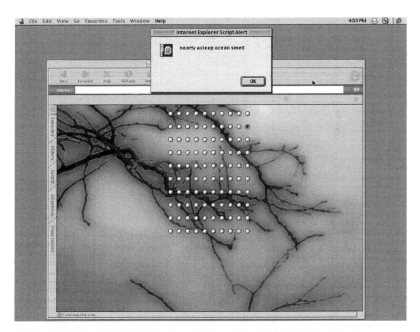

Frame grab from "Short Work" by John Hudak. Courtesy of the artist and turbulence.org.

Like the confirmation window and the warning, the pop-up window, so maddeningly familiar to users of "free" servers like Yahoo!, reminds us of the inexorable limits of the interactive medium, in this case its commercial constraints. Commercial GUIs (graphical user interfaces) use these "sticky windows" to prolong a visitor's exposure to advertising; artists' sites use them to critique the ideology of interactivity. In some art sites pop-up windows fill the screen faster than you can click them closed, until your computer runs out of memory and shuts down. Examples include Alexei Shulgin's "This morning," on easylife.org—in which windows pop up announcing "I want to eat", "I want to smoke," "I want to fuck," "All at Once!" faster than we can click them shut—and the unruly "1.000.000" by Antoni Abad. Clicking on the innocent box in the center of the page elicits a pop-up window with a little movie of the artist's stubbleclad lips forming a kiss. Another pops up, and another, threatening to fill the computer screen with a million osculating mouths. "1.000.000" renders the commercial form of the pop-up window useless and even dangerous, draining our computers' memory reserves to the point of shutdown unless we reject all these virtual kisses by quitting the program. A final example, Emmanuel Lamotte's "exp_140300.html" on his "erational" site, fills the screen with tidy, Mondrianesque pop-up windows that seem relatively benign, until my computer issues the warning: "Memory is getting full, please try to alleviate by closing unnecessary documents."

These sites critique the commercialization of the Web in a formal manner, by making "inappropriate" uses of commercial software. Yet a more radical critique lies in making software available to other users, harkening to the days when work on the Web was a radical exchange of information without regard to its status as intellectual property. Here m9ndfukc, for example, reveals its commercial stripes on an embedded sales page, kagi.com, in which its proprietary software is for sale in U.S. dollar amounts prohibitive for many noncommercial users.

Certainly it makes sense for artists to profit from their work, and selling your code is a more proactive way to do so than fighting for sponsorship from corporate and art organizations. But other artists argue that a truly transparent interface not only historicizes its software but makes the software available to others. Transparency on the Web also involves passing on the tools of production, including nonproprietary software, to other users. An excellent example of nonproprietary, free software is GNU, a free, UNIX-compatible software system (reflexive acronym for "GNU's Not Unix!"). Launched in 1984 by Richard M. Stallman, and

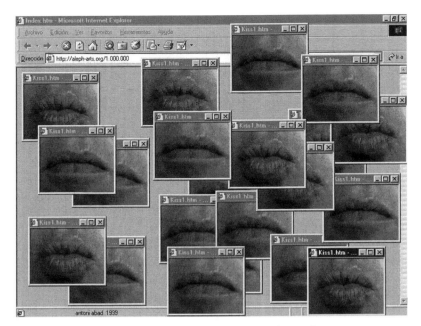

Frame grab from "1.000.000" by Antoni Abad. Courtesy of the artist.

Frame grab from *erational* by Emmanuel Lamotte. Courtesy of the artist.

involving the donated time of scores of programmers, GNU offers a radical alternative to copyrighted software. GNU's online mission statement asserts the importance of social connectivity over digital-style fragmentation. "Society needs to encourage the spirit of voluntary cooperation in its citizens. When software owners tell us that helping our neighbors in a natural way is 'piracy,' they pollute our society's civic spirit."[6] GNU's developers encourage users to take and develop its free software and to make donations of time, money, programs, and equipment. With GNU, sociality is built into the software.

The Social Level

Beyond the quantum, electronic, hardware, and software levels, a fifth level at which the materiality of the World Wide Web can assert itself is the broadly social. Artists' Web sites dealing with this level are too numerous to mention, because their material for parody, subversion, and sabotage is so broad. But to mention a few: The survey accumulates information about consumers in order to better market products and services to them. Amazon.com, for example, greets repeat visitors with "Hello, [Laura]! We have new suggestions for you in books, videos, and music." This format has been most famously subverted in Komar and Melamid's "The Most Wanted Paintings" Web site. Their meticulously accumulated and charted information results in outlandishly undesirable "favorite paintings" for each of the fifteen countries they survey. Komar and Melamid are basically critiquing digital thinking, which attempts to quantify and categorize subjective desires and beliefs. "Hello, Kenya! You prefer outdoor scenes, wild animals, and the color blue? We have a painting for you!"

Faux-commercial sites criticize the commercialization of what was once an interactive medium by delivering useless or impossible products. The faux-commercial Web site has the potential to draw unsuspecting surfers into what looks like just another chance to shop but really is designed to critique the commercial usurpation of the Web. As with many actual e-commerce sites, it is near-impossible to divine, through the fog of sales rhetoric, what products these sites are selling. For example, pavu.com appears to be a commercial site selling designer soap, with the same breezy rhetoric and ad-cluttered front page, but it's really an art distributor. The fearless ®™ark savages corporate capitalism and the institutions that support it in sites mimicking the World Trade Organization and the George W. Bush presidential campaign ("George W. Bush—Not a Crackhead!"); while Alex Rivera's Cybraceros site straightfacedly sug-

gests that Mexican workers could use telerobotics to harvest California fruit without crossing the border. Jennifer and Kevin McCoy program Airworld.net to search the Web on buzzwords and download images and text from corporate Web sites into their own, changing all company names to Airworld, so indeed it looks like you could join the Airworld company, invest in Airworld stock, fly Airworld airlines, and purchase Airworld hair products.

At the faux-commercial level, sites like Airworld are *noophagic*; that is, they eat information. These sites suck information off other sites and reprocess it. They include some of the most sophisticatedly programmed sites: jodi.org, Mark Napier's "Shredder" and "Composter," Marek Wisniewski's Internet "slotmachine" Jackpot, easylife, and m9ndfukc. Jackpot downloads three randomly selected Web sites and displays them in the browser's window along with their top-level domain names (.com, .org, .gov, etc.). Visitors use a remote control to try to match any of the top-level domains. Nebula_m81, the software designed by the author of m9ndfukc, "makes it possible to simultaneously process several data channels connected to selected URLs. The system allows one to generate a hybrid signal out of heterogeneous Internet

Frame grab from *Airworld* by Jennifer and Kevin McCoy. Courtesy of the artists.

raw material."[7] The Shredder and Composter are death and resting places for Web pages whose time has come. Napier thoughtfully suggests the Microsoft and Lotus home pages as good candidates for shredding, and if you enter their URLs the program cogitates for a moment and returns the home pages in useless but beautiful form, images stuttering and HTML code floating in scraps. These vampiric sites live off the commercial activity on the Web and recirculate it in monstrous forms, rather than permit the free circulation necessary to the Web as shopping mall. They make information that normally would have a limited lifespan Undead. These and other works for the Web insist that electronic media occupy not a "virtual" space but a physical, global socioeconomic space.

Some programming is so sophisticated that it begins to approximate the random nature of analog life. Lamotte's "less is" interacts intimately with the visitor. A straight line across a white screen engages in an angular chase when you move the cursor close, subsides into quiescence when you move far away; it's like playing with a cat. Watching the pixels dance on m9ndfukc can be as entrancing as watching a plastic bag flying on currents of wind. Describing the nebula_m81 software, the author of m9ndfukc points out that "the majority of processes are stochastic hence operator mind activity is stimulated not by the imposition of decision making—rather by an invitation to observe and analyze data transformations—to be distracted—and ultimately to select. this constitutes true interactivity and is the singularity." It is hard to determine whether these digital approximations of life forms are replacements for the thick world of analog reality or form a continuity with it.

Let me return to the desire for indexicality I mentioned at the beginning. Digital media are indeed indexical, if we keep in mind what level of materiality they are indexing. They may index the imperfect flow of electrons that constitute them, or the platforms on which they were built. They may index what they cost to make, or the social networks in which they exist. I'll briefly conclude by arguing that when we read the materiality of the Web, we replace the discourse of transcendence with a discourse of immanence.

You'll notice that many of the works I've mentioned have user-unfriendly interfaces—freezing our screen, making it impossible to exit the site, draining our computer's memory. In their nastiness, they remind us that interfaces are "friendly" in the service of corporate interests. By refusing to let us make the usual choice from a limited "interactive" menu, materialist sites invite us to refuse the pathetic "choices" con-

sumerist culture offers us. Our paralysis in front of the spasmodic screen embodies our paralysis as active agents in the commercialized space of the Web.

We can read an online artwork for bodily existence just as Walter Benjamin sought to divine the hand of the painter in the form of brush-strokes. Here the bodies indexed are the material bodies of subatomic particles; the physical bodies of platforms and servers; the bodies of software that are dematerialized into commodities or rematerialized as social goods; the tired bodies of programmers. These bodies are all *immanent* in the pages that flash on our screens: we only need to be able to read them. What is actualized on the screen is the tip of a virtual iceberg. What is virtual within the Web is bodies, organic and nonorganic, all interconnected. It is easier to be aware of these many bodies when transparency is not perfect.

The truth is that technologies age and die just as people do—they even remind us of our common mortality—and this is another fact that the myth of virtuality would like to elide. Digital aesthetics thus invites a phenomenological understanding, in which we can understand media in terms of our shared corporeality. M9dfukc fucks with our minds, but maybe it also wrenches our stomachs in its exploration of the guts of its own code. When your computer jitters and crashes, do you not bleed too? Does the aborted connection remind you of your tenuous hold on this world? When your computer sprouts a rash of warnings and mindless confirmation messages on its face, do you similarly grow hot and bothered? I know I do. When they compel us to feel along with our machines, materialist web sites remind us that we humans continue to inhabit a common, physical, social space. It is immanent, just waiting to be actualized, in the seemingly virtual world of cyberspace.[8]

13. Ten Years of Dreams about Art

To celebrate the tenth anniversary of the Toronto experimental screening venue Pleasure Dome, the author has examined a decade of experimental media through the lens of that organization's programming history, other venues for experimental media, and her own dreams over the same period. She finds that she has internalized the experimental film and video scene to the degree that that her unconscious accurately charts developments in the scene over the past decade. Dreams recorded over the years 1990–99 (and one from 2002) uncannily reflect shifts in independent media cultures: the shift from a linguistic to a phenomenological bent; the seemingly opposed move from a visual to an information culture; changing debates in the politics of identity; the shifting interest in sexual representation. Her dreams also reflect the position of Canadian film and video in relation to an international and U.S.-dominated art world. Above all, they celebrate the myriad of small, quirky, rebellious, anarchic—yet easily overlooked, indeed repressed—image-worlds that comprise ten years of programming at Pleasure Dome and

Ten Years of Dreams about Art
All dreams guaranteed dreamed by the author.

This running excursion into Peircean semiotics is intended to help us understand aesthetic developments in experimental film and video of the 1990s in terms of the dynamic of emergence, struggle, resolution, and reemergence.

C. S. Peirce's semiotic theory, unlike the better-known Saussurean theory, allows us to think of signs as existing at different removes from the world as we experience it, some almost identical to raw experience, some quite abstract. For Peirce the real appears to us in three modes, each at a more symbolic remove from phenomena, like layers of an onion: Firstness, Secondness, and Thirdness. Firstness, for Peirce, is a "mere quality," such as "the color of magenta, the odor of attar, the sound of a railway whistle, the taste of quinine, the quality of the emotion upon contemplating a fine mathematical demonstration, the quality of feeling of love, etc."[1] Firstness is something so emergent that it is not yet quite a sign: we can't see red itself, only something that is red. What is First is so close to the object of experience that it cannot describe it. Secondness is for Peirce where these virtual qualities are actualized, and this is always a struggle. In the actual world, everything exists through opposition: this and not that, action-reaction, etc. Secondness is the world of brute facts. Thirdness is the realm of interpretation and symbolization. It permits reflection on this experience in relation to others, or thought; and this in turn prepares the ground for new experiences. The attitudes toward the world of the three kinds of sign are perceptive, active, and reflective.

The goal of the process of semiosis, according to Peirce, is to achieve a constant flow from First to Third, which reemerges as a First. In the following, I note where art practice seems to get "stuck" at one or another stage of this semiotic process.

How do dreams fit into this process? In Peirce's broad conception of reality, what is real is what has effects. "A dream has a real existence as a mental phenomenon, if somebody has really dreamt it; that he dreamt so and so, does not depend on what anybody thinks was dreamt, but is completely independent of all opinion on the subject. On the other hand, considering, not the fact of dreaming, but the thing dreamt, it retains its peculiarities by virtue of no other fact than that it was dreamt to possess them. Thus we may define the real as that whose characters are independent of what anybody may define them to be."[2] Dreams are real insofar as they have effects. Dreams are indices—but of what? This essay insists that dreams are indices not only of my particular unconscious, but of changes in the world of art as the wisdom of my unconscious, less encumbered and more creative than my conscious mind, discovers them to be.

Best Musicians Are Three Bugs

August 29, 1989—I dream that the best jazz musicians in the world are three bugs. One is a spider who plays clarinet and is like Charlie Parker; one is named Habermas; the third is not characterized. They float into a

huge pool, on a raft, and begin playing and the audience goes wild. They are very wise and give us to think how advanced bugs can be. I know one of them and am a little bit in love with it, and I am crying and crying, maybe because I know the bug will be killed, maybe because of the passing of all things.

A handful of small programming venues worldwide, including Toronto's Pleasure Dome, devote themselves to the most marginal and evanescent of moving-image media. Why is this kind of programming valuable from the point of view of the larger culture? Some of the works and artists will eventually be taken up by the broader art world. More important, experimental film and video are a microcosmic laboratory of the most important developments in culture—experimental makers get to all the issues years, or decades, before mainstream media get hold of them. But finally this work is important because it is *not* valuable from the point of view of culture at large. While it's common to say that reproducible media do not have "aura," that sense that the art object is a living being, single-print and low-circulation films and videos have an aura denied to mass-circulation media. Experimental programming venues nourish short films and videos, works in low-budget and obsolete media, filmic detritus rescued from landfills—in short, works that have aura in inverse proportion to their commercial value. Pleasure Dome revives works that are ephemeral or forgotten, films that have been censored, banned, and burned. Like bugs on a raft, they are precious because they are imperiled.

Brains or Love

December 4, 1989—I dream that I am in a crowd of people, Japanese and foreigners, at the station by the My City department store in Tokyo. There's a stall where for a 9,000-yen piece we can buy a new brain. There are only two of them; it's a kind of last-chance deal. A tall, young, clean-cut guy with glasses buys one immediately so that he can go to a vending machine. I am trying to decide whether to take this rare opportunity to get this new brain. If I don't take it, my own brain will be reduced by 50 percent. I am trying to decide how important my intelligence is to me, since after all I would still have love, and love of beauty, and be more simple: I could live in a cottage. Also I don't feel I need the extra years of life the new brain would give me.

The choice between brains and love was a central struggle for filmmakers in the early 1990s. Some insisted on using their media as intellectual tools

on the model of verbal intelligence. This is why so many works from this end of the decade are characterized by scrolling text and quotations from important scholars: in effect, purchased brains. At this period art schools, funders, and art magazines were telling young artists that being a "dumb artist" was no longer a viable choice. Artists were now expected to issue their own considered statements and locate themselves within a verbal intellectual milieu. Work suffered as a result, though certain artists expanded the verbal imperative into an expressionist form in its own right: witness the assaultive verbality of later videotapes by Istvan Kantor, such as *Black Flag* (1998) and *Brothers and Sisters* (1999). A few brave others accepted the apparent deterioration of their brains as a consequence of love. For example, John Porter and George Kuchar, Pleasure Dome regulars throughout the decade, generated huge numbers of films and videos that seemed to be produced from pure passion for the media, rather than from particular ideological or aesthetic agendas. Yet both these artists internalized the logic of film- and videomaking so profoundly that it informs even their most seemingly artless work. As a result, Porter's and Kuchar's works, and those of others who followed this route, are fertile with ideas, even if the artists themselves are not extremely articulate in interviews.

The verbal-art phenomenon is a case of Thirdness preceding Secondness: judgments and symbolic pronouncements, such as "Film should/should not offer visual pleasure," generate a course of action. This top-heavy semiotic configuration is dangerous for artists because it tends to backfire, since Thirdness is not a stable state but generates new and unforeseen states of Secondness and Firstness. For example, numerous feminist works from the late '80s and early '90s, in a double reaction to the pronouncement above, made "unpleasurable" works that caused audiences to howl in amusement or "pleasurable" works that made us feel we were being bullied. In contrast, work that luxuriates in Secondness, in the realm of simple action—like Porter's time-lapse films, Toy Catalogue versions, and Cinefuge versions— generates all kinds of conceptual responses in the minds of audiences.

History of Cars and Boats

June 9, 1990—I dream of an artist's book where each page is a thin wooden slab with a wood-burned picture. There are pictures of cars from five-year intervals, beginning in 1920, and pictures of boats in five-year intervals. If you flip the pages like a flip book you can see a little animation of the evolution of car and boat design.

Postmodernism malingered into the 1990s, and with it the disempowering notion that it was impossible for artists to produce their own new

images. Many filmmakers looked to found and archival images as sources of fresh meaning. While any image they produced themselves seemed to arrive already encoded in the culture's sign systems, archival images had a kind of strangeness and excessiveness that resulted from their codes having been forgotten.[3] Archival images had a way of deconstructing themselves, because their codes, once implicit, were now humorously obvious. Scavenger/archivists Jack Stevenson (in 1993) and Rick Prelinger (in 1996 and 1997) visited Pleasure Dome to uncarton their precious collections of 1930s stag movies, 1950s sex-ed films, and home movies to be rediscovered. Craig Baldwin took advantage of '50s science-fiction B movies for their connotations of the homogeneous nation facing invasion by aliens, in *Tribulation 99: Alien Anomalies under America* (1991). Mike Hoolboom in *Escape in Canada* (1993) served up archival U.S. propaganda about Canada with a solarized parsley garnish.

The postmodern dilemma mentioned here is that the entire Real seems to exist in the realm of Thirdness, the general idea that engulfs all particulars. According to the Baudrillardian logic by which many people were seized in this period, the meaning of everything that we perceive has already been encoded, indeed dictated in the form of what Peirce calls a legisign. If, as Peirce writes, the recipe for apple pie exists in the realm of Thirdness, but the particular apples used are Second, then postmodernism told us that there were no apples any more, only recipes.[4] Thirdness can be paralyzing, but, as when these artists treat the oversymbolized old recipes as raw material, it can generate new signs, such as the arousal and nausea that are sure indicators of Firstness.

Dealing with Regeneration

April 13, 1991—My dream is set on the wooded grounds of a college campus. A cultivated flowerbed has been burned, and an Asian student is complaining to my husband about it. But there are iris shoots growing up through the charred surface, and my husband says no, it's good, it's something to pray about. He starts saying a beautiful Aboriginal prayer, and hundreds of students are listening. I'm standing ankle-deep in a pool, and I notice there are lots of speckled brown tadpoles becoming both little fish and long-legged speckled brown birds. I bend over and say to them, "You guys are so *tiny!*" An "Amish" guy says sternly, "Shh!"

Art movements, including movements in film and video, tend to become reified almost as soon as they are born. From the scorched earth of an idea that appears to have been collectively done to death rises a tender new idea—and in turn that evolves into its own order and comes to

dominate the field. Programmers face the challenge to both chart new movements as they appear and pay attention to the even more marginal work, which may be the sign of something new, of unexpected evolutions. One way to do this was to host open screenings and "new works" events without premeditated themes: there was no agenda but an interest in what people are up to. Another was to act as a *salon des refusés* from the big-name festivals. Pleasure Dome also encouraged artists to indulge their most impressionable states in frequent screenings of low-end punk work by art gangs like J.D.s (in 1990) and Abbatoir (in 1992) and in the "Puberty Film Show," featuring the don't-wanna-grow-up medium of Super-8, in fall 1995.

Before even Firstness there is a degree zero, a point where everything is possible, where anything can evolve into anything else. Peirce wrote, "The present pure zero is prior to every first. . . . It is the germinal nothing, in which the whole universe in involved or foreshadowed."[5] It is only when perception seizes on something that it enters the cycle of signs. Firstness lasts for only a flash before it is seized on by perception, and in turn by action, and before we can say "hey!" it is taken up symbolically in Thirdness. In art movements this process is accelerated by the market-driven anxiety to produce something new.

Immobilized Heads of Mass Culture

April 16, 1992—I dream that a friend and I are walking near a long reflecting pool, and a female reporter is speaking to the cameras from the edge of the pool, only her face visible. As we walk by I see that her face is mounted in a shoe, a gold sandal, and in fact it is all of her there is. I am intrigued by the gimmick but also shocked. Later my friend and I pass a dumpster and two anteaters walking at the edge of the road.

August 13, 1992—I dream about a craft project in a women's magazine: a stiff nosegay of plastic flowers with an eyeball built into the base looking up at them, lit from below by a lightbulb.

Mass culture, or what the Frankfurt School theorists called "affirmative culture," is a fixed eyeball or a mounted head that can gaze in only one direction. Marginal culture is free to wander and swivel. Film and video, as industrial media, have a particular relationship to mass-produced media. Because their techniques are shared with movies and television, artists in these media are more pressured (than painters, for example) at every step of the production process to consider their relationship to mass culture.

Canadian film and video in the '90s continued their head-swiveling relationship with popular culture. In belated (as it can only be) counter-propaganda to the Gulf War, Phil Hoffman, Stephen Butson, and Heather Cook's *Technilogic Ordering* (1992–93) was a diary of television coverage of the Gulf War edited into a mosaic whose impenetrability reflected the powerlessness many Canadians felt in our complicity with the U.S. war for oil. In 1994 the spokes-Barbie of Igor Vamos's Barbie Liberation Organization coolly outlined the patriarchy-toppling intentions behind the BLO's terroristic voice-box switching between herself and GI Joe. The same year Brian Springer's *Spin* tore open the media doctoring of the 1992 U.S. presidential election. Screened at Pleasure Dome in 1996, AdBusters' "Uncommercials" alerted couch potatoes to the military-industrial intentions of benign-sounding sponsors like Kraft and General Electric (wait a minute, doesn't Kraft own General Electric?).

In the early '90s artists referred to themselves as "cultural workers" or "cultural producers" more than artists do now. This was supposed to mean that artists, as producers of culture, were responsible members of their communities, as well as to shy away from the high-art connotations of the word "artist." More work was overtly activist in the late '80s and early '90s. What happened?

Certainly part of what happened is that less money was available for artists who wanted to make "unmarketable," that is, truly political, work. (By contrast, "critical" art, as Gary Kibbins points out, always has a relatively ready market.[6]) But another way to understand the shift away from overtly political work that occurred in this decade is to acknowledge different ways of being political. A work that critiques popular culture reinforces its dependent relationship with popular culture. Its goal is political change at the level of language, which is collective but not deeply embodied. This relation of dependency is twofold in Canadian critical experimental work, because it must take on all of American mass media as well as the popular in Canadian culture, if the latter can be said to exist independently.[7] By contrast, a work that is only about itself and the passion of creation offers a model of freedom from popular culture. Its goal is political change at the level of individual action—which is embodied but not collective. And of course in between these poles lay art that politicized personal, embodied experience. In short, the shift away from activist art to personal art during the '90s can be seen as not a depoliticization but a shift in political strategies. It was also a sign of retreat in the wake of political exhaustion, after the overtly political work did not seem to exert any discernible social change.

Yet we cannot deny that the early '90s was a lively period for work in the arguably reactive mode of identity politics. Little of this work showed up in the artist-curated programs at Pleasure Dome, in contrast to, for example, the annual Images festival also based in Toronto. Why?

In particular, the politics of ethnicity and nationality informed the work of many Canadian media makers who got up to speed in the mid-'80s to the early '90s. The best of this work, such as Donna James's gentle meditation on her foremothers' Jamaican aphorisms, *Maigre Dog* (1990), and Shani Mootoo and Wendy Oberlander's canoe-generated rumination on Trinidadian-Canadian nationality in *A Paddle and a Compass* (1992), dissolved identity categories in favor of the fecundity of not knowing who one was, or alternatively, as in the intentionally frustrating work of Jayce Salloum, in the spirit of dissolving all predetermined bases for knowledge. While Helen Lee's critique of ethnic fetishism in *Sally's Beauty Spot* (1990) was enthusiastically received, her poetic sensibility emerged in the seemingly lighter and less critical narrative *My Niagara* (1992), especially in the concluding shot of an Asian-Canadian latter-day Marilyn Monroe carrying a flimsy flowered suitcase and walking away from the camera in teetering heels. *My Niagara* suggested that presence can be prized from identity to float precariously away—whether toward freedom or annihilation is for the viewer to decide.

Cultural critique tends to take place in the mode of Secondness, or reaction. It is thus doomed to a somewhat parasitic relationship with the mass media that goad it along. The best such works, however, are rich enough in their Secondness that they generate the mental connections that are the realm of Thirdness, or, more rarely, the perceptual surprises of Firstness. Identity politics, for example, when it worked, mobilized felt qualities of life into struggle (for identity, by existing in opposition to something other, is Second) and into new forms of communication. In the best cases, such work incorporated the active and reactive mode of Secondness into a journey toward the creation of mental images productive of thought, in the spirit of Thirdness.

Consciousness Is No Different From Reality

February 8, 1990—I dream that a bunch of us are having a political demonstration at the bottom of the stairwell in the college administration building. A tall thin white-haired lady from the registrar's office comes out and tells us, "For Marx his consciousness of himself was no different from his reality." This is an absolutely huge revelation to us: the demonstration breaks up and we are all laughing with the craziness of

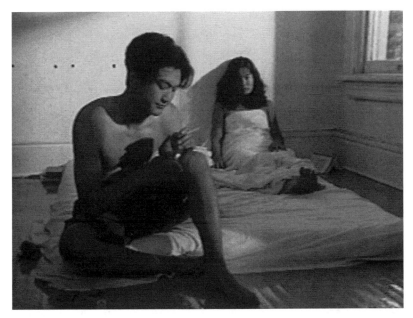

Frame enlargement from *My Niagara* (1992), by Helen Lee.

the enlightened. Then we go to the student lounge and, to people's mixed delight and dismay, a woman lights a papery thing in her hand and throws it into the room, where it bursts into flowery ashes.

The relationship between reality and representation was a typically '80s concern in art. Many works critiqued popular culture. Video artists in the '80s, in particular, eschewed the structuralist experiments of the preceding decade as being politically reactionary, and instead looked to critique the social and economic foundation of the medium, television. Hence many videos looked like TV shows, with something amiss. The critique of representation, more generally, became the air artists breathed. Saussurean semiotic theory, in turn, gave us ways to understand the world as a compendium of signs, all of which have been effectively preperceived for us. This gave film- and videomakers plenty of grist to grind, in the *subversion* of existing images.

But some people were uneasy with the idea that we cannot know reality directly. If their consciousness was their reality, then surely they did have direct access to some sort of reality? Less pressured to evolve with their art form than videomakers, filmmakers were somewhat freer to represent their own experience in the act of experiencing it. Politically

suspect though it may have been, they gave the gift of their own perception to viewers and listeners. Ellie Epp, in *notes in origin* (1987), allowed the camera to be moved by the beating of her own heart. In *All Flesh Is Grass* (1988) Susan Oxtoby allowed luminous textures and slanting shadows to express the catharsis that comes from abandoning oneself to mourning. Zainub Verjee's gentle *Écoute s'il pleut* (1993) allowed the viewer to experience silence, full as a drop trembling on a leaf, for eight minutes out of ordinary time. And a master of the art of gradual revelation, Barbara Sternberg retained a rich, impressionistic audiovisual texture in her work throughout the decade. These and other filmmakers remained convinced that the world is still enchanted and need only be properly recorded to enchant the viewer.

In other words, they used the medium of film as an entranced Perceiver of the world, an agent of Firstness. One might define art as a practice that cannot be subsumed in a symbolic mode. As Floyd Merrell suggests, wine-tasters, jazz musicians, and others with a nonverbal grasp of their art "know more than they can explicitly tell. A portion of their knowledge will always remain at the level of Firstness and Secondness, unmediated and unmediable by Thirdness."[8]

"The Pink"

April 20, 1991—I dream I am masturbating to this commercial-looking montage of lots of women talking about "the pink," which meant masturbation, and how their men left them alone to do it.

In the '90s a second generation of feminist film- and videomakers came of age. While their predecessors had been into subverting patriarchal culture, the critical stance lost favor with younger artists. Constant vigilance is exhausting and not much fun. Instead, more artists, especially women queer and straight (but later in the decade gay and then straight men as well), began making work that focused on their own sexual pleasure. Again, this work may have looked apolitical or self-indulgent, but as with the general shift from activist to personal work, it was rather a move to a politics of action rather than critique. Paula Gignac and Kathleen Pirrie Adams transcended the dyke-music-video genre in *Excess Is What I Came For* (1994), a sensuously grainy video shot in the low light of Toronto's Boom Boom Room. A work like Annie Sprinkle and Maria Beatty's *Sluts and Goddesses Video Workshop* (1992) considered women's self-pleasure and bodily self-knowledge to be inherently political, and used lush, campy production values and Sprinkle's honeyed voice to present its

Frame enlargement from *I Know What It's Like to Be Dead* (1989), by Bruce LaBruce. Courtesy of the artist.

pedagogy in a pleasurable way. Queer punk movies indulged in a pleasure that was harder-edged but just as sweet, in Greta Snider's hand-processed *Shred of Sex* (1991), Bruce LaBruce's *I Know What It's Like to Be Dead* (1989), G. B. Jones' *Trouble Makers* (1987), and Nadia Sistonen's private performances for Super-8 camera. Kika Thorne luxuriated in female sexuality in work that had a characteristic *flou* or unwillingness to be bound by structure—although other kinds of bondage were fair game. In Thorne's *Sister* (1995), heat-seeking infra-red film makes a woman's cunt (the artist's own?) glow in the throes of self-pleasure.

A Hard Day at the Arts Council

March 6, 1994—I dream that I have to go to an arts council jury, and it is in a building, maybe in Paris, one of those buildings that's supposed to be rationally designed, but it's a huge box divided internally into three parts with undulating inner walls. I'm trying to find Floor N, and a lady in a tiny stairwell office tells me I can't get into that room, but then she gives me a key. I have to try the key in doors on about twenty floors, but doing this I'm actually pricking my arm with a needle, all the way up the inside.

I have this row of twenty neat red pricks up my arm; I put antibiotic oint-
ment on them.

Honestly, arts council juries have provided some of the most democratic,
well-informed, and passionate discussions about art I've ever taken part
in. The jurors' investments and expertise are different, and it's hard to
make rational decisions about what kind of art deserves funding, but
somehow we always reach consensus about which projects should get the
money. Then we find out there's not enough money to fund even half of
them, because of funding cuts during this decade across Canada, never
mind the utter devastation of government arts funding south of the bor-
der. The Ontario Arts Council was cut by 40 percent during the first pre-
miership of Mike Harris; the arts budgets of Alberta, British Columbia,
Manitoba, and Nova Scotia experienced similar cuts, and the Canada
Council lost funding and then had it restored to less than the previous
level. That's where the self-mutilation comes in.

Equations for Your Eye

April 4, 1997—I have one of those dreams where I have to take a math
exam, and I am all confident, then I get into the exam and do terribly. I'm
trying to recall trigonometry, remembering nothing. This bright-eyed
young woman explains to me: "Sine and cosine are the equations for two
waves that cancel each other out. Between them they produce the equa-
tion for the shape of the lens in your eye."

Structural film and video returned to the scene in the 1990s. This was part-
ly because the concern with representation diminished and artists were
newly interested in medium specificity. In addition, the development of
new, computer-based media made it timely to reexamine the intrinsic
properties of older media. Structuralism respected the internal coherence
of a film or video as a physical body, with all its implied mortality. Many of
John Porter's films were structured by the three-minute length of a roll of
8mm, and this internal logic was as pleasurable to audiences as finding that
the shape of one's own eye describes an equation. A rash of tapes was pro-
duced on the Pixar 2000 in the mid-'90s, and part of the pleasure of watch-
ing Pixelvision was knowing that these videos were recorded on audiotape
and that the jagged black scar on the frame was the actual image of an in-
camera edit. Hard-core experimental filmmakers imposed rigid structures
on the most vulnerable material. Mike Cartmell used a "chiasmic" struc-
ture to explore identity and paternity in *Film in the Shape of the Letter X*

(1986). In a sort of on-the-spot structuralism, Phil Hoffman's *Opening Series* (1992–) is presented in pieces to be reorganized by audiences before each screening. James Benning (celebrated in 1998 with the program "Structural Film Is Dead, Long Live James Benning!"), the duration of whose shots in *Deseret* (1995) was dictated by the length of newspaper articles about Utah, was by virtue of such strictures able to make films whose content ranged over *everything*. This kind of structuralism has the same effect as lacing a corset around a pliant torso: it allows the stuff inside to remain soft and formless. Later in the decade it would evolve into the scratch video genre, where the ephemerality of forgettable television clips was given a loose structure by randomized commands of digital editing.

Sad Classified Ads

September 30, 1997—I dream I am in a room full of people who are all lying on sofas and reading newspapers. People are getting all weepy reading, and the mood is very mournful, but another woman and I are catching each other's glance and grinning. It turns out everybody had placed "Sad Classified Ads": it was kind of a performance.

Like the caress of a stingray, grief immobilizes the body it traverses. As the AIDS epidemic continued, people succumbed to melancholic paralysis. Although the urgency of AIDS activism abated—it's hard to remain in a state of crisis indefinitely—some artists returned feeling to our numbed bodies with blazing offerings of rage and love. Sadomasochism had a profound place in this process, as in the work of Tom Chomont, for whom S/M was a way to take control of the disease in his body. During this decade Mike Hoolboom built a flaming body of work around AIDS, whose melting saturated colors and glistening high-contrast skins, as much as the bitter poetry of their words, impelled us to cling to life even while we flailed against it.

In its power to immobilize, grief imposes a state of perpetual Firstness. According to Peirce it is impossible to exist sempiternally in a world of Firstness, a world that "consists in nothing at all but a violet color or a stink of rotten cabbage"—or in a pure feeling, be it love or pain.[9] A changeless state of mourning, or of any emotion, is unbearable. The most powerful AIDS work of this decade transmuted the Firstness of grief into the contemplative and active states of mourning and activism. In its most transformative state, Thirdness—ideas that are preconceived, verbalized, yea, published in the newspaper—still has the power to move us to emotional states that far precede discourse.

Frame enlargement from *House of Pain* (1996), by Mike Hoolboom. Courtesy of the artist.

Deleuze Overcharges for Drinks

February 8, 1998—I dream that there is a lecture by my hero Gilles Deleuze and afterward people are going to his house for a reception. We have to get there on little red handtrucks. I take the smallest one because I can see it is really high-tech and expandable. I take off on it separately from the others, who are "wankers," and go careening down these very steep streets, a town like San Francisco but tropical with slanting light and lush purple flowers. The cart turns into these speedy old-fashioned roller-skates, and I am careening down this steep street, grabbing at trees and signposts as I pass and feeling exhilarated because I am on my own. Deleuze has this big empty house, like an expensive windowless concrete bunker, with nothing inside except for a lot of Far Side cartoons, a pool, and a Jacuzzi. He's sitting at a counter where you come in, selling drinks. An orange juice and rum is very delicious but costs $28. I get depressed because his new book is not very good.

Pleasure Dome screened many historical works over this decade, but notably absent was the Canadian avant-garde of Michael Snow, Bruce Elder, and the other great fathers who had, for the eyes of this generation, repressed as much as they had allowed to flourish. Even Joyce Wieland didn't get a show at Pleasure Dome in the '90s. For marginal fimmakers

in the '90s, watching *Wavelength* again was like crashing your speedy go-kart into a pretentious soirée. Instead of this canonized tradition, which everybody had seen in school anyway, Pleasure Dome looked to historical films from the New York and San Francisco undergrounds. Curt McDowell's *Thundercrack* (1975), Jack Smith's *Flaming Creatures* (1962), Chick Strand's *Kristalnacht* (1979, in a program of women's carnivalesque films), and other works were preceded by word of mouth not about their formal qualities but their bodily functions. These works helped nourish a new interest in performance and the body—not just any body, but a raw, uncomfortable body; not a polished performance but an unabashedly amateur performance.

Woman Ejaculates on Prospective Canadian

March 18, 1998—I dream I am watching a video, or maybe a commercial for McDonald's, where a sensual pregnant woman is saying she loves eating hamburgers so much she makes them last for three hours. Then there is a performance in a gallery in L.A., where this same pregnant woman is in a shallow pool, masturbating while watching another woman. Then she ejaculates into the face of a man standing in the pool—she shoots a good six feet! It's from my point of view, as though I were ejaculating. I am offended at the performance though, I think it's cheap-shot (!) feminism. This poor man turns out to be a performance artist himself, probably teaches at Cal Arts. He is doing work on orgasm too: he said that in orgasm he is cultivating his plant nature. Something to do with *sisal*. I promise to mail him a Canadian magazine with a review of his work, a Canadian road map, and something else. He tries to give me money for it, but I have the impression that it's all the money he has, so I refuse to accept his payment.

Experimental cinema has almost always rejected acting as implicated in the illusionist aesthetics of commercial cinema. Plus, acting is expensive to film. But performance, confronting the viewer with a real body enduring experience in real time, has none of the illusionism of acting. Part of the return to phenomenal experience that characterized the '90s was the return of performance. Often this was inspired by unabashedly enthusiastic performances from decades past. However, few contemporary filmmakers had not been infected in some way by the poststructuralist disease that would have us believe our own bodies are just textual objects and don't even really exist. For a while in the '90s it was uncool to believe that a person could ever reveal the essence of himself or herself, or even

that there was an essence. But in performance you find the meaning of the body through physical, not mental acts; the body has to be right there, not a construct. Performers sacrificed their own bodies so that the rest of us could have ours back. In her 1993 series "Aberrant Motion" Cathy Sisler spun in the streets as a proxy for our collective disequilibrium. In *Super 8½* (1994) and *Hustler White* (1996) Bruce LaBruce stripped all the way down to the layer of plastic wrap covering his heart, so that we didn't have to, or we could if we wanted to. Donigan Cumming convinced nonactors to pray for a Nettie they had never met (*A Prayer for Nettie*, 1995), sacrificing their authenticity to an audience that in turn suddenly became responsible for both them and her (the deceased Nettie had been Cumming's photographic collaborator and model, but the video does not tell us that).[10]

Another way—a canny, '90s way—to exploit the rawness of performance while acknowledging the artifice involved was to fake it. Monique Moumblow created fake personas, as did Alex Bag. In *Fresh Acconci* (1995) Paul McCarthy and Mike Kelley hired San Fernando Valley porn actors to restage Vito Acconci's 1970s performance scripts. In *Shulie* (1997) Elisabeth Subrin meticulously recrafted a 1970 documentary about feminist writer Shulamith Firestone, then a young painter, right down to the cat's-eye glasses and ignorant, sexist professors. Playing her fictional suicidal sister Gretchen in *Chronic* (1993), Jennifer Reeves cut her own arms and shed real blood for the fish-eye lens.

In 1967 Godard famously responded to criticism of his gory movie *Weekend*, "It's not blood, it's red," meaning that his film was meant to be taken as a sign that was already at some remove from the real world it signified. But for a performers in the '90s it was red *and* it was blood.

In performance the perceiving and acting body is a Peircean sign machine, quivering like a tethered string between the poles of experience and communication. Whenever one presents one's body and actions for public consumption—that is, presents oneself consciously as a sign—the same accelerated oscillation between the three modes takes place, for one is required to act an operation of Secondness, and to be genuine, or to operate in the mode of Firstness, at the same time that one manages oneself as a mental image. Ejaculating or shedding blood before an audience are only two ways to do this.

Divorce Ritual

August 29, 1998—I dream I am in Los Angeles. I exit the freeway on a ramp that is made of wood and undulates like a little roller-coaster, into a hilly

Still from *A Prayer for Nettie* (1995), by Donigan Cumming. Courtesy of Cinéma Libre.

neighborhood that is part Chicano, part Asian, and all the houses are close together and kind of doll-like with thatched roofs. Lots of people are in the toylike park, old Mexican men and little boys playing chess. I am going to a museum where my husband and I are supposed to have a postdivorce ritual. It looks like one of those hands-on museums that were cool in the '70s, with lots of winding passages and purple and black walls. We get there and there are several couples, presumably also divorcing, gathered around the table. I've forgotten to bring some document, and also photographs, that we're supposed to burn as part of this ritual. I'm picturing an old photograph in my head and thinking I don't want to burn it!

Later I walk by the village again and see that the little houses with thatch roofs have been burned for acres. The whole landscape is smoking and gray. It's awful. I am embarrassed when the people from the town see me staring at their misfortune.

One of the most painfully visceral experiences you can have at the movies is when the film catches in the projector gate and burns, especially if it is a precious lone print. We have seen that in the '90s many artists turned to archival film for a source of images. While the images could be deftly recontextualized and critiqued, filmmakers also became fascinated by the material of the film itself. In this decaying surface, archival filmmaking witnessed a death, a divorce of the original meaning from the image. Rather than recontextualize the images, filmmakers held funerals for their charred remains. The unholiest of these officiants was SchmelzDahin, the German collective that tortured Super-8's emulsion with bleach and hydrochloric acid, buried it, and hung it from trees to fade. Corinne and Arthur Cantrill, those indefatigable Australian supporters of Super-8 film, passed through Pleasure Dome several times during the decade with curated programs. In 1994 they returned not to celebrate but as celebrants in a mass for the "end of the photo-chemical film era," in the performance "Projected Light: On the Beginning and End of Cinema." Gariné Torossian built up a body of work during the decade whose surfaces were thick with painstakingly collaged film fragments, their scratched and glued textures overwhelming the appropriated images on their surfaces. Carl Brown's oeuvre throughout this decade continued to be a body of self-immolating cinema, whose recorded images dissolved in the chemical conflagration on the surface of the film. Earlier in the decade, Brown collaborated with Michael Snow on *To Lavoisier, Who Died in the Reign of Terror* (1991). Through this film's scarred and

crackling surface, vignettes of everyday life are just barely visible, like the charred remains of a neighborhood.

In the '90s filmmakers returned to touch the material body of film at a time when the medium has been pronounced obsolete. Of course, the idea of obsolescence is meaningless to nonindustrial filmmakers: when a medium has been superseded by the industry, that's when artists can finally afford it. But the industry calls the shots, as the Cantrills pointed out in mourning Kodachrome. What precipitated the divorce of the images from their medium was perhaps the institution of digital filmmaking; the medium of analog video had not been the same threat to film, because the two media looked and functioned so differently. Over in the world of commercial cinema, and increasingly among independent filmmakers as well, films were edited and processed not on a Steenbeck or at a lab but in the virtual space of the Media 100. Where now was the film's body? Celluloid became just an output medium for the virtual body of the film encoded in software.

As well as these moving reflections on film's body, the end of the decade saw a surprising nostalgia for analog video. Videomakers who moved to nonlinear editing swore they would never go back—yet digital videos were being turned out that simulated analog interference, dropout, and generational loss!

Frame enlargement from *To Lavoisier, Who Died in the Reign of Terror* (1991), by Michael Snow and Carl Brown. Courtesy of CFMDC.

A Peircean would note that these works of materialist cinema liberate the medium to be meaningful as a body in itself, rather than the medium for another message. While plumbing archival films for their images is an operation of Thirdness, the mourning of film's material death is First in its reaction to the film as to another body.

I Forget I Own Art

February 2, 1999—I dream I own a work of art I'd forgotten about, even though it's very expensive, because it's thin like a pamphlet and it's just sitting in a letter rack like the Purloined Letter.

Steve Reinke's "The Hundred Videos" appear to sum up the various concerns of the decade. They began with a linguistic understanding of meaning, and the use of psychoanalysis, a linguistic form of interpretation, to unravel it. They moved to interests in sexuality, desire, the body, and AIDS. Following the antivisual turn in the arts mid-decade, they questioned documentary's relation to the truth. But throughout the decade Reinke maintained a conceptual rigor that made these slight works linger in the memory of the viewer. "The Hundred Videos" enter the mind through a tiny aperture of attention and then expand to fill all the available space. The sad ashtray, the sincere inventor of potato flakes, Neil Armstrong's lunar-transmitted tribute to his dead dog—they went by in one to three minutes but stayed with me for years. By the end of the decade, in a final rejection of linguistic signification, Reinke and his video camera were chasing dust balls under the desk *(Afternoon, March 22, 1999)*.

These are theorematic videos, examples of the most fertile mode of Thirdness. By creating relations among other signs, they are mental images. Reinke brought things together: foreign films and porn films, a love letter and a yearbook photo, an over-the-top pornographic performance and a list of self-doubts. In so doing he generated enabling new concepts and new models for thinking, such as, use hand puppets to role play your fondest desires. Reinke's work showed the generosity of Thirdness, giving audiences material (not about which, but) with which to think.

Aggressive House

March 18, 1999—I dream I am in the house of these radical and rich art-world people who have two young children. It is a radical house, very dark inside, claustrophobic with rough concrete walls. They all go out, while I stay. I crawl under the heavy, ancient wood furniture. The floors have escalatorlike treads moving through them constantly, with the angles

facing up like teeth, making it fairly impossible to walk. There is something even more menacing in the floor, concealed by long shreds of carpet, but I forget what it was. I think how irresponsible to raise children in such a dangerous house. I go into the little girl's (like three years old) room and see that she's programmed her computer to organize her stuff while she is out; things are moving through the air as though on an invisible conveyor belt. I am impressed and think maybe I'm the only one who's intimidated by a house like this!

At the end of the decade we were confronted with the Peircean extremes of performance, work so obsessed with action that it could barely think, and information media, work so highly encoded in symbolic form that it was incapable of affect. Now that digital editing could alter voice and gesture to simulacral perfection, the apparent naïveté of appearing live before the camera's witness had a new urgency. Emily Vey Duke, Anne McGuire, Scott Beveridge, and other artists exhibited pure affect for the camera, in performances whose virtue was in being as spontaneous as the single-take exhibitionism of their '70s forebears. Ironically, it was mostly thanks to digital editing that Hollywood movies, as always belatedly stealing ideas from independent artists, found new ways to produce affective responses in the audience.

At the extreme of Thirdness, artists moved to the small screen and concentrated information with such density that it could no longer be processed as information, but only as affect. This time, however, the body experiencing hot flashes was not human but silicon-based. Attacked by hell.com, jodi.org, and other online artworks, computers jittered with illegible information, sprouted rashes, and crashed. Their human caretakers felt this affective rush, at most, sympathetically. Meanwhile, many media artists seized on, or continued to develop, installation as a medium that was apparently more physical than the virtual light of single-screen projection. In works by David Rokeby, Nell Tenhaaf, and other interactive media artists, the intelligent interface embraced the visitor as though to spill its brains into our attentive bodies.

At the end of the decade, everybody was saying we had moved decisively from a visual culture to an information culture. What, then, would become the role of the audiovisual media that artists had been coddling and pummeling throughout the decade, indeed the century? Now that we had machines to see, hear, and act for us, raw experience was a more precious commodity than ever before. The processing of information and the debased notion of interactivity were behaviorist, Secondness-based modes, which in

Frame enlargements from *My Niagara.*

any case our computers could do without us. Throughout the decade, experimental film and video artists had been pulling their media from the Secondness-based modes of narrative and critique to a Firstness that was felt only in the body, and a hypersymbolic Thirdness that was experienced as First by the proxy bodies of our machines. We hoped that new connections, new mental images, some Third thing as yet unimagined, would come to animate our minds again.

February 14, 2002—Intercut with a predictable dream of being pursued by a killer, who in the end is lurking right under my bed (I wake up screaming)—intercut with that, I dream of an extended, global conversation among millions of people. It looks like a swirling, spiraling rose and golden river, moving from right to left, which represents past to present. In the present it is diffuse, and as it goes back in time it becomes deeper and more complex. Inside the streams are concentrated arabesques that represent specific past conversations. I try "clicking" on them, a bit embarrassed to apply such a crude notion of interface, and sure enough they don't "open," so I'm unable to learn what the conversations were. But I recognize its beauty: a liquid, embodied archive.

My dream is an image of what Grahame Weinbren calls the Ocean of Streams of Story—borrowing from Salman Rushdie, who in turn borrowed from Shahrazad—"all the stories that had ever been told . . . in fluid form."[11] A dream of interactive narrative that is endlessly complex and satisfying because you can never know the whole, only the stream you happen to dip into. The older our global conversation gets, the more it is rich, concentrated, and impossible to retrieve. Peirce would assent that we cannot know what happened in the past except as it is expressed in the present. If only the World Wide Web could be like this ocean!

And the killer, whose certain arrival the dream predicts with every Hollywood cliché? That's the impoverished database of stories we already know too well. Interactive media, at this point in time, have not achieved the subtle complexity of the ocean of streams of story. Maybe they won't: maybe the killer under the bed, the clichéd stories that package our lives into ordinary nightmares, will tiresomely truncate our dreaming. But this dream is not about that: this dream is a valentine to the artists who keep giving us reasons to go swimming in a river of infinitely rich, endless conversation.[12]

Notes

Introduction

1. In synesthesia, the senses do not translate information but express in their own form the quality of a given perception: yellow sounds like a trumpet; the taste of mint feels like cool glass columns. See Wassily Kandinsky, "Concrete Art," in *Theories of Modern Art,* ed. Herschel B. Chipp (Berkeley: University of California Press, 1968), 346–62; Richard E. Cytowic, *The Man Who Tasted Shapes* (Cambridge: MIT Press, 2000), 6.

2. Walter Benjamin, "The Task of the Translator," in *Illuminations: Essays and Reflections,* ed. Hannah Arendt (New York: Schocken, 1968), 69–82.

3. *Haecceity,* a word Deleuze and Guattari borrow from Charles Sanders Peirce, who seems single-handedly to have revived it from Duns Scotus: thisness, singularity.

4. Gilles Deleuze and Félix Guattari, "The Plane of Immanence," *What Is Philosophy?,* trans. Hugh Tomlinson and Graham Burchell (New York: Columbia University Press, 1994), 35–60.

5. Peirce describes the movement from sensation to symbolization as a never-ending process of semiosis. Charles Sanders Peirce, "The Principles of Phenomenology," in *Philosophical Writings of Peirce,* ed. Justus Buchler (New York: Dover, 1955), 74–97. I describe these relationships in more detail in "A Tactile Epistemology: Mimesis," *The Skin of the Film: Intercultural Cinema, Embodiment, and the Senses* (Durham: Duke University Press, 2000), 138–45.

6. Maurice Merleau-Ponty, *The Visible and the Invisible*, trans. Alphonso Lingis (Evanston: Northwestern University Press, 1968), 126.

7. Morgan Fisher, "Script of *Standard Gauge*," in *Screen Writings: Scripts and Texts by Independent Filmmakers*, ed. Scott MacDonald (Berkeley: University of California Press, 1995), 175–89.

8. "Surface" does not imply mere appearances, a Platonic notion that would oppose false surfaces to true, abstract depths or heights. Surface is all there is. Gilles Deleuze, "Second Series of Paradoxes of Surface Effects," in *The Logic of Sense*, ed. Constantin V. Boundas, trans. Mark Lester (New York: Columbia University Press, 1990), 4–11.

9. Gilles Deleuze and Félix Guattari, "1440: The Smooth and the Striated," *A Thousand Plateaus: Capitalism and Schizophrenia*, trans. Brian Massumi (Minneapolis: University of Minnesota Press, 1987), 474–500.

10. Ibid., 493.

11. Dudley Andrew, "The Neglected Tradition of Phenomenology in Film Theory," in *Movies and Methods II*, ed. Bill Nichols (Berkeley: University of California Press, 1985), 625–32.

12. See Marshall McLuhan, "Media Hot and Cold," in *Video Re/View: The (Best) Source for Critical Writings on Canadian Artists' Video*, ed. Peggy Gale and Lisa Steele (Toronto: Art Metropole and V Tape, 1997), 45–56.

13. The distinction between imperial and minor science is discussed in Deleuze and Guattari, "Treatise on Nomadology—The War Machine," *A Thousand Plateaus*, 361–74.

14. Sean Cubitt, *Digital Aesthetics* (London: Sage, 1998), xi.

15. Deleuze, "Ninth Series of the Problematic," in *Logic of Sense*, 52–57.

16. Benjamin, "Task of the Translator," 81; quoting Rudolf Pannwitz.

17. Gilles Deleuze, *Logic of Sense*, 260.

18. Cubitt, *Digital Aesthetics*, ix–x; see also Jennifer Fisher, "Relational Sense: Towards a Haptic Aesthetics," *Parachute* 87 (July–September 1997), 4–11.

19. Elaine Scarry, *The Body in Pain: The Making and Unmaking of the World* (New York: Oxford University Press, 1985), 28–51.

20. Leo Bersani, "Is the Rectum a Grave?," in Douglas Crimp, ed., *AIDS: Cultural Analysis, Cultural Activism* (Cambridge: MIT Press, 1988).

21. Joanna Frueh, *Erotic Faculties* (Berkeley: University of California Press, 1996), 2.

22. Gilles Deleuze, *Negotiations* (New York: Columbia University Press, 1997), 44.

23. Vivian Sobchack, *The Address of the Eye: Phenomenology and Film Experience* (Princeton: Princeton University Press, 1992).

24. Lyall Watson, *Jacobson's Organ and the Remarkable Nature of Smell* (London: Penguin, 1999), 55.

1. Video Haptics and Erotics

1. Margaret Iversen, *Aloïs Riegl* (Cambridge: MIT Press, 1993), 78–79; quoting Riegl, 1985.

2. Aloïs Riegl, *Late Roman Art Industry*, trans. Rolf Winkes (Rome: Giorgio Bretschneider Editore, 1985). Originally published as *Spätromisches Kunstindustrie*, 1927.

3. Ibid., 13.

4. Antonia Lant, "Haptical Cinema," *October* 75 (fall 1995): 64.

5. Thanks to Paolo Cherchi Usai for this observation.

6. Gilles Deleuze and Félix Guattari, "1440: The Smooth and the Striated," in *A Thousand Plateaus: Capitalism and Schizophrenia*, trans. Brian Massumi (Minneapolis: University of Minnesota Press, 1987), 493.

7. Ibid., 497.

8. Svetlana Alpers, *The Art of Describing: Dutch Art in the Seventeenth Century* (Chicago: University of Chicago Press, 1983).

9. Norman Bryson, "The Gaze and the Glance," in *Vision and Painting* (New Haven: Yale University Press, 1983).

10. Naomi Schor, *Reading in Detail: Aesthetics and the Feminine* (New York: Methuen, 1987).

11. Mieke Bal, *Reading "Rembrandt": Beyond the Word-Image Opposition* (New York: Cambridge University Press, 1991).

12. See Jennifer Fisher, "Relational Sense: Towards a Haptic Aesthetics," *Parachute* 87 (July–September 1997): 4–11.

13. Luce Irigaray, *This Sex Which Is Not One*, trans. Catherine Porter and Carolyn Burke (Ithaca: Cornell University Press, 1985), 26.

14. See Tom Gunning, *D. W. Griffith and the Origins of American Narrative Film* (Urbana: University of Illinois Press, 1991), and James Lastra, "From the Captured Moment to the Cinematic Image: A Transformation in Pictorial Order," in *The Image in Dispute: Art and Cinema in the Age of Photography*, ed. Dudley Andrew, with Sally Shafto (Austin: University of Texas Press, 1997), 263–91.

15. Gunning, *D. W. Griffith and the Origins of American Narrative Film*, 41–42 and passim.

16. Noël Burch, "Primitivism and the Avant-Gardes: A Dialectical Approach," in *Narrative, Apparatus, Ideology*, ed. Philip Rosen (New York: Columbia University Press, 1987); he expands this argument in "Building a Haptic Space," *Life to Those Shadows* (Berkeley: University of California Press, 1990), 162–85.

17. Gilles Deleuze, *Cinema 2: The Time Image*, trans. Hugh Tomlinson and Robert Galeta (Minneapolis: University of Minnesota Press, 1989), 12.

18. Lant, "Haptical Cinema."

19. See Bill Nichols, "The Ethnographer's Tale," in *Visualising Theory: Selected Essays from V.A.R., 1990–1994,* ed. Lucien Taylor (New York: Routledge, 1994), 60–83; Jane M. Gaines, "Political Mimesis," in *Collecting Visible Evidence,* ed. Jane M. Gaines and Michael Renov (Minneapolis: University of Minnesota Press, 1999), 84–102.

20. Jacinto Lejeira, "Scenario of the Untouchable Body," trans. Brian Holmes, "Touch," special issue of *Public,* no. 13 (1996): pp. 32–47.

21. As Michael James Stock demonstrates, the "blot" effect arouses desire through distance, by obscuring the place where desire ought to reside. Michael James Stock, "Bodies and the 'Blot': Electronic Obscuration in Reality TV," *Spectator* 16, no. 2 (1996): 90–97.

22. It could be argued that the intimacy of the television screen encourages a more "embodied" relationship of viewer to image. However, given the use of video projection, giant screens, etc., and also the increasing commingling of film and video in the same productions, I find this distinction less important.

23. Ron Burnett, "Video Space/Video Time: The Electronic Image and Portable Video," in *Mirror Machine: Video and Identity,* ed. Janine Marchessault (Toronto: YYZ/Center for Research on Canadian Cultural Industries and Institutions, 1995), 142–96.

24. David Bordwell and Kristin Thompson, *Film Art: An Introduction* (New York: McGraw Hill, 1997), 31.

25. John Belton, "Looking Through Video: The Psychology of Video and Film," in *Resolutions: Contemporary Video Practices,* ed. Michael Renov and Erika Suderberg (Minneapolis: University of Minnesota Press, 1996), 71.

26. Archived at http://thecity.sfsu.edu/users/xfactor/fw/index.html.

27. Wulf Herzogenrath, "Notes on Video as an Artistic Medium," in *The New Television,* ed. Douglas Davis and Allison Simmons (Cambridge: MIT Press, 1977), 90.

28. The American toy company Tyco manufactured a similar children's video camera, also discontinued now. Then webcams seemed to fill the gap for those who desired low-res images, but unfortunately they too are now able to deliver high-quality, optical pictures.

29. Vivian Sobchack, *The Address of the Eye: A Phenomenology of Film Experience* (Princeton: Princeton University Press, 1992), 10–15.

30. See Jessica Benjamin, *The Bonds of Love: Psychoanalysis, Feminism, and the Problem of Domination* (New York: Pantheon, 1988).

31. This definition is central to Linda Williams's description of pornography in *Hard Core: Power, Pleasure, and the "Frenzy of the Visible"* (Berkeley: University of California Press, 1989), though Williams posits a more vulnerable and embodied viewing position for pornography in her later essay "Corporealized Observers: Visual Pornographies and the 'Carnal Density of Vision,'" in *Fugitive*

Images: From Photography to Video, ed. Patrice Petro (Bloomington: Indiana University Press, 1995), 3–41.

32. Parveen Adams, "Per Os(cillation)," in *Male Trouble,* ed. Constance Penley and Sharon Willis (Minneapolis: University of Minnesota Press, 1993), 3–26.

33. See Mary Ann Doane, *The Desire to Desire: The Woman's Film of the 1940s* (Bloomington: Indiana University Press, 1987).

34. See Gaylyn Studlar, *In The Realm of Pleasure: Von Sternberg, Dietrich, and the Masochistic Aesthetic* (Urbana: University of Illinois Press, 1988).

35. Emmanuel Levinas, *Collected Philosophical Papers* (Dordrecht: Martinus Nijhoff, 1987), 118.

36. Paul Davies, "The Face and the Caress: Levinas's Ethical Alterations of Sensibility," in *Modernity and the Hegemony of Vision,* ed. David Michael Levin (Berkeley: University of California Press), 269.

37. Quoted in ibid., 267.

38. Michael Taussig, *Mimesis and Alterity: A Particular History of the Senses* (New York: Routledge, 1993), 45.

39. In *The Skin of the Film: Intercultural Cinema, Embodiment, and the Senses* (Durham: Duke University Press, 2000), chapter 4.

2. Animal Appetites, Animal Identifications

1. Donna J. Haraway, "The Past Is the Contested Zone: Human Nature and Theories of Production and Reproduction of Primate Behavior Studies," in *Simians, Cyborgs, and Women: The Reinvention of Nature* (New York: Routledge, 1991), 21.

2. Haraway, "Animal Sociology and a Natural Economy of the Body Politic: A Political Physiology of Dominance," in *Simians, Cyborgs, and Women,* 11–12.

3. Anne Friedberg, "Der vierbeinige Andere und die Projektion im Kino (The four-legged other and cinematic projection)," *Frauen und Film,* no. 47 (September 1989): 4–13.

4. Greg Mitman, *Reel Nature: America's Romance with Wildlife on Film* (Cambridge: Harvard University Press, 1999), 200–01.

5. Ibid., 194.

6. Raymond Bonner, *At the Hand of Man: Peril and Hope for African Wildlife* (New York: Knopf, 1993).

7. Quoted in Johanne Lamoureux, "La bête à deux têtes: Langue et programme dans l'intertitre *Le Bestiaire/Endangered Species,*" *Parachute,* no. 73 (spring 1994): 20.

8. See Laura U. Marks, "Suspicious Truths: Flaherty 1991," *Afterimage* 19, no. 3 (October 1991): 4, 21; and Ken Feingold, Coco Fusco, and Steve Gallagher, "Trouble in Truthsville," *Felix* 1, no. 2 (spring 1992): 48–49, 128–31.

9. "Interview with Mike MacDonald by Tom Sherman," *Interviews with Artists Series* (Toronto: Mercer Union, 1991), 6.

10. Ibid., 2.

11. Quoted in the videotape *Starting Fire with Gunpowder* (1991) by David Poisey and William Hansen.

12. Victor Masayesva, "Indigenous Experimentalism," in *Magnetic North: Canadian Experimental Video*, ed. Jenny Lion (Minneapolis: University of Minnesota Press, Video Pool Inc., and the Walker Art Center, 2001), 232.

13. Darrell Varga, "The Politics of Meat in Recent Canadian Documentary," paper presented at the Film Studies Association of Canada, May 2000.

14. My thanks to Akira Mizuta Lippitt and Darrell Varga for comments in the long course of this writing, and to Maggie McCarthy for the bang-up translation of Anne Friedberg's "Der vierbeinige Andere."

3. "I Am Very Frightened by the Things I Film"

1. Paul Arthur, "Jargons of Authenticity (Three American Moments)," in *Theorizing Documentary*, ed. Michael Renov (New York: Routledge, 1993), 128; Bill Nichols, "Documentary Modes of Representation," in *Representing Reality: Issues and Concepts in Documentary* (Bloomington: Indiana University Press, 1991), 59.

2. Trinh T. Minh-ha, *Woman, Native, Other: Writing Postcoloniality and Feminism* (Bloomington: Indiana University Press, 1989), 76.

3. "Hara Kazuo," interviews with Scott MacDonald and members of the Robert Flaherty Seminar, translated by Steven Schible, 17–18 August 1993. In Scott MacDonald, *A Critical Cinema 3: Interviews with Independent Filmmakers* (Berkeley: University of California Press, 1998), 133, 134.

4. Linda Williams, "The Ethics of Documentary Intervention: Dennis O'Rourke's *The Good Woman of Bangkok*," in *Collecting Visible Evidence*, ed. Jane M. Gaines and Michael Renov (Minneapolis: University of Minnesota Press, 1999).

5. David Desser, *Eros Plus Massacre: An Introduction to Japanese New Wave Cinema* (Bloomington: Indiana University Press, 1988), 166–68.

6. MacDonald, "Hara Kazuo," 135.

7. Ibid.

8. For a detailed discussion of the film's production and reception contexts, see Jeffrey Ruoff and Kenneth Ruoff, *The Emperor's Naked Army Marches On / Yukiyukite Shingun* (Wiltshire, England: Flicks Books, 1998).

9. MacDonald, "Hara Kazuo," 138.

10. Jeffrey K. Ruoff, "Filming at the Margins: The Documentaries of Hara Kazuo," paper presented at the Society for Cinema Studies, February 1993, 5.

11. Williams, "The Ethics of Documentary Intervention," 14.

12. Sigmund Freud, "The Economic Problem of Masochism," quoted in Kaja Silverman, *Male Subjectivity at the Margins* (New York: Routledge, 1992), 188.

13. MacDonald, "Hara Kazuo," 129.

14. Silverman, *Male Subjectivity*, 201–10.

15. Leo Bersani, "Is the Rectum a Grave?", *October* 43 (winter 1987): 222. Bersani is writing specifically of male anal sex as the site for this shattering of subjectivity. I find his argument more viable at the level of experiences of *psychic* receptivity and penetration.

16. David MacDougall, "Whose Story Is It?", *Visual Anthropology Review* 7, no. 2 (fall 1991): 6. MacDougall recounts several strategies ethnographic filmmakers use to distinguish between the "structures we inscribe in films" and "the structures that are inscribed upon them, often without our knowing, by their subjects" (4). He allows for the possibility that the meaning of the film text does not lie with the producer; that it can be "inscribed" by maker and objects ("subjects") alike.

17. Jean Rouch, "Les aventures d'un nègre blanche," interview with Philippe Esnault, *Image et Son* 249 (April 1971); quoted in Mick Eaton, "The Production of Cinematic Reality," in *Anthropology—Reality—Cinema,* ed. Mick Eaton (London: British Film Institute, 1979), 51.

18. See, for example, the testimony by Oumarou Ganda, the central "character" of *Moi, un noir,* in "Edward Robinson: My Life and Adventures in Treichville," trans. Mick Eaton, in Eaton, "The Production of Cinematic Reality," 9–10.

19. Ruoff, "Filming at the Margins," 3–4. As Angelo Restivo suggested in a private correspondence, this preference for films with impossibly virile and competent male characters certainly sounds like a compensatory mechanism for the submissive stance Hara takes in his own films. As well, the narrative self-containment of the superhero movies seems to offer a recourse from the loss of control that characterizes Hara's own work.

20. Ruoff, "Filming at the Margins," 6.

21. Gilles Deleuze, *Cinema 2: The Time Image,* trans. Hugh Tomlinson and Barbara Habberjam (Minneapolis: University of Minnesota Press, 1989), 150. These views are elaborated by Deleuze and Félix Guattari in *Kafka: Toward a Minor Literature,* trans. Dana Polan (Minneapolis: University of Minnesota Press, 1986).

22. On becoming, see Gilles Deleuze and Félix Guattari, "1730: Becoming-Intense, Becoming-Animal, Becoming-Imperceptible," in *A Thousand Plateaus: Capitalism and Schizophrenia* (Minneapolis: University of Minnesota Press, 1987), 232–309.

23. Gilles Deleuze, "Mediators," trans. Martin Joughin, in *Zone 6: Incorporations,* ed. Jonathan Crary and Sanford Kwinter (New York: Urzone, 1992), 286.

24. Hara's dismissal of American influence is disputed by the fact that Jonas Mekas's *Reminiscences* was widely discussed when it was screened in Tokyo in 1973, and critics subsequently compared *Extreme Private Eros* to Mekas's film (Ruoff, "Filming at the Margins," 6).

25. MacDonald, "Hara Kazuo," 130.

26. Garlic does not separate in layers, as onions do, but into cloves, which would seem to obviate the metaphor. However, pickled garlic is a common Japanese condiment.

27. MacDonald, "Hara Kazuo," 130.

28. Norman Bryson, "The Gaze in the Expanded Field," in *Vision and Visuality*, ed. Hal Foster (Seattle: Bay Press, 1988), 87–113.

29. Ibid., 99.

30. Ibid., 107–08.

31. MacDonald, "Hara Kazuo," 135.

4. Here's Gazing at You

1. See my article "The Audience Is Revolting: Coalition and Transformation at the Flaherty Seminar," in Patricia R. Zimmermann and Erik Barnouw, eds., *The Flaherty: Four Decades in the Cause of Independent Cinema,* special issue of *Wide Angle* 17, nos. 1–4 (1996): 41–61, for a discussion of this phenomenon.

2. The entire discussion is transcribed in Scott MacDonald, "At the Flaherty," in *A Critical Cinema 3: Interviews with Independent Filmmakers* (Berkeley: University of California Press, 1998), 158–65. The volume also includes MacDonald's interview with Ken and Flo Jacobs.

3. Laura Mulvey, "Visual Pleasure and Narrative Cinema," *Screen* 16, no. 3 (1975); reprinted in *Visual and Other Pleasures* (Bloomington: Indiana University Press, 1989).

4. Jesse Lerner, "Flaherty in Motion," *Afterimage* 20, no. 5 (December 1992): 4.

5. Linda Williams, *Hard Core: Power, Pleasure, and the "Frenzy of the Visible"* (Berkeley: University of California Press, 1989), 39–41.

6. Stan Brakhage, *Film at Wit's End* (New York: McPherson, 1989), 149–56.

7. Jonas Mekas, "Movie Journal," *Village Voice,* 2 May 1963.

8. P. Adams Sitney, *Visionary Film: The American Avant-Garde* (New York: Oxford University Press, 1974), 372.

9. Ken Jacobs, *Film-Makers Cooperative Catalogue no. 5,* 165; quoted in Sitney, *Visionary Film,* 371.

10. MacDonald, "At the Flaherty," 159–60.

11. Patricia Mellencamp, *Indiscretions: Avant-Garde Film, Video, and Feminism* (Bloomington: Indiana University Press, 1990), 96–97.

12. Williams, *Hard Core,* 57.

13. Phil Solomon, "XCXHXEXRXRXIXEXSX," *Cinematograph* 5 (1993): 55.

14. Ibid., 56.

15. The foundational example of this discourse is Annette Michelson's phenomenological discussion of Michael Snow's *Wavelength,* "Toward Snow," in *The Avant-Garde Film: A Reader of Theory and Criticism* (New York: Anthology Film Archives, 1987), 173–83. Originally published in *Artforum,* June 1971.

16. MacDonald, "At the Flaherty," 163–65; additional information (Tshaka's comment, identification of Fisher) is from my own notes taken during the discussion.

17. Thanks again to Pat Thompson, Lisa Cartwright, Gordon Bleach, Chris Horak, Scott MacDonald, and Helen Molesworth for their feedback and encouragement during the original writing of this essay.

5. Love the One You're With

1. Steve Neale, "Masculinity as Spectacle: Reflections on Men and Mainstream Cinema," *Screen* 26, no. 6 (November/December 1983): 2–16.

2. Richard Dyer, "Don't Look Now: The Instabilities of the Male Pin-Up," *Screen* 23 (1982); reprinted in *Only Entertainment* (London: Routledge, 1992), 116.

3. See Thomas Waugh, *Hard to Imagine: Gay Male Eroticism in Photography and Film from Their Beginnings to Stonewall* (New York: Columbia University Press, 1996).

4. An important alternative way to read queerness into manifestly heterosexual films is camp, a subversive delight in the excesses of hetero culture. See, for example, Corey Creekmur and Alexander Doty, "Introduction," in *Out in Culture: Gay, Lesbian, and Queer Perspectives on Popular Culture,* ed. Corey Creekmur and Alexander Doty (Durham: Duke University Press, 1995), 1–11, and Fabio Cleto, ed., *Camp: Queer Aesthetics and the Performing Subject: A Reader* (Ann Arbor: University of Michigan Press, 1999).

5. Kaja Silverman, *Male Subjectivity at the Margins* (New York: Routledge, 1992).

6. Ibid. See also Kaja Silverman, "From the Ego-Ideal to the Active Gift of Love," in *The Threshold of the Visible World* (New York: Routledge, 1996). This book continues the search for a cinema that would invite viewers to identify with fragmented and disempowered characters. Doing this helps to break down our illusory subjecthood, which, Silverman argues, is what prevents us from truly loving and empathizing with one another.

7. Katherine Hurbis-Cherrier, letter to the author, November 1994.

8. Paul Smith, "Vas," *Camera Obscura,* no. 17 (spring 1988): 89–111.

9. Gaylyn Studlar, *In the Realm of Pleasure: Von Sternberg, Dietrich, and the Masochistic Aesthetic* (Urbana: University of Illinois Press, 1988), 48.

10. Jessica Benjamin, *The Bonds of Love: Feminism, Psychoanalysis, and the Problem of Domination* (New York: Pantheon, 1988), 73–74.

11. Studlar, *In the Realm of Pleasure*, 52.

12. Susan Bordo, "Reading the Male Body," in *The Male Body: Features, Destinies, Exposures*, ed. Laurence Goldstein (Ann Arbor: University of Michigan Press, 1994), 265–306.

13. Incidentally, this work belongs to a microgenre of skateboard porn that also includes Candyland Productions' *Sex Bombs!* (1987) and G. B. Jones's *The Yo-Yo Gang* (1992).

14. This issue was first broached, to my knowledge, by Richard Fung in his tapes *Orientations* (1984) and *Chinese Characters* (1987), and has also come up in works such as *GOM* (1994) by Kirby Hsu and *Seven Questions for Sticky Rice* (1994) by Hong Nguyen.

15. For example, in the Rochester Lesbian and Gay Film and Video Festival, where I was a programmer from 1992 to 1994, our programs with titles like "Sexy Shorts for All Sorts" met with such mixed reactions that in the third year we returned to separate "boys'" and "girls'" erotic programming.

16. Douglas Crimp, "Right On, Girlfriend!" in *Fear of a Queer Planet*, ed. Michael Warner (Durham: Duke University Press, 1993), 12.

17. Thanks to Douglas Crimp, Katherine Hurbis-Cherrier, and Ming-Yuen S. Ma for their helpful comments during this writing, as well as to Chuck Kleinhaus and Julie Lesage at *Jump Cut*.

6. Loving a Disappearing Image

1. Vivian Sobchack, *The Address of the Eye: Phenomenology and Film Experience* (Princeton: Princeton University Press, 1992).

2. I include single-channel video in the category of cinema.

3. Seth Feldman, "What Was Cinema?," *Canadian Journal of Film Studies* 5:1 (spring 1996): 1–22. Feldman suggests that the "assaultive" style of contemporary cinema makes it more oriented toward spectacle, or toward a "cinema of attractions." This is an interesting assertion, because the "attraction" of early cinema was not the attraction of secondary identification with characters in a movie but a relationship with the screen image itself. In this essay I argue that identification with the screen, and with a screen image that is dissolving and incomplete, permits a look that acknowledges death.

4. "L'histoire du cinéma naît d'une absence. Puisque, si toutes les images en mouvement étaient présents en leur état initial, il n'y aura pas d'histoire du cinéma, celle-ci ne peut qu'expliquer pourquoi ces images ont disparu, et leur valeur hypothéthetique dans la mémoire culturelle d'une époque; c'est leur type de disparition qui induit une périodisation." Paolo Cherchi Usai, "Une image modéle,"

Hors Cadre 6 (spring 1988): 230; my translation. This argument has since been expanded in English in the remarkable *The Death of Cinema: History, Cultural Memory, and the Digital Dark Age* (London: British Film Institute, 2001).

5. Ibid., 235.

6. The authoritative source on the use of found footage in experimental films is William C. Wees, *Recycled Images: The Art and Politics of Found Footage Films* (New York: Anthology Film Archives, 1993).

7. Phil Solomon, conversation with the author, 29 March 2001.

8. Roland Barthes, *Camera Lucida: Reflections on Photography*, trans. Richard Howard (New York: Hill, 1981), 127.

9. Thomas Waugh, *Hard to Imagine: Gay Male Eroticism in Photography and Film from Their Beginnings to Stonewall* (New York: Columbia University Press, 1996). Waugh describes the process of legal and digital censorship his precious images underwent in "The Archaeology of Censorship," in Lorraine Johnson, ed., *Suggestive Poses: Artists and Critics Respond to Censorship* (Toronto: Toronto Photographer's Workshop and Riverbank Press, 1997). He also tells the story in John Greyson's *Uncut* (1997), a film that, in Greyson's lateral fashion, compares image censorship to circumcision.

10. Christian Metz, "Identification/Mirror" and "The Passion for Perceiving," in Gerald Mast, Marshall Cohen, and Leo Braudy, eds., *Film Theory and Criticism* (New York: Oxford University Press, 1992 [1975]), 730–45.

11. Kaja Silverman, *The Threshold of the Visible World* (New York: Routledge, 1996), 23–24.

12. As Kobena Mercer, and before him Third Cinema theorists such as Fernando Solanas and Octavio Getino, argue, narrative closure is often inappropriate in films made within minority communities, because the struggle will still be going on when the film is over. See Kobena Mercer, "Recoding Narratives of Race and Nation," in *Welcome to the Jungle: New Positions in Black Cultural Studies* (New York: Routledge, 1993), 69–95; Fernando Solanas and Octavio Getino, "Towards a Third Cinema," trans. Julianne Burton and Michael Chanan, in Michael Chanan, ed., *Twenty-Five Years of New Latin American Cinema* (London: British Film Institute, 1983 [1969]).

13. Sigmund Freud, "Mourning and Melancholia," in James Strachey, ed. and trans., *The Standard Edition of the Collected Psychological Works*, vol. 14 (London: Hogarth, 1957 [1917]), 255.

14. Ibid., 245.

15. William James, "The Sick Soul," in *The Varieties of Religious Experience* (Cambridge: Harvard University Press, 1985 [1902]), 147; James's emphasis.

16. Ibid., 151.

17. Roland Barthes, *Camera Lucida*, 90.

18. Ibid., 93.

19. Timothy Murray offers an interesting discussion of Barthes's photographic melancholia in *Like a Film: Ideological Fantasy on Screen, Camera, and Canvas* (London: Routledge, 1993).

20. Sandilya, *One Hundred Aphorisms of Sandilya*, ed. and trans. Manmath-amnath Paul, in *Sacred Books of the Hindus*, vol. 7, pt. 2 (New York: AMS Press), i.

21. *Tiruvaymoli* 9.9.2; quoted in Vasudha Narayanan, *The Way and the Goal: Expressions of Devotion in the Early Sri Vaisnava Tradition* (Washington, D.C.: Institute for Vaishnava Studies, 1987), 42.

22. Narayanan, *The Way and the Goal*, 66; 97–99.

23. Rumi (Jalal al-Din Rumi, Maulana), *The Essential Rumi*, trans. Coleman Barks (New York: HarperCollins, 1995), 155.

24. The practice of safe sex certainly is a pointed example of the cultural desire to preserve individual boundaries: never getting to taste one's lover and touch one's lover on the inside, because of fear of contracting HIV. On "how to have promiscuity in an epidemic," see Douglas Crimp, "Mourning and Militancy," in Russell Ferguson, Martha Gever, Trinh T. Minh-ha, and Cornel West, eds., *Out There: Marginalization and Contemporary Culture* (New York: New Museum of Contemporary Art, 1990), 233–45.

25. Warmest thanks to Shauna Beharry for her support and suggestions during this writing. I also thank Robin Curtis and Phil Solomon for inspiring conversations.

7. The Logic of Smell

1. Some of this information was found at www.digiscents.com, no longer online; also Ronna Abramson, "Sniff-Company DigiScents Is a Scratch," *The Standard*, 11 April 2001. http://www.thestandard.com/article/0,1902,23654,00. html.

2. Abramson, "Sniff-Company DigiScents Is a Scratch."

3. Constance Classen, David Howes, and Anthony Synnott, *Aroma: The Cultural History of Smell* (London: Routledge, 1994), 180.

4. Science popularizers argue that human pheromones are received by the vomeronasal organ or Organ of Jacobson, high up in the nose. These substances produce effects more profound and intractable than any collectively understood image. Unlike odors, for which we learn particular, individual responses, pheromones carry specific information about gender, reproduction, and social status that engender hard-wired responses. They might explain, for example, why women living together menstruate at the same time. See Lyall Watson, *Jacobson's Organ and the Remarkable Nature of Smell* (London: Penguin, 1999). If we accept this argument, pheromones are already symbolic. Odors are not; they are semi-

otized through individual experience. Another way to say this is that phero-
mones are the deep structure of olfactory language, odors are the phonemes.
However, sober scientists argue there is insufficient evidence that humans re-
spond to pheromones, since the vomeronasal organ is vestigial in many humans.
See Richard L. Doty's literature review, "Olfaction," *Annual Review of Psychology*
52 (2001): 423–52. Given this wariness in the scientific community, I will confine
my discussion, for the most part, to perceptible smells. Further discoveries about
pheromones would complicate, but not obviate, this chapter's argument that the
response to smell is learned.

5. Gilles Deleuze, *Cinema 1: The Movement Image*, trans. Hugh Tomlinson
and Barbara Habberjam (Minneapolis: University of Minnesota Press, 1987), 97.

6. Charles Sanders Peirce, "The Principles of Phenomenology: The Cate-
gories in Detail," in *Collected Papers of Charles Sanders Peirce*, ed. Charles Hart-
shorne and Paul Weiss, vol. 1, *Principles of Philosophy* (Cambridge: Harvard Uni-
versity Press, 1931), 150.

7. Sean Cubitt, *Digital Aesthetics* (British Film Institute, 1998).

8. Laura U. Marks, *The Skin of the Film: Intercultural Cinema, Embodiment,
and the Senses* (Durham: Duke University Press, 2000), chapters 3 and 4.

9. Author Michael Ondaatje praised editor Walter Murch's use of unrelated
diegetic sound to emphasize a sensuous moment in the adaptation of his novel
The English Patient. During a shot of Hana feeding a peeled plum to the immobi-
lized patient, a bell rings, as though from a distant church. "You can't get taste
across in a film, so Walter put a bell there, which is like a memory of his tasting
something he tasted years ago. And that bell, which comes about 15 minutes into
the film, is the first civilized sound in the film. Up to that point, you've heard tanks
rolling by, or bombs. This is the first decent, human sound. So behind everything
quite casual like that, there was a huge philosophy." Ben Ratliff, "They've Kid-
napped 'The English Patient,'" *New York Times Book Review*, 23 March 1997.

10. The three smells are (1) Ivory soap, (2) cumin, (3) lavender. For a story
about the author's associations with each, see "J's Smell Movie: A Shot List," in
this volume.

11. Rachel S. Herz and Trygg Engen, "Odor Memory: Review and Analysis,"
Psychonomic Bulletin and Review 3, no. 3 (1996): 300; P. F. C. Gilbert, "An Outline
of Brain Function," *Cognitive Brain Research* 12, no. 1 (August 2001): 61; and
A. Maureen Ronhi, "Tracing Scents to an Odor Map," *Chemical and Engineering
News*, 23 December 1996. http://ep.llnl.gov/msds/ScanDbase/Smell-CEN-12-23-
96.html.

12. Mark Stopfer and Gilles Laurent, "Short-term Memory in Olfactory Net-
work Dynamics," *Nature* 402 (9 December 1999): 664–68.

13. "iSmell a New Gaming Standard: Scent Enabling PC Games with the

ScentWare Software Development Kit (SDK) v 1.0," www.digiscents.com (no longer online).

14. Herz and Engen, "Odor Memory," 307.

15. Marks, *The Skin of the Film,* chapter 1.

16. Watson, *Jacobson's Organ,* 181.

17. Doty, "Olfaction," 436.

18. The logic of sense is an exercise against abstraction: for each proposition, we derive its sense, which leads us in turn to another proposition, etc., rather like a differential equation, which proceeds from a particular set of points, or a problem, and generates a set of vectors.

19. Gilles Deleuze, "Ninth Series of the Problematic," in *The Logic of Sense,* ed. Constantin V. Boundas, trans. Mark Lester (New York: Columbia University Press, 1990), 53.

20. Deleuze, "Twenty-Second Series: Porcelain and Volcano," in *The Logic of Sense,* 154–61.

21. Deleuze, "The Simulacrum and Ancient Philosophy," in *The Logic of Sense,* 260.

22. I pursue a definition of the fossil image in *The Skin of the Film,* chapter 4.

23. Peirce notes that the recipe for apple pie, as a general principle, is Third, while the apples themselves, being particular apples, are Second, and apple quality is First. "What [the cook] desires is something of a given quality; what she has to take is this or that particular apple." "The Principles of Phenomenology," 172–73.

24. Natasha Singer, "The Suit That Makes You Feel as Good as Prozac," *New York Times,* 11 June 2000.

25. "Only odors that have been learned as positive or negative through prior association can elicit corresponding hedonic responses." Herz and Engen, "Odor Memory," 307. See also Piet Vroon, *Smell: The Secret Seducer,* trans. Paul Vincent (New York: Farrar, Straus and Giroux, 1994), 107.

26. Tor Nørretranders, *The User Illusion: Cutting Consciousness Down to Size,* trans. Jonathan Sydenham (New York: Penguin, 1999), xi.

27. I beta-tested versions of this essay as an olfactory performance on some wonderfully game-to-smell audiences: at the conference "Come to Your Senses" at the Amsterdam Society for Cultural Analysis, May 1998; the Department of Art History, University of British Columbia, March 2000; the conference "Affective Encounters: Rethinking Embodiment in Feminist Media Studies," University of Turku, Finland, September 2001; and the Harpur College Dean's Interdisciplinary Film Workshop at SUNY Binghamton, November 2001. I am very grateful to them for sharing their rich smell associations and stern criticism. Particular

thanks to Dorit Naaman, and to my parents, Bill Marks and Anne Foerster, for combing and explaining the neuroscience literature to me yet again.

8. Institute Benjamenta

1. See Leslie Felperin, review of *Institute Benjamenta, Sight and Sound* 5, no. 12 (winter 1995): 46; Jonathan Romney, "Life's a Dream," *Sight and Sound* 5, no. 8 (August 1995): 12–13; Thyrza Nichols Goodeve, "Dream Team: An Interview with the Brothers Quay," *Artforum* (April 1996): 82–85, 118, 126.

2. Quays, in Goodeve, "Dream Team," 84.

3. Robert Walser, "An Address to a Button," trans. Mark Harman, in *Robert Walser Rediscovered: Stories, Fairy-Tales, and Critical Responses,* ed. Mark Harman (Hanover: University Press of New England, 1985), 28.

4. Mark Harman, "Introduction: A Reluctant Modern," in *Robert Walser Rediscovered,* 4.

5. Unless otherwise noted, this and other quotes from the Quays are from interviews with me on 13 September 1995 and 21 May 1996.

6. The sort of gaze to which such a detailed look appeals is discussed in, for example, Svetlana Alpers, *The Art of Describing: Dutch Art in the Seventeenth Century* (Chicago: University of Chicago Press, 1983) and Naomi Schor, *Reading in Detail: Aesthetics and the Feminine* (New York: Methuen, 1987). The great-uncle of tactile visuality is art historian Aloïs Riegl; see *Late Roman Art Industry,* trans. Rolf Winkes (Rome: Giorgio Bretschneider Editore, 1985; originally published 1927).

7. Trygg Engen, *Odor Sensation and Memory* (New York: Praeger, 1991), 5.

8. Quays, in Goodeve, "Dream Team," 84–86 passim.

9. D. Michael Stoddart, *The Scented Ape: The Biology and Culture of Human Odour* (Cambridge: Cambridge University Press, 1990), 163. Other material in this paragraph is drawn from pp. 161–63.

10. Constance Classen, David Howes, and Anthony Synnott, *Aroma: The Cultural History of Smell* (London: Routledge, 1994), 124.

11. Engen, *Odor Sensation and Memory,* 2–3, 115–17; Rachel S. Herz and Trygg Engen, "Odor Memory: Review and Analysis," *Psychonomic Bulletin and Review* 3, no. 3 (1996): 307.

12. Stoddart, *The Scented Ape,* 33–35.

13. Quays, in Goodeve, "Dream Team," 85.

14. Stoddart, *The Scented Ape,* 171–80.

15. Ibid., 196–97.

16. Ibid., 12–13.

17. Ibid., 96–97. I suspect that this aversion to women's genital odors is strongest in dualist, patriarchal cultures. Stoddart notes, however, the tradition

of "love magic" in some Melanesian cultures, based on the "fishy smell" of some women's vaginas. A male suitor uses a small red ground cherry to catch a fish. If it catches a fish, it should also be able to attract the vagina of his beloved! (*The Scented Ape*, 91).

18. Freud wrote to his colleague Wilhelm Fleiss: "I have often suspected that something organic played a part in repression. . . . In my case the notion was linked to the changed part played by sensations of smell: upright carriage adopted, nose raised from the ground, at the same time a number of formerly interesting sensations attached to the earth becoming repulsive—by a process still unknown to me. (He turns up his nose = he regards himself as something particularly noble.)" In *The Complete Letters of Sigmund Freud to Wilhelm Fleiss, 1887–1904,* ed. and trans. Jeffrey Moussaieff Masson (Cambridge: Belknap Press of Harvard University Press, 1985), 279. Thanks to Akira Mizuta Lippitt for pointing out this reference to me.

19. When I screened *Street of Crocodiles* in a second-year film course, the class Internet newsgroup exploded in a virtual riot. One student wrote, "I would rather have my left testicle severed with a dull butter knife than ever sit through a film like that again"; others made equally creative and graphic, as well as occasionally thoughtful, rejoinders. This was the same newsgroup that requested we see more violent movies in class.

20. Miriam Hansen shows how reluctantly Benjamin expunged cabalistic, astrological, and other nonscientific ideas from earlier drafts of the "Artwork" essay. Hansen, "Benjamin, Cinema, and Experience: 'The Blue Flower in the Land of Technology,'" *New German Critique* 40 (winter 1987): 179–224.

10. Video's Body, Analog and Digital

1. See, for example, Roberta Smith, "Art of the Moment, Here to Stay; the Bill Viola Show at the Whitney Underscores the Steady Rise and Long Reach of Video Art," *New York Times,* 15 February 1998, timed to coincide with the New York arrival of a Bill Viola retrospective originating from the San Francisco Museum of Modern Art.

2. See Vivian Sobchack, *The Address of the Eye: Phenomenology and Film Experience* (Princeton: Princeton University Press, 1992); "Nostalgia for a Digital Object: Notes on the Quickening of Quicktime," *Millennium Film Journal* 34 (fall 1999): 4–23; and (as editor) *Meta-Morphing: Visual Transformation and the Culture of Quick-Change* (Minneapolis: University of Minnesota Press, 2000).

3. Lev Manovich, "Database as a Symbolic Form," www.manovich.net/texts_00.htm.

4. Not to be confused with Ken Jacobs's Nervous System film projection apparatus, The Very Nervous System analyzes video frames and converts their light

patterns into a database of information. The user can then translate that information into another modality. See www.interlog.com/~drokeby/VNSII.html.

5. Barry E. Stein and M. Alex Meredith, *The Merging of the Senses* (Cambridge: MIT Press, 1993), 9–10.

6. Now that many films are edited digitally, filmmakers are taking advantage of the spatializing property of digital editing as well. An interesting comparison in commercial cinema is Martin Scorsese's two mobster films, one edited on a flatbed, one digitally, namely *Goodfellas* (1990) and *Casino* (1995). *Casino* takes advantage of digital editing to multiply the opportunities for flashbacks, parallel storylines, and other rhizomatic narrative techniques, producing a story that is so dense it expands into space as much as it moves forward in time. Experimental video remains the pioneer of the digital open form, as it is more free of narrative cinema's will to linearity.

7. Berg writes: "These paired binaries are arranged according to one of the most commonly used binary text encoding schemes: the ASCII code (American Standard Code for Information Interchange). In ASCII code each character of the alphabet can be reduced to a 7 digit binary string. ASCII Alphabet is structured so as to slowly reveal the encoded alphabet by first transcribing these strings using the 26 pairs of sounds (A-Z), then by adding the numeral 1 and 0, and finally by using both the opposing images and sounds together." V Tape, www.vtape.org.

8. Lev Manovich, *The Language of New Media* (Cambridge: MIT Press, 2001), 307–08.

9. Vivian Sobchack, "Introduction," in *Meta-Morphing*, xi.

10. Vivian Sobchack, "'At the Still Point of the Turning World: Meta-Morphing and Meta-Stasis," in *Meta-Morphing*, 137.

11. Interestingly, a "locked groove" is a term from the analog days of vinyl records, where a groove in a record could be made to circle back on itself, producing a sound loop. This practice does not translate well to the digital medium of the compact disc, where a sound loop usually indicates that the CD is "stuck." It is ironic that repetition in this case is a property of an analog medium characterized by linear temporality, while the digital medium must appear to have temporal continuity rather than reveal its fundamentally nonlinear, database form.

12. Vivian Sobchack, "Nostalgia for a Digital Object," 4–23.

13. William Gibson, *Idoru* (London: Penguin, 1996); on lossy compression see Manovich, *The Language of New Media*, 54.

14. Tess Takahashi, talk at "Uncommon Senses," Concordia University, Montréal, 29 April 2000.

15. See Laura U. Marks, "Live Video," *The Independent* (July 2000); reprinted

in *The End of Cinema as We Know It,* ed. Jon Lewis (New York: New York University Press, 2001).

11. How Electrons Remember

1. Manuel De Landa, "Nonorganic Life," in *Zone 6: Incorporations,* ed. Jonathan Crary and Sanford Kwinter (New York: Urzone, 1992), 128–67. See also *A Thousand Years of Non-Linear History* (Cambridge: Zone Books/MIT Press, 1997).

2. C. S. Peirce, quoted in Vincent M. Colapietro, *Peirce's Approach to the Self: A Semiotic Perspective on Human Subjectivity* (Albany: SUNY Press, 1989), 18.

3. An index is simply a sign that points to the thing it represents, index-finger style. Strictly speaking, digital images are indexical, in that they point to their source. See the Peircean study by Marc Fursteneau, "An Anxious Discourse: New Image Technologies and the Challenge to Film Theory." Ph.D. diss., McGill University, 2002.

4. Gene Youngblood, "Art and Ontology: Electronic Visualization in Chicago," in *The Event Horizon,* ed. Lorne Falk and Barbara Fischer (Toronto: Coach House Press, 1987), 335.

5. David Wick, *The Infamous Boundary: Seven Decades of Controversy in Quantum Physics* (Boston: Birkhäuser, 1995). Compared to humanities scholarship, the sciences are less subject to fashionable breezes. In science, as in other disciplines, theories are accepted if they explain phenomena. However, science's orthodoxy often means that graduate students and postdocs only work on areas that they think have a good chance of being published and getting them jobs, established scientists do the kinds of work that are assured to receive grants, and in other ways the discipline renews the status quo. In science it's hard to get by on chutzpah. Passion and faith, however, are important ingredients in remaining a scientist, especially if one's work is not recognized in one's lifetime.

6. Schrödinger, who was not a positivist, "hated" Born's interpretation of his equation as merely a probabilistic one (Wick, *The Infamous Boundary,* 31), but the interpretation stuck.

7. Similarly, matrix quantum mechanics explains quantum behavior in mathematical terms that cannot be expressed physically.

8. J. P. McEvoy and Oscar Zarate, *Quantum Theory for Beginners* (Cambridge, U.K.: Icon, 1996), 146–47.

9. John Bell joked about the famous measurement problem, "Was the wavefunction of the world waiting to jump for thousands of millions of years until a single-celled living creature appeared? Or did it have to wait a little longer, for some better-qualified system . . . with a Ph.D.?" Quoted in Wick, *The Infamous Boundary,* 145.

10. Ibid., 169.

11. Einstein's letter to Schrödinger, May 1928, quoted in ibid., 139.

12. *"Spukhafte Fernwirkungen"*; this was Einstein's phrase for Max Born's interpretation of quantum mechanics. Born proposed that if one photon approaches a piece of photographic film, it must collapse from a wave to a particle when it is absorbed by a silver atom, in an impossibly great and instantaneous shift of magnitude. Letter from Einstein to Born, March 1947, quoted in ibid., 132.

13. Gary Zukav and David Finkelstein, *The Dancing Wu-Li Masters: An Overview of the New Physics* (New York: William Morrow, 1980).

14. *Nature* 386 (30 November 1995): 449.

15. Electrons also "remember" their more proximate relationship to their neighbors. According to the Pauli exclusion principle, each electron in a single atom has its own distinct set of quantum numbers (the size of its orbit; the shape of its orbit; the direction in which the orbit is pointing; and the "spin" of the electron). Knowing its own address, it also knows not to enter other electrons' territory, for if it did the atom would implode. McEvoy and Zarate, *Quantum Theory for Beginners,* 93–99.

16. David Bohm and Basil J. Hiley, *The Undivided Universe* (London: Routledge, 1993), 357.

17. Ibid., 358–60.

18. Bohm died, not exactly in obscurity (he was an emeritus professor at Birkbeck College, University of London), but having seen his life's work ignored by most physicists, in 1992 (Wick, *The Infamous Boundary,* 73).

19. See, for example, Lee Smolin, *The Life of the Cosmos* (Oxford: Oxford University Press, 1999). See also the Quantum Mind listserv, http://listserv.arizona.edu/lsv/www/quantum-mind.html; thanks to Jim Ruxton for pointing it out.

20. James P. Crutchfield, "Space-Time Dynamics in Video Feedback," in *Eigenwelt der Apparatewelt: Pioneers of Video Art,* ed. David Dunn (Vienna: Ars Electronica, 1992), 205. This indispensable book, and the associated exhibition curated by Steina and Woody Vasulka, document early experiments in video synthesis in the United States and Europe. Stephen Jones is compiling a comparable document of the lively video-synthesis scene in Australia in the 1960s and early 1970s.

21. We can speak of charge interchangeably with wavelength, since $E = hf$, or energy equals frequency times Planck's constant.

22. This metaphor courtesy of Bill Marks.

23. Since currently we use digital computers more than any other encoding system for complex information, "digitization" has come to mean encoding. But keep in mind that digitization is only one way of encoding information.

24. Compare the "noble gases" such as neon, which have the full complement of eight electrons, allowing these atoms to remain imperiously alone.

25. These properties of silicon, as well as the scarcer and more heat-volatile germanium, were discovered in World War II radar research; see *Electronic Genie: The Tangled History of Silicon* by Frederick Seitz and Norman G. Einspruch (Urbana: University of Illinois Press, 1998). Military support was, of course, crucial to transistor research: from 1953 to 1955, half the money for transistor development at Bell Labs was military. During the Korean War, Bell Labs' brilliant William Shockley had the bright idea that a mortar shell driven by a microwatt junction transistor could be detonated just above the ground, raining shrapnel on the heads of the Communist enemy. The first fully transistorized digital computer was developed for the Air Force in 1954 by Bell's Whippany lab, to command guided missiles. Michael Riordan and Lillian Hoddeson, *Crystal Fire: The Birth of the Information Age* (New York: Norton, 1997), 187–88, 203–04.

26. Similarly, vacuum tubes, the precursor to the transistor, provided vacuums or no-electron's-lands that the electron could only jump when at a state of higher excitation.

27. For example, the OR circuit has two or more inputs and one output, and it emits a pulse if any of the inputs receives a pulse (Seitz and Einspruch, *Electronic Genie*, 198). In other words, the OR circuit is designed so that if a herd of excited electrons surges (through a wire of gold, copper, or aluminum) into any of its inputs, it will release a herd of excited electrons in turn.

28. See Gilles Brassard, Isaac Schuang, Seth Lloyd, and Christopher Monroe, "Quantum Computing," *Proceedings of the National Academy of Sciences 95*, no. 19 (15 September 1998): 11,032–033. http://www.pnas.org/cgi/content/full/95/19/11032.

29. As artist and flea-circus director Maria Fernanda Cardoso has told me, fleas do not learn per se, but they become more lively when stimulated with oxygen, as when she blows on them. Similarly, electrons exhibit four quantum states of excitation and "spin."

30. B. C. Crandall, "Molecular Engineering," in *Nanotechnology: Molecular Speculations on Global Abundance*, ed. B. C. Crandall (Cambridge: MIT Press, 1996), 31.

31. See, for example, Richard Hall's "Cosmetic Nanosurgery" and the fantasy of a seamless nanotech environment in J. Storrs Hall's "Utility Fog: The Stuff That Dreams Are Made Of," both in Crandall, *Nanotechnology*, 61–80 and 161–84.

32. See Brassard et al., *Proceedings*.

33. Three "science guys" helped me enormously in the course of researching and developing this argument. First and foremost, "How Electrons Remember" was developed through many head-spinning conversations, involving fevered drawing of diagrams on napkins and laptop-tapping telephone calls, with my father, neuroscientist and amateur physicist Bill Marks. Quantum computer scien-

tist and amateur physicist Gilles Brassard helped me remove my argument's quantum foot from its classical mouth. Electronic engineer and video synthesist Stephen Jones offered a lucid and sophisticated reading of the penultimate version of this essay. Jones encouraged me not to conflate self-organization with subjectivity, and as I ignored his advice, the essay remains open to charges of anthromorphism.

It was my pleasure to develop this essay for a unique intellectual milieu, the "Subtle Technologies" conference, organized annually by Jim Ruxton through the InterAccess Electronic Media Arts Centre in Toronto. Finally, many thanks to Grahame Weinbren, whose demanding editing allowed this essay to expand exponentially.

12. Immanence Online

1. See Gilles Deleuze and Félix Guattari, *What Is Philosophy?* (New York: Columbia University Press, 1994), 35–61.

2. See ibid., 35–39; Henri Bergson, *Matter and Memory*, trans. Nancy Margaret Paul and W. Scott Palmer (New York: Zone, 1988), chapter 1; David Bohm and Basil J. Hiley, *The Undivided Universe* (New York: Routledge, 1993), chapter 15; and Charles Sanders Peirce, "How to Make Our Ideas Clear," *Collected Papers*, vol. 5, ed. Charles Hartshorne and Paul Weiss (Cambridge: Harvard University Press, 1934), 252–58, and "The Architecture of Theories," *Collected Papers*, vol. 6, ed. Charles Hartshorne and Paul Weiss (Cambridge: Harvard University Press, 1935), 11–27.

3. Norm White, discussion at "Subtle Technologies" conference, Toronto, 10 April 2000.

4. See the archive at http://209.196.53.130/linebackn/guis/index.html.

5. Vivian Sobchack, "Nostalgia for a Digital Object: Regrets on the Quickening of Quicktime," *Millennium Film Journal* 34 (fall 1999): 4–23.

6. www.gnu.org/philosophy/philosophy.html. See J. J. King's interview with Stallman, "Free Software Is a Political Action," *Telepolis*, 18 August 1999. http://www.heise.de/tp/english/special/wos/6469/1.html.

7. Mark Rudolph, http://www.ciac.ca/magazine/en/pers-m9ndfukc.html.

8. Thanks to Grahame Weinbren for encouraging me to develop a more sophisticated notion of materiality, Alexandre Castonguay for turning me on to GNU and for stimulating harangues about proprietary software, Csaba Csáki for lively programming conversation, and Anne Ciecko and Bill Hector Weye for drawing my attention to Lineback's GUI archive. I'm also grateful to the Available Light Collective and SAW Gallery in Ottawa for helping me to develop "Lo Tek and Loving It: Electronic Media from Analog to ASCII," an exhibition in

May 1999 that generated ideas for this essay. An interactive version of this essay can be "played" at www.artengine.ca.

URLs of sites mentioned in this essay:

www.lowtech.org: Redundant Technology Initiative

www.ludd.luth.se/users/vk/pics/ascii/ASCIIM.HTML: Veronika Carlsson ASCII art

www.julietmartin.com/oooxxxooo: Juliet Martin, "oooxxxooo"

www.jodi.org

www.m9ndfukc.com

www.turbulence.org/Works/now/index.html: David Crawford, "Here and Now"

www.worldofawe.com/index.html#: Yael Kanarek, "World of Awe 1.0"

www.c3.hu/collection/form/competition.html Form Art Competition

http://zuper.com/form/: Michael Samyn, Form Art piece

easylife.org

www.turbulence.org/Works/short/index.html: John Hudak, "Short Work"

http://aleph-arts.org/1.000.000/indexv.htm: Antoni Abad, "1.000.000"

www.diacenter.org/km/index.html: Komar + Melamid, "Most Wanted Paintings"

www.pavu.com

www.airworld.net: Jennifer and Kevin McCoy, "Airworld"

www.potatoland.org/: Mark Napier, "Shredder" and "Composter"

http://adaweb.walkerart.org/context/jackpot/: Marek Wisniewski, "Jackpot"

www.erational.org/: Emannuel Lamotte, erational

http://gatt.org: ®™ark's fake GATT site

www.gwbush.com: ®™ark's fake Bush site

www.cybracero.com: Alex Rivera's "Cybraceros"

13. Ten Years of Dreams about Art

1. C. S. Peirce, "The Principles of Phenomenology: The Categories in Detail," in *Collected Papers of Charles Sanders Peirce*, vol. 1, ed. Charles Hartshorne and Paul Weiss (Cambridge: Harvard University Press, 1931–1958), 150.

2. C. S. Peirce, "How to Make Our Ideas Clear," *Collected Papers*, vol. 5, ed. Charles Hartshorne and Paul Weiss (Cambridge: Harvard University Press, 1934), 248–71. This was introduced to me by Marc Fursteneau's unpublished essay "Dreaming As Observing."

3. See William Wees, *Recycled Images: The Art and Politics of Found Footage Film* (New York: Anthology Film Archives, 1993), and Scott Mackenzie, "Flowers

in the Dustbin: Termite Culture and Detritus Cinema," *Cineaction!* 47 (September 1998): 24–29.

4. Peirce, "The Categories in Detail," 172–73.

5. Peirce, "Objective Logic," in *Collected Papers,* vol. 6, 148.

6. Gary Kibbins, "Bored Bedmates: Art and Criticism at the Decade's End," *Fuse* 22, no. 2 (spring 1999): 32–42.

7. This reactive mode takes us into the footsteps of Bruce Elder, who memorably argued that experimental work is the quintessentially Canadian cinema in "The Cinema We Need," *The Canadian Forum* (February 1985); reprint, *Documents in Canadian Film,* ed. Douglas Fetherling (Peterborough: Broadview Press, 1988), 260–71.

8. Floyd Merrell, *Peirce's Semiotics Now: A Primer* (Toronto: Canadian Scholars' Press, 1995), 116.

9. Peirce, "The Categories in Detail," 150.

10. Sally Berger, "Beyond the Absurd, Beyond Cruelty: Donigan Cumming's Staged Realities," in *Lux: A Decade of Artists' Film and Video,* ed. Steve Reinke and Tom Taylor (Toronto: YYZ Books and Pleasure Dome, 2000), 282.

11. Grahame Weinbren, "How Polluted Is the Ocean of Streams of Story? A Nostalgia for Interactivity . . . ," *Immediacy: A Forum for the Discussion of Media and Culture* 2, no. 1 (spring 2000). http://robinson.dialnsa.edu/~immedia/avantgarde/grahame.html. See also "In the Ocean of Streams of Story," *Millenium Film Journal* 28 (spring 1995): 15–30. http://mfj-online.org/journalPages/MFJ28/GWOCEAN.HTML.

12. Warmest thanks to Steve Reinke and Tom Taylor for putting before me the daunting challenge of surveying a decade of experimental media.

Filmography and Videography (with Distributor Information)

Distributors appear at the end of each entry; full names of distributors, along with contact information, are given at the end of this list.

A So Desu Ka (Steina, U.S./Japan, 1994, video, 9:40), EAI
Afternoon (March 22, 1999) (Steve Reinke, Canada, 1999, video, 23:00), VT
Aletheia (Tran T. Kim-Trang, U.S., 1992, video, 16:00), TWN, VDB
Alexia (Tran T. Kim-Trang, U.S., 2000, video, 10:00), TWN, VDB
All Flesh Is Grass (Susan Oxtoby, Canada, 1988, 16mm, 15:00), CFMDC
Animal Appetites (Michael Cho, U.S., 1991, video, 18:00), TWN, NAATA
ASCII Alphabet (Dorion Berg, Canada, 1999, video, 5:30), VG, VT
Barbie Liberation Organization Newsreels (Igor Vamos, U.S., 1994, video, 30:00), VDB
Boulevard of Broken Sync (Winston Xin, Canada, 1995, video, 5:00), VO
Chronic (Jennifer Reeves, U.S., 1993, 16mm, 58:00), WMM
Cold Pieces (Seoungho Cho, U.S., 1999, video, 11:20), EAI
The Color of Love (Peggy Ahwesh, U.S., 1994, 16mm, 8:00), Canyon, FC
De Profundis (Lawrence Brose, U.S., 1996, 16mm, 60:00), Canyon
Déconstruction (Rémi Lacoste, Canada, 1997, video, 7:00), Perte de Signal, www.perte-de-signal.org
Deseret (James Benning, U.S., 1995, 16mm, 82:00), CFMDC, Canyon
Diastole (Ines Cardoso, Brazil, 1994, video, 3:00), Casa des Rosas, www15.vianetworks.com.br/casadasrosas/radio/arquivos/video/ acervo/acervo.htm

Écoute s'il pleut (Zainub Verjee, Canada, 1993, video, 7:34), VO, VT

Ekleipsis (Tran T. Kim-Trang, U.S., video, 1998, 22:00), TWN, VDB

The Emperor's Naked Army Marches On (Kazuo Hara, Japan, 1986, 16mm, 122:00), Kino, www.kino.com

Everybody Loves Nothing (Steve Reinke, Canada, 1997, video, 16:00), VT

Excess Is What I Came For (Paula Gignac and Kathleen Pirrie Adams, 1994, 16mm, 8:00), CFMDC

Extreme Private Eros: Love Song 1974 (Kazuo Hara, Japan, 1974, 16mm, 92:00), distributor unknown

First World Order (Philip Mallory Jones, U.S., 1994, video, 20:00), EAI

Forever Young (Benny Nemerofsky Ramsay, Canada, 2001, video, 4:00), VT

Forward, Back, Side, Forward Again (Seoungho Cho, U.S., 1995, video, 10:41), EAI

Frank's Cock (Mike Hoolboom, Canada, 1993, 16mm, 8:00), CFMDC

Fresh Acconci (Paul McCarthy and Mike Kelley, U.S., 1995, video, 45:00), EAI

Glass Jaw (Michael O'Reilley, U.S., 1991, video, 20:00), VDB

Haptic Nerve (Dave Ryan, U.S., 2000, video, 12:00), Ryan, dvryan@rconnect.com

Her Sweetness Lingers (Shani Mootoo, Canada, 1994, video, 12:00), VT

The Hundred Videos (Steve Reinke, Canada, video, 1989–1995), VT

Hustler White (Bruce LaBruce, Canada, 1996, 16mm), LaBruce

I Know What It's Like to Be Dead (Bruce LaBruce, Canada, 1989, 16mm), LaBruce

Identical Time (Seoungho Cho, U.S., 1997, video, 14:21), EAI

Igliniit (Philip Joamie, Canada, 1989–90, television program), APTN

In the Present (Phyllis Baldino, U.S., 1996, video, 12:00), EAI

Institute Benjamenta (Brothers Quay, U.K., 1995, 35mm, 105:00), Zeitgeist

In the Form of the Letter "X" (Mike Cartmell, Canada, 1985, 16mm, 5:30), CFMDC

It Wasn't Love (Sadie Benning, U.S., 1992, video, 20:00), VDB, WMM

Je Changerais d'Avis (Benny Nemerofsky Ramsay, Canada, 2000, video, 4:00), VT

Jollies (Sadie Benning, U.S., 1990, video, 11:00), VDB, WMM

Kore (Tran T. Kim-Trang, U.S., 1994, video, 17:00), TWN, VDB

Letters from Home (Mike Hoolboom, Canada, 1996, 16mm, 15:00), CFMDC

Locked Groove (Caspar Stracke, U.S., 1999, video, 7:00), Stracke, kasbah@thing.net

Maigre Dog (Donna James, Canada, 1990, video, 7:30), VT

Measures of Distance (Mona Hatoum, Lebanon/Canada, 1988, video, 15:25), VDB, VT, WMM

Morphology of Desire (Robert Arnold, U.S., 1998, video, 5:45), VT

My Niagara (Helen Lee, Canada, 1992, 16mm, 40:00), WMM

Nano-Cadabra (Phyllis Baldino, U.S., 1998, video, 5:05), EAI

Nest of Tens (Miranda July, U.S., 1999, video, 27:00), VDB

Nice Girls Don't Do It (K. Daymond, Canada, 1990, 16mm, 11:00), CFMDC

Nitrate Kisses (Barbara Hammer, U.S., 1992, 16mm, 67:00), Frameline

notes in origin (Ellie Epp, Canada, 1987, 16mm, 15:00), CFMDC

Nunavut (Zacharias Kunuk, Canada, 1995, video, 13 episodes, 28:50 each), VT, IIP

Obsessive Becoming (Daniel Reeves, U.S., 1995, video, 58:00), EAI, VDB, VG

Ocularis: Eye Surrogates (Tran T. Kim-Trang, U.S., 1997, video, 20:00), TWN, VDB

Opening Series (Phil Hoffman, Canada, 1992–, 16mm), CFMDC

Operculum (Tran T. Kim-Trang, U.S., 1993, video, 14:00), TWN, VDB

A Paddle and a Compass (Shani Mootoo and Wendy Oberlander, Canada, 1992, video, 9:10), VO, VT

Paiaxão Nacional (Karim Aïnouz, 1994, 16mm, 10:00), distributor unknown

Phosphorescence (Anthony Discenza, U.S., 1999, video, 13:50), VDB

A Prayer for Nettie (Donigan Cumming, Canada, 1995, video, 33:00), CL

Rapt and Happy (Emily Vey Duke and Cooper Battersby, Canada, 1998, video, 17:00), VO

Rat Art (Mike MacDonald, Canada, 1990, video), VO

Robinson and Me (From the Far East) (Seoungho Cho, U.S., 1996, video, 11:00), EAI

Ronnie (Curt McDowell, U.S., 16mm, 1972), Canyon

Sally's Beauty Spot (Helen Lee, Canada, 1990, 16mm, 12:00), CFMDC, TWN, WMM

Seeing Is Believing (Shauna Beharry, Canada, 1991, video, 7:00), GIV

Seven Sisters (Mike MacDonald, Canada, 1989, video), VO

Shred of Sex (Greta Snider, U.S., 1991, Super-8), Canyon

Shulie (Elisabeth Subrin, U.S., 1997, 16mm, 36:30), VDB

Sinar Durjana (Wicked Resonance) (Azian Nurudin, U.S., 1992, Super-8), Frameline

Sister (Kika Thorne, Canada, 1995, video, 11:00), CFMDC

Slanted Vision (Ming-Yuen S. Ma, Canada/U.S., 1996, video, 50:00), TWN, VO

Sluts and Goddesses Video Workshop (Annie Sprinkle and Maria Beatty, U.S., 1992, video, 52:00), Sprinkle, www.gatesofheck.com/annie/

Sniff (Ming-Yuen S. Ma, U.S., 1997, video, 5:00), VO

Spin (Brian Springer, U.S., 1995, video, 57:30), VDB, VT

Starting Fire with Gunpowder (Boyce Richardson, Canada, 1991, video, 59:00), FRI

Super 8½ (Bruce LaBruce, Canada, 1994, 16mm), LaBruce

Takuginai (Leetia Ineak, Canada, television program, 1987–), APTN

Technilogic Ordering (Phil Hoffman, Stephen Butson, and Heather Cook, Canada, 1992–93, 16mm, 52:00), CFMDC

Those Fluttering Objects of Desire (Shu Lea Cheang, U.S., 1992, video, 60:00), VDB

Thundercrack (Curt McDowell, U.S., 1975, 16mm), Canyon

To Lavoisier, Who Died in the Reign of Terror (Michael Snow and Carl Brown, Canada, 1991, 16mm, 53:00), CFMDC

Toc Storee (Ming-Yuen S. Ma, U.S., 1993, video, 21:00), TWN, VO

Tribulation 99: Alien Anomalies under America (Craig Baldwin, U.S., 1991, 16mm, 48:00), Canyon

Triggers (Benton Bainbridge, U.S., 2000, multimedia), Bainbridge, www.benton-c.com

Twilight Psalm II: Walking Distance (Phil Solomon, U.S., 1999, 16mm, 23:00), Solomon, solomon2@stripe.colorado.edu

Un Chien Délicieux (Ken Feingold, U.S., 1991, video, 18:45), EAI

The Vision Engine (Anthony Discenza, U.S., 1999, video, 5:00), VDB

Work (Kika Thorne, Canada, 1999, video, 11:00), VT

XCXHXEXRXRXIXEXSX (Ken Jacobs, U.S., 1980–, 16mm, approx. 2:10:00), FC, Jacobs, nervousken@aol.com

You(r) Sex and Other Stuff (Katherine Hurbis-Cherrier, U.S., 1992, video, 5:00), Hurbis-Cherrier, Kh4@is.nyu.edu

Distributors

APTN	Aboriginal People's Television Network, www.aptn.ca
Canyon	Canyon Cinema, www.canyoncinema.com
CFMDC	Canadian Filmmakers Distribution Centre, www.cfmdc.org
CL	Cinéma Libre, www.cinemalibre.com
EAI	Electronic Arts Intermix, www.eai.org
Frameline	www.frameline.org
FRI	First Run/Icarus Films, www.frif.com
GIV	Groupe Intervention Vidéo, www.givideo.org

IIP	Igloolik Isuma Productions, www.isuma.ca
LaBruce	Bruce LaBruce, www.brucelabruce.com
NAATA	National Asian-American Television Association, www.naatanet.org
TWN	Third World Newsreel, www.twn.org
VDB	Video Data Bank, www.vdb.org
VG	Vidéographe, www.videographe.qc.ca
VO	Video Out, www.videoinstudios.com
WMM	Women Make Movies, www.wmm.org
Zeitgeist	Zeitgeist Films Ltd., www.zeitgeistfilm.com

Publication Information

An earlier version of chapter 1 appeared in *Screen* 39, no. 4 (winter 1998). Chapter 1 also contains sections from *The Skin of the Film: Intercultural Cinema, Embodiment, and the Senses,* by Laura U. Marks (Durham: Duke University Press, 2000); copyright 2000 Duke University Press.

Portions of chapter 2 appeared in an earlier form in *Parachute* 72 (fall 1993).

An earlier version of chapter 3 appeared as "Hara Kazuo: 'I Am Very Frightened by the Things I Film,'" *Spectator* 16, no. 2 (spring/summer 1996).

An earlier version of chapter 4 appeared in *The Independent* 16, no. 3 (December 1993).

An earlier version of chapter 5 appeared in *Jump Cut* 40 (1996).

An earlier version of chapter 6 appeared in "Cinéma et mélancholie," a special issue of *Cinémas* (fall 1997).

An earlier version of chapter 8 appeared in *Afterimage* 25, no. 2 (September 1997).

Portions of chapter 10 appeared in an earlier form in *Nach dem Film,* www.nachdemfilm.de.

An earlier version of chapter 11 appeared in *Millennium Film Journal* 34 (autumn 1999).

An earlier version of chapter 13 appeared in *Lux: A Decade of Artists' Film and Video,* ed. Steve Reinke and Tom Taylor (Toronto: YYZ Books and Pleasure Dome, 2000), 15–33; copyright 2000 YYZ Books and Pleasure Dome. Reprinted with permission.

Index

®™ark, 188

Abad, Antoni: "1.000.000," xi, 186–87
Abbatoir collective, 198
Aboriginal media, 34–38; Aboriginal
 People's Television Network, 36
Acconci, Vito, 154, 208
Activist art, xiv, 199–200, 202, 205
Adams, Kathleen Pirrie: *Excess Is What
 I Came For,* 202
Adams, Parveen, 17
Adbusters: "Uncommercials," 199
Aesthetics, xv, 123; of failure, 66
Ahwesh, Peggy: *The Colour of Love,* xi,
 99–101, 102
AIDS, 91–92, 98–99, 109, 205, 228n24
Aïnouz, Karim: *Paixão Nationale,* 73,
 83–84, 88
Alpers, Svetlana, 6
Alterity or unknowability, xi, 19–20,
 24–25, 27, 32, 97
Analog media, 148, 162, 233n11; elec-

tronics of, 168–70. *See also* Film,
 experimental; Film and video;
 Photography; Video
Andrew, Dudley, xiii
Animals: as commodities, 31–34, 37;
 conservation, 27; in fiction, 23–25;
 hunting, 36–38; identification
 with, 23–26, 31–39. *See also* Dogs
Animation, 131–32, 136
Animism, 129, 131, 139
Antihumanism, 38. *See also* Identifica-
 tion; Nonorganic life; Subjectivity
Archival images, 58–59, 66, 93,
 99–103, 105–7, 197, 210–12
Arnold, Martin: *Pièce Touchée,* 63–64
Arnold, Robert: *Morphology of Desire,*
 152
Art history, 4–7
Arthur, Paul, 41
Art movements, 197–98, 202–3, 204–5
ASCII art, 181, 184, 233n7. *See also*
 Software

249

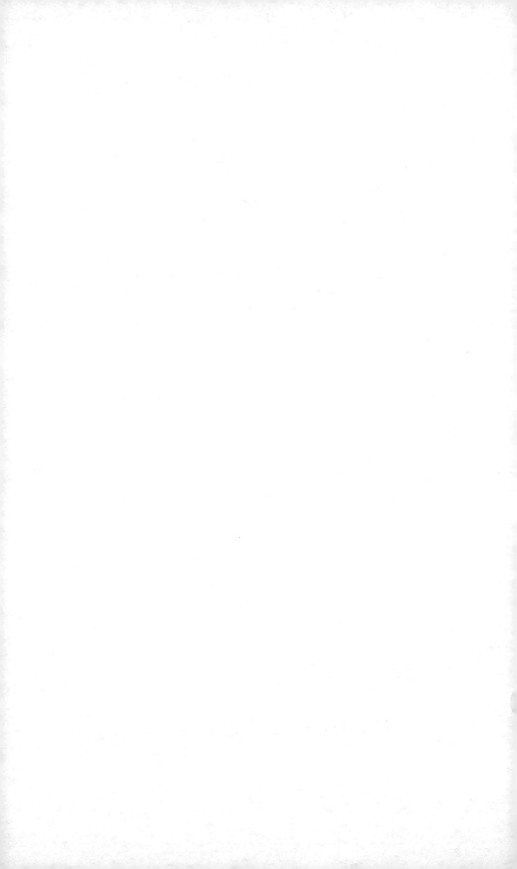

Laura U. Marks is a theorist, critic, and curator of artists' independent media. She is the author of *The Skin of the Film: Intercultural Cinema, Embodiment, and the Senses,* and her essays and articles have been published widely in scholarly and popular arts journals. Since 1991 she has curated numerous programs for artist-run centers and festivals. She is associate professor of film studies at Carleton University, Ottawa.